Designing and Producing Media-Based Training

Designing and Producing Media-Based Training

STEVE R. CARTWRIGHT

G. PHILLIP CARTWRIGHT

Focal Press

Boston • Oxford • Auckland • Johannesburg • Melbourne • New Delhi

 Butterworth–Heinemann supports the efforts of American
Forests and the Global ReLeaf program in its campaign for
the betterment of trees, forests, and our environment.

Library of Congress Cataloging-in-Publication Data

Cartwright, Steve R.
 Designing and producing media-based training / Steve R.
Cartwright, G. Phillip Cartwright.
 p. cm.
 Includes bibliographical references and index.
 ISBN 0-240-80325-6 (pbk. : alk. paper)
 1. Employees — Training of. 2. Educational technology.
3. Computer-assisted instruction. I. Cartwright, G. Phillip
(Glen Phillip), 1937– . II. Title.
HF5549.5.T7C29855 1999 99-18133
658.3′12404 — DC21 CIP

British Library Cataloguing-in-Publication Data
A catalogue record for this book is available from the British Library.

The publisher offers special discounts on bulk orders of this book.
For information, please contact:
Manager of Special Sales
Butterworth–Heinemann
225 Wildwood Avenue
Woburn, MA 01801-2041
Tel: 781-904-2500
Fax: 781-904-2620

For information on all Focal Press publications available, contact our
World Wide Web home page at: http://www.focalpress.com

10 9 8 7 6 5 4 3 2 1

Printed in the United States of America

Table of Contents

Foreword

In today's fast-paced, ever-changing business world, companies have embraced the concept of training to help their employees meet the growing demands placed on them. During the last five years, training budgets have increased by almost 50 percent. While I would be among the first to insist that training is critical and necessary, too often it can fail when the training process is not fully thought out.

One of the great myths of the business world is that you just conduct a quick training program and the problem is solved. Sometimes I'm reminded of the line from an old Mickey Rooney movie, "Let's get a barn and put on a show." An elaborate production is staged with modest effort and limited attention given to the real needs of the audience.

Granted there are some experienced trainers who can move through the process very quickly, giving the appearance of a quick fix to the problem. However, any program that is to provide effective results over a long period of time must follow a process that requires thought, time, and effort.

In the early 1990s, I worked for a national retailer of athletic footwear. We realized that to gain the reputation of a premier nationwide retailer we needed to ensure that each customer was provided a uniform shopping experience and a consistently high level of service. Our executives said, "Let's put on a training program," and with that they turned it over to me, expecting a training program in a couple of months. What I didn't know at the time was that I was about to embark on one of the greatest learning experiences of my career.

My first step was to renegotiate the amount of time needed to develop the program. We also agreed that we wanted a program that would last for several years. Like many retailers, our workforce was relatively young—the average age was 18 to 24—so we had to seriously consider how they would best receive the message. We decided to use video and reinforce the message with print materials. I knew, however, that the standard instructional video "chalk-talk," with an expert preaching to the audience, just would not work for our sales force.

Because we had no one on staff who had experience in scriptwriting and video production, we determined it would be best to hire an expert.

Hiring an outside authority proved to be beneficial in two areas. First, it is imperative that if you want a truly professional product you must utilize a qualified professional. Someone who knows not only how to "shoot" the video, but who can and will help you fully utilize all the advantages of the medium. For a good mutual working relationship, this can be one of the most critical decisions you make. In contrast, a few years later I hired a "video guy" to come in and produce a short program on employee benefits. Although he had "professional" equipment and "shot" what we thought we wanted, he provided very little direction. The finished program was disappointing to say the least, proving that having the right equipment to do the job is only half the equation. It takes talent and experience behind the camera as well as in front of the camera.

A second advantage of hiring an outside professional was that it provided us with additional help in clarifying the information. When the process began, we thought we knew what we wanted, but as we put the script together, we had to keep going back to the operations group to clarify what "good" looked like. For example, there were many critical behaviors they wanted the associate to perform each time they encountered a customer. Such as, how many pairs of shoes should be brought out of the stock room? What kind of questions should you ask the customer? Should technical information (features and benefits) be used in each customer interaction? Before you can provide visual behavior modeling, there must be a clear definition—down to the smallest detail—of what behavior you want to see. We also found that often we would throw too much information at the associates. Our expert producer helped us clarify our true message, so that we could convey it in a clear and concise manner.

We knew that we were going to have a great video message. What we needed next was material to reinforce the message, exercises to ensure that the associates would practice the behavior they learned, and last but not least, a way to know whether they were utilizing the tools we had developed.

Ultimately we developed four training videos, each with an accompanying workbook and test. The program was used with only minor revisions to the workbooks for almost seven years. After the program had been in place for a couple of years, we were asked to have the program dubbed for use with our franchise operations in Europe.

Our research, planning, clarity of message, reinforcement of message, and compliance tools all worked together to provide a program that was credited as being a critical component in a 35 percent increase in sales.

Today, there are many more ways to reach an audience: interactive multimedia, satellite, and Internet training delivery to name just a few. *Designing and Producing Media-Based Training* will help you learn how to use technology effec-

tively to produce training for your audiences. The material in this book will not simply show you what a nice finished product will look like; it provides clear points for you to consider as you look at the best medium for your audience as well as specific details in the creation of a training program you can be proud of.

Technology alone is not the answer—as I painfully learned first hand. It must be combined with good design and an understanding of the most appropriate use of the media. Don't let the hype of manufacturers make critical decisions for you. Choose training technology carefully so that your audience will be able, ultimately, to achieve your training goal.

Judy Potter
Vice President, Human Resources
Asset Management Outsourcing, Inc.
Atlanta, GA

Introduction

Training represents a $60 billion market,[1] and that market continues to increase each year. More than $14 billion of that figure is spent on outside services, with almost $4 billion dollars going toward technology. The key questions are: Will these dollars be spent wisely? Will training organizations receive measurable results for what they spent on training? This book was written to help your organization respond to those questions with an enthusiastic "Yes."

It's easy to get caught up in the excitement of the technology available and to focus your energies on issues such as Internet training distribution; choosing between CD-ROM and DVD; measuring the value of MPEG versus M-JPEG technology—the list is endless. Indeed, if we are not careful, such issues will consume all of our time and energy, leaving no room for the most important issue: providing effective training. Effective, efficient training requires that trainers have a solid background in instructional design as a functional competency. Design comes first; then comes technology to support compelling instruction. This book focuses on how to design effective training and how to deliver it through technology-based delivery systems. Our belief is that trainers need information and experience in traditional instructional design as well as new technologies but that design and planning are paramount. You simply can't have effective technology-based training without paying attention to critical issues in instructional design.

There is no perfect technology and no one system that is appropriate for all communication goals. We can, however, learn the successful program design and implementation techniques needed to accomplish training objectives using current technologies. This book addresses these techniques and offers solutions to the numerous technology choices confronted by trainers on a daily basis.

Why should trainers be concerned with graphic design, the "language of video," or interactive multimedia authoring? Because the ability to create effective communication that influences thoughts and moves people to action is important to the learning process. Trainers must fully understand how technology influences the learner and how to effectively utilize technology to accomplish training goals.

Rapid advances and breakthroughs in technology keep us living on the edge of a decision. As technology makes it easier for all of us to make graphics, create animation, and burn CD-ROMs for training, the real question should be, are we using the technology effectively? Are we creating graphics, animation, video, and CD-ROMs that help our audiences *learn?* This book addresses the important issues that surround technology: how to use technology-based learning effectively, and how to design and produce graphics, animation, video, and interactive multimedia so that it creates the results you aim for.

This book is a natural extension of the training technology workshops and seminars we have been conducting over the years. It is an update of *Training with Video*, published in 1985 by Knowledge Industry Publications, Inc., and it represents the authors' combined total of more than fifty years of experience in the training and education fields. The purpose of this book is to provide a realistic resource for trainers and media producers to turn to, as well as useful tips on designing and producing technology-based training.

The nine chapters of this book offer tried-and-true solutions to designing and implementing video-based and interactive multimedia training, with the emphasis always on excellence in the design of training programs. Chapter 1, "Technology-Based Training," addresses the advantages of using technology-based training and includes highlights of studies comparing technology-delivered training versus traditional classroom approaches. Several examples of successful video-based training and interactive multimedia training programs are presented. Chapter 2, "The Training Design Process," provides an overview of the training program design process with a five-phase approach to program development: needs assessment, training program design, training materials development, program implementation, and program evaluation techniques. Chapter 3, "Technology-Base Program Development Process," details training program design essentials, including how to do a thorough needs assessment, budget preparation, interactive multimedia program design considerations, training assessment tools, and legal issues.

Chapter 4, "Scriptwriting and Storyboarding," offers scriptwriting techniques and examples for both video-based and interactive multimedia, and Chapter 5, "Production Design," offers production design considerations. This chapter introduces the concept of "production design," or how to design and produce effective media elements for incorporation into training programs. It also looks at working with the special characteristics of light, sound, motion, composition, and color as it applies to creating video-based and interactive multimedia training programs.

Chapter 6, "Choosing an Authoring System," takes you into the land of interactive multimedia authoring systems. Such systems offer easier approaches to the preparation of multimedia than standard programming languages. This chapter provides valuable information about how to select an appropriate authoring program to meet the needs of your projects and resources. Chapter 7,

"Interactive Multimedia Design Considerations," unveils some of the mysteries of how best to use computer-based interactive programs to help you get your points across. It covers a wide range of issues such as proper color selections, navigation techniques, hierarchical planning, feedback, and learner control.

Chapter 8, "Training Design and Production Tips," offers usable tips for designing and producing video and multimedia training programs. The tips are organized into the main topics of training design, video production, audio production, graphic design, animation techniques, multimedia creation, and legal considerations, as well as tips on working with talent. We also hope you find Chapter 9, "Resources," to be a helpful guide to software programs, books, organizations, and manufactures related to the video and multimedia development field.

We would like to thank our editor, Terri Jadick, for her patience and insight into the formation of this book. We would also like to thank our contributors: Cecil Smith, consulting engineer; Mark McGahon, Dallas-based graphic artist; Jerry Freund, Tucson Medical Center; Scott Wheeler of Chicago's Wheeler Multimedia; and Robert Tat, San Francisco-based video producer. Now let's address the real issues of training with technology.

NOTE

[1] *Training* magazine, Lakewood Publications, October 1998.

Technology-Based Training

Technology's effectiveness as a tool for training has been demonstrated at every level of education, from laptop computers to pilot flight simulators. Its use for training in industry, government, health care, and education has increased dramatically in the last decade. Technology such as video and computer-based, interactive multimedia shifts time, space, and content into viewer-controlled programming, making information available whenever, wherever, and in whatever amounts needed. Technology-based training today uses text, graphics, video, animation, and sound to convey technical skills, concepts, and behavior equally well. It is cost-effective, saves valuable training time, and increases the effectiveness of achieving training goals.

This book discusses how technology has become such a successful training tool and provides the basics for designing and producing technology-based training programs. It examines why, how, and when you can use technology for training, and describes successful approaches to creating effective technology-based training. It describes the instructional design process, scriptwriting, multimedia authoring, media production, and new, technology-based training delivery systems. The emphasis of this book is on how to design successful technology-based training. It is not meant to be a complete study of the instructional design process, nor is it written to be the final word on instructional technology, but it is meant to provide an easy to follow, step-by-step approach that will set the reader in motion to creating successful, technology-based training programs.

The emphasis of this book will be on the training and media design process as it relates to developing technology-based training programs. We will discuss the instructional design process as it relates to selecting and developing media. We will also detail the steps involved in designing and producing instructional, media materials. From video-based training to videoconferencing, from CD-ROM to Web-based training, this book looks at the design and production issues that surround the production of media-based training.

TRAINING DEFINED

First, let's look at what training is and isn't. Companies throughout the country are providing safety training, supervisory and management training, basic skills training, technical and sales training, and customer training. Training represents (depending on who you talk to) a $40 billion industry. But "training" often becomes a catch-all phrase. It is easy to fall into the trap of trying to solve all problems with "training." It is important to first have a good working understanding of what training is.

Nadler and Wiggs in their popular book, *Managing Human Resource Development: A Practical Guide*, provide a popular definition of training as techniques that "focus on learning the skills, knowledge, and attitudes required to initially perform a job or task or to improve upon the performance of a current job or task." In other words, an activity designed to change an attitude, behavior, or skill.

We should try to separate "training" from "information." Quite often we are asked to do a "training" program that is actually an "information" program. The difference between the two should be defined so that we can produce the appropriate results. We define "information" programming as having content that is "nice to know" but is not necessarily critical to job performance or, more specifically, does not hold the viewer accountable for a specific action. A training program, on the other hand, should hold the viewer accountable for a specific action after viewing the program. It should affect the performance, behavior, or skill level of the viewer. With training we are after change—a change in behavior, attitude, or skills. Technology can help us achieve this change.

Many training programs that do not work well do not have a clear, defined purpose or goal. Training programs differ from information programs because each tries to achieve a different result. An information program is designed primarily to create a better understanding of a job or to bring awareness to a subject. It may influence a better work environment or attempt to affect morale. Information is usually helpful to know, but it is not absolutely necessary or critical to job performance. After viewing informational programming, the audience will not necessarily be held responsible for the information. Scrolling through page after page of text on a computer screen or staring at a postage-size, video "talking head" on a computer is not training, nor is an employee information or news program. Viewers are not usually held accountable for any action after viewing these "training" programs. They are not held responsible for the content of the program. However, these programs can be justified through their communication objectives. Video news programs tend to be a great way to deliver information in a visually interesting manner. As an example, television adds credibility to messages that might otherwise go unread in a memo. The successful approaches to news programs that we have seen tend not to take themselves too seriously. They stick to visually interesting stories and are delivered in the atmosphere of a staff meeting, with a supervisor present who responds to and encourages discussion.

On the other hand, a training program has to generate accountability, and an action or result is expected after participating in the program. The viewer is held accountable for the content and is expected to perform differently on the job after viewing the program. The viewer is tested or audited for a specific change in performance, behavior, or attitude. An old Chinese proverb helps me to define what good training should do:

Tell me and I'll forget. Show me and I may remember. Involve me and I'll understand.

Effective training involves the viewer and creates understanding. You should determine whether the program will be used for training or information, because the end result or expectation will be different for each. Hence, the designs of the two kinds of programs must differ. For example, in information programs, such as corporate news shows, corporate messages, employee benefit and orientation programs, producers try to create excitement and impact through music, fast pacing, glamorous talent, and attractive visuals. The person delivering the message is often as important as the message itself, as is its impact on the viewer. The impact of the program, in fact, often becomes its overall objective or goal. Thus, the evaluation of the informational program is based on the effect it has on the audience. There is certainly nothing wrong with this goal, but it has to be defined at the outset.

By contrast, training programs are designed to create specific results that will effect a change in performance, behavior, or attitude. You must carefully design the program so that the desired changes in your audience will occur. The programs need to be designed so that they are precise and to the point, using pictures and words that aid understanding. Visuals are carefully chosen and created not to interfere with the message but to add to, clarify, and reinforce the message. In a training program, you will become less concerned about creating a pretty picture and more concerned that the images are accurate and not misleading, and that they create a clear understanding.

Training programs use music judiciously so that it does not distract from learning. Talent is selected carefully for credibility and accuracy of delivery. The pacing is purposely slowed down in critical areas so that the viewer has a chance to digest the information and so that all viewers can follow along. Since you are expecting an action to take place after the viewing, you have to plan for different levels of acceptance by your audience. Each person viewing the program will receive it a little differently and at a different pace. This acceptance has to be planned for. In training programs you are less concerned with entertaining than you are with teaching. Effective adult learning principles apply, as we will learn in Chapter 2.

Now let's look at why today's media technology works so well for training delivery.

ADVANTAGES OF USING VIDEO-BASED TRAINING DELIVERY

Video is an unusually successful training tool. It saves time, money, and resources. It adapts to a wide variety of situations and requirements, and, at the same time, it guarantees consistency in repeated viewing unmatched by a live performance. It makes use of the inherently interesting features of color, motion, and sound in one universally acceptable medium.

How Video Saves Time

Even though it usually takes about ten times as long to create a video training program as it does to prepare and present traditional classroom training, video ultimately saves far more time at the point of delivery and when the material must be repeated. With a well-designed video program, you save up to 75 percent of the time it would take to deliver the same message in traditional lecture style. If training time can be reduced by as much as 75 percent, money and other resources can certainly be saved as well.

At BHP-Copper in Arizona for example, a copper mining company, operator training time was reduced by 50 percent as soon as they started to use training modules that incorporated video. This meant that the operators of technical equipment who participated in the training could master the materials in half the time. BHP-Copper's Training Coordinator Dale Ridgeway expects this training cycle time to be reduced even further as his trainers become more efficient with the modules. Ridgeway calculated that eighteen two-hour traditional classroom training programs created 10,800 contact hours (36 hours with 300 operators), costing the company approximately $270,000 a year. With video training, Ridgeway cut the two hours of instruction into fifteen-minute modules, creating 1,350 contact hours at a savings of over $128,250 the first year.

In designing video training you have the advantage of compression. You can cut out unnecessary information and deliver only as much information as is directly related to the training objective. When you compress information, the student can learn in much less time than it would usually take in a classroom setting, so the objective of the training program can be obtained in much less teaching and learning time.

Not only does the use of video in training save student time, it also saves instructor time. No longer tied up in the classroom, instructors can devote more time to program development, auditing, and testing. This translates into more information being delivered to the student in less time.

How Video Saves Money

By reducing the time spent by staff, management, and instructors, video can reduce the cost of training and communications. If it takes less time to communicate corporate messages through the use of video, staff and management time

is saved; if it takes less time to train new workers, they become productive that much sooner; if the training process itself takes less time, instructional staffs may be reduced, or their time may be employed more economically. Thus, video effectively creates cost savings throughout the corporation.

How Video Increases Efficiency

The student is seldom ready to receive information at the same time the trainer is ready to deliver it. Video enables you to bring these two times together and allows the learner to adjust information reception to his or her own schedule. No longer are you locked into prescheduled information delivery. The learner now controls the schedule of viewing.

With well-designed video training, instructors do not have to be present to deliver information. Thus, video can assume the responsibility of training twenty-four hours a day.

A typical example of using video as a training tool on a twenty-four-hour work basis can be observed at the Tucson Medical Center. This hospital has set up an effective MATV (master antennae distribution system) for its television programs through the use of master antennae, cable, satellite reception, and computer media servers.

Programming is available around the clock to patients and staff. Hospital clinical skills, equipment operation, patient information, and surgical techniques are made available through the various distribution systems. (A more detailed description of TMC's television distribution system follows later in this chapter.)

How Video Reduces Travel Time and Costs

Time and money are saved when video replaces the traveling instructor. Using a video network (video players placed in field offices, or through Intranet/Internet delivery) learners in regional or international offices can benefit from on-site training without the instructors having to travel to each location. Video extends the viewing audience and opens up communications among local, regional, national, and international offices.

Video Training Is Consistent

Another significant advantage of using video in training is its ability to deliver information consistently. All viewers receive the same information in the same style of delivery. The videotape records the lecture or program and preserves its style and meaning exactly as the presenter originally intended them. The individual differences in the interpretation, style, or philosophy of a number of instructors is never a problem. All viewers receive the same message every time they view the program. This is extremely important when it comes to teaching attitudes and philosophy, as in supervisory or management training. The presentation of the organization's policy and philosophy is not left to individual

interpretation. Instructors need not feel the pressure of presenting the material over and over again in a consistent, organized manner. All viewers, whether they are impressionable new employees receiving their first exposure to the company, or seasoned sales personnel in offices around the country, receive consistent information that has been designed, written, and controlled by the organization. Video creates a reliable, constant delivery system that is readily available and delivers the same corporate message each time.

Video Is Inherently Interesting

Video is a visual medium, and it has the ability to hold interest through color, motion, and sound. If used properly, video can create interest through visual stimuli. According to one expert, visual images hold a viewer's interest and also increase the retention and recall of information. Visuals help achieve both accuracy and standardization, as does color. Color helps to illustrate difficult concepts and clarify information. Various studies have proven that color and visuals can accelerate learning by 78 percent, and improve and increase comprehension by 70 percent. They can increase recognition and perception and reduce errors. Color and visuals affect motivation and participation. Video can turn the learning situation into a positive, motivating experience.

Video, like film, has another advantage that contributes to training: motion. Through motion you can provide performance feedback, role modeling, product and safety demonstrations, process examples, and motion skill development. Motion helps to deliver the message. If used effectively, it increases the training reception. In some situations, such as skill development, motion is essential for effective learning.

Audio is an element of video that helps in many training situations as well. You can use audio to reproduce various voice and sound conditions. You can also use it for recognition and discrimination. Sound effects, music, and voice add interest, realism, and excitement. Audio in video productions is frequently overlooked, but if incorporated into the script and into the learning objectives, audio can add to any training experience.

SPECIAL FEATURES OF VIDEO

Standard Format

One of the outstanding advantages of video is the ease with which it can deliver information because of the standardization of video formats. In the early days of video, several different formats were not compatible with each other. A tape created on one system or standard could not be played on another, different system. With the introduction of the VHS (Video Home System) by JVC Corporation in the late 1970s, however, the compatibility problem has been greatly diminished for video playback. The quick acceptance of VHS in the consumer market soon made the for-

mat a standard in the training industry. However, standardization for Internet or Intranet delivery has a long way to go. In later chapters, we will cover in detail the video production and distribution equipment needed in training situations.

Portability of Equipment

Most of the money spent on video production equipment is now going for single-camera systems that can produce high-quality videotapes in the field. Portable video production equipment, available at very reasonable prices, offers producers the realism that field shooting provides. It helps video managers get away from the high cost of maintaining studios and allows them the freedom of shooting more productions on location.

Field production creates realism for the training situation. It allows you to visit the work site and present the working situation that the trainee will experience eventually. It gets away from the stale, standard "talking head" of studio production and lets the viewer travel visually to the sites and to the experiences that are needed to deliver accurate training information.

In review, video has some significant attributes that can be applied specifically to creating training results:

1. Video delivers information consistently; everyone throughout the organization receives the same message.
2. Video provides convenience and availability. Programs are available when and where the viewer needs them.
3. Video is a visual medium that helps illustrate and demonstrate difficult concepts. Video adds the dimension of motion for skill-building and behavior-modeling.
4. Video is a cost-effective medium. Programs can be distributed to hundreds of viewers, creating training results at a fraction of the cost of traditional training methods.
5. Video is capable of handling a variety of training requirements; behavior modeling, skills, and concepts can all be taught with video.

INTERACTIVE MULTIMEDIA TRAINING FEATURES AND ADVANTAGES

Thanks to the computer, multimedia has interactive capabilities that are combined with high-resolution color graphics, stereo sound, digitized images, full-motion video, animation, and text to create a highly interactive, cost-effective, self-directed, training and performance tracking system.

Interactive multimedia applications range from computer-based presentations to computer games, from video conferencing to corporate training.

Interactive multimedia can be delivered on desktop computers, at in-store kiosks, or on corporate computer networks. It offers an abundance of training and communications opportunities, as well as new technologies incorporating interactive capabilities that influence the way we receive information and learn.

There are numerous advantages in using interactive technology for training and communications, including the following:

Retention

- The process of interaction with content material provides strong learning reinforcement that significantly increases content retention.
- Interaction with the material creates involvement with the learning process.
- Students learn at their own pace and control the sequence of learning.
- Students are in control of the information they receive, the direction the information takes, and the amount of information they receive.

Time and Efficiency

We have found that interactive learning reduces learning time by an average of 50 percent for the following reasons:

- Interactivity creates the most efficient path to the mastery of content.
- Visuals and audio provide powerful tools for clearer understanding.
- Good interactive programs provide constant, positive, highly effective reinforcement.
- Interactive learning provides for and accommodates different learning styles to maximize student training efficiency.

Consistency

- Interactive media provides consistent, reliable training delivery, not varying in quality.

Reduced Costs

- Interactive media saves instructor time and student time because it takes less time to teach concepts.
- It reduces delivery costs (compared to classroom training when large numbers of students are involved and the training is repeated for many students), travel costs, and time away from the job.
- It provides immediacy of training, bringing the training on-line when and where it's needed to decrease downtime.

There have been literally hundreds of research studies carried out in which interactive-multimedia instruction was compared with conventional instruction in controlled research environments. In general, these studies[1] reveal that computer-assisted instruction (interactive-multimedia) is superior to conventional instruction in the following variables: student achievement, including both immediate and long-term retention; attitude toward subject matter; and time to complete the task.

The research clearly reveals that interactive-multimedia students realize higher achievement in significantly less time than conventionally instructed students. Interactive-multimedia training creates:

- immediate and long term achievement and retention — 25 to 30 percent higher achievement rates compared to conventional instruction;
- reduced training time — 25 to 40 percent savings in time over conventional instruction; and
- course completion rates are much higher than other forms of instruction.

As a result, training costs are reduced through both the time saved and the dependability of instruction. In short, self-directed learning saves time for instructor and student alike.

Some additional interactive-multimedia advantages include:

- Computer-based interactive training allows the trainee immediate access to context-sensitive help screens.
- Computer hardware storage capabilities allow for supplementary materials for study and review, such as safety issues, extensive glossary items, and policies and procedures.
- A trainee's progress through an interactive program can be tracked through record-keeping, along with the assurance that all training is being followed.
- Formal evaluation, such as section quizzes and achievement activities, assure mastery of the material.
- Training designers can include appropriate simulations for on-line/off-line procedures to assure a high degree of realism in presenting the material to the trainee.
- Training designers can provide practice for the trainee within the context of the material being presented, in the form of drills, exercises, prompts, questions, or working simulations, without any distractions from the program.

The use of interactive multimedia continues to grow in the training and education field. Technology choice is a reflection of audience demands, budget,

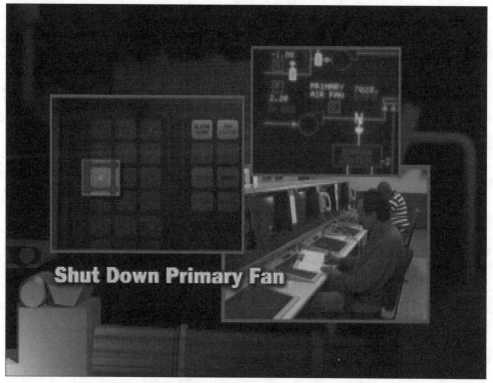

Figure 1.1 Graphics mixed with video create a clearer understanding of a process for the viewer.

equipment (platform) compatibility, and multimedia program development resources. The training goals and audience demands should play a key role in the selection of technology.

OPTICAL DISC TECHNOLOGY

Another training delivery technology that is very popular today is CD-ROM, a good choice now and in the future. CD-ROM, or Compact Disc-Read Only Memory, is an economical storage medium (650 MB of storage capacity) and has been a publishing and distribution medium for text, database, photo, graphics, and video. CD-ROM can be fully integrated into a computer providing computer-based, interactive multimedia programming. Full-motion, digital video, and CD-quality audio coupled with interactive capabilities create a great future for CD-ROM.

Optical disc technology is changing rapidly. Market demand has created rewritable CDs that allow users to record onto CDs for programming and storage. Low-cost CD-Rs (Compact Disc-Recordable) allow trainers to record their own interactive programs onto CDs for program testing (called check discs) and,

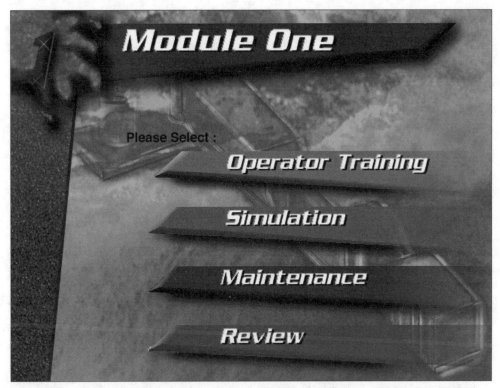

Figure 1.2 Interactive multimedia training delivered in CD-ROM provides a popular training format.

in some cases, to record small amounts of interactive CD-ROM programs for delivery directly to the viewer.

Developing CD-ROMs for training delivery has a shorter history than developing video training; consequently, the development process can be challenging. Anyone who has taken a step toward CD-ROM publishing knows the path can be rocky. There are a host of considerations that have to be made, considerations that do not exist in the world of print and video. With multiple computer platforms available to the end user, along with varying processing speeds, screen size, display quality, sound playback variables, and total available memory limitations, compatibility issues soon arise. Developers quickly learn that standards in the optical media world are few and far between. (Suggestions for CD-ROM delivery may be found in Chapter 8, "Training Design and Production Tips.")

DVD

New optical disc technology called DVD (Digital Versatile Disc) holds the promise of being *the* accepted training delivery platform. DVD-Video is a stand-alone

Figure 1.3 *DVD, Digital Video Disk Player,* by Panasonic (photo courtesy of Panasonic Corporation).

player manufactured by several companies including Philips, JVC, Panasonic and Sony. DVD-Video can hold 133 minutes (per side) of full motion (near broadcast) MPEG-2 quality video and CD-quality audio (three channels) with a storage capacity ranging from 4.7 to 17.8 gigabytes of non-linear access storage—twenty-six times the capacity of a standard CD.

A downward compatible format, meaning it will play all CD-ROM formats, DVD has the potential of replacing VCRs, audio CD, CD-ROM, and removable storage drives. DVD has excellent picture quality and sound but will be slow moving into the marketplace because of manufacturing compatibility problems. There are five DVD Disc types that vary in data storage formats—from single-sided single layer, to double-sided double layer—each having its own development and delivery specifications. Since DVD is not a universal medium like CD-ROM, check with the DVD manufacturer for the specifications before you start a DVD design and development process.

DVD-ROM, a subset standard of DVD, is designed for computer use. DVD-ROM acts like a CD-ROM player but holds seven times more data. The DVD-ROM promises large storage capabilities, fast data transfer rates, and excellent picture and sound, giving multimedia training producers plenty of speed and room for dynamic, fully interactive programs. DVD stores data similarly to the CD-ROM and is very complex. However, with the stringent authoring and pre-mastering requirements of DVD, the multiple formats available and the limited number of development tools, the production and mastering process promises to be a challenge for trainers for years to come.

There are very few DVD authoring programs available to the trainer. Sonic DVD Producer from Sonic Solutions is one of the first authoring systems to hit the market. With a starter price of $25,000, Sonic DVD Producer offers real-time tools for authoring and formatting interactive content for DVD. At this point in time, however, trainers should seriously consider outsourcing DVD development for their training titles.

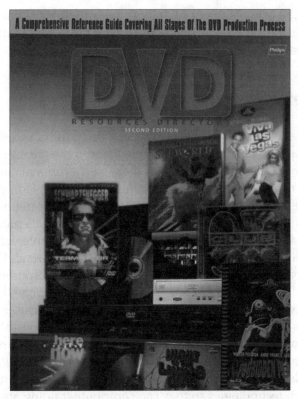

Figure 1.4 *DVD Resource Directory*, available from Knowledge
Industry Publications, White Plains, NY.

Eventually the dust will settle on all of these optical media standards, and DVD will be another very viable distribution media. A good resource for optical media information is *Emedia* magazine at *http://www.on-lineinc.com/emedia*. Knowledge Industry Publications (914-328-9157) also publishes the *DVD Resources Directory*.

Technology choices affect multimedia development and delivery. Often we try to develop the program on the same platform that it will be delivered on, which simplifies the development and distribution process. However, this is becoming less of a concern with new authoring programs that allow you to develop a multimedia program on one platform, such as the popular Macintosh, and deliver it on a PC platform. This is also called multiplatform development. Macromedia's authoring program *Director*, for example, allows multiplatform authoring (for more information, go to *http://www.macromedia.com*).

Corporate computer networks are also starting to handle the delivery of multimedia training and communications. Graphic enhancement cards, sound cards, video boards, storage capabilities, and input devices all add to technology

choices. Just as the establishment of an effective training system require profes-sional assistance, multimedia technology requires professional analysis and con-sultation at an early stage of system development.

TRAINING DELIVERY TRENDS

Video has been, and will be for years to come, a very cost-effective training deliv-ery method. In fact, according to *Training* magazine, there are more video training programs presented in corporations then there are traditional classroom presen-tations. Video is clearly a winner when it comes to training. However, as outlined above, optical disc technology is also a popular medium for training delivery and will grow in use in years to come. CD-ROM and DVD formats provide interactive and training management capabilities as well as cost-effective delivery.

Moving training to the World Wide Web is a growing trend. Utilizing local or wide-area networks and the Internet to deliver training to corporate computer net-works or to the desktop — often referred to as *On-Line Learning* — is gaining popu-larity for some types of training requirements. However, a closer examination of what is actually being delivered on the Internet usually reveals *information* not training. Software (CBT, or computer based training) programs can be made avail-able on the Internet or workers can interact on-line with other people in a "learn-ing" situation (leading to the term *virtual classroom*). Trainers need to become familiar with Web technologies so they can contribute training applications.

On-line learning is an exciting way to create, deliver, and manage training materials using computers linked to the Internet or to the corporate Intranet. It allows users to navigate through material, respond to questions, watch videos, and explore hyperlinks to related topics. However, at this point in time, On-Line Learning is so new that trainers would be advised to turn to consultants for help and to partner with their IS (Information Services) Department. On-line learning does create wonderful potential for delivering certain types of training. Accessibility to information is the key, and with increased video and audio qual-ity, the Internet offers tremendous training potential.

Due to bandwidth limitations on the Web, video is delivered at a very slow speed (even compared to disc or CD-ROM). Therefore, video for Web delivery has to be compressed. A full-screen, full-frame 24-bit video image takes six sec-onds to display from a CD-ROM and nearly a minute from a 28.8kbps modem, and full-motion video requires that exercise to happen thirty times a second. At 28kbps, it would take thirty hours per recorded minute to download uncom-pressed video. Compression schemes downsize video so that CD-ROM and Web delivery can become possible. (We will discuss video compression in detail in Chapter 8, "Training Design and Production Tips.") On-line students will need a video-ready browser, a fast modem, and a player such as *RealMedia 5.0* to see video. However, expect substantial loss of quality to the videos you view over

the Internet. Most viewers of Webcasts without specialized hardware, will see jerky video at five frames per second in a 160x120 window.

Asymetrix Learning Systems offers a suite of development and delivery tools for custom development of training design and management. Through specialized development tools such as *Asymetrix ToolBook,* custom on-line learning can be created using the *OpenScript* programming language. *ToolBook* authoring tools provide for a range of distribution options ready for Internet delivery. Asymetrix offers an excellent reference for developing on-line learning called "Guide to Interactive On-line Learning" at *http://www.asymetrix.com.*

Video on the Internet, called streaming video, allows trainers to send video clips and programs over Internet or Intranet systems. Video streaming hardware and software development tools such as *RealVideo* from RealNetworks (*http://www.real.com*) or *Netstream* 2 from Sigma Designs (*http://www.sigmadesigns. com*) allows you to compress and author video for Internet delivery. These hardware/software programs will also provide the capabilities needed to playback the video on the receiving end. Microsoft's *NetShow* and Apple's new *Quicktime* are impressive contenders in the streaming video arena. Again, however, the problem of multiple formats, bandwidths (some servers and browser programs cannot handle the bandwidth and transfer speed required by full-motion video), download times, and standards make delivery of video over the Net extremely challenging, and trainers may want to consider the use of service bureaus for these projects. Seattle's Encoding.com (*http://www.encoding. com*) offers video compression services and supports all of the streaming video software formats. John Leland of Communication Bridges is a good resource for information about Internet video delivery. Leland can be reached at *http://www.mediamall.com.* And look for tips on designing and producing training for on-line learning in Chapter 8, "Training Design and Production Tips." *A Trainer's Guide to the World Wide Web and Internet* is available through Lakewood Publications (800-707-7769).

Satellite-delivered training allows geographically dispersed students to access classroom-led training. Typically, systems feature one-way video and two-way audio bringing live broadcasts of training classes to remote locations. And

Figure 1.5 Macy's West Satellite
Network logo.

Figure 1.6 Macy's training department.

with new satellite receiving technologies such as DBS (Direct Broadcast Satellite), students can receive training at their individual work sites, homes, or offices.

One example of satellite broadcast training and communications is Macy's West Satellite Network. MSN provides an immediate, interactive, and cost-effective means of internal communications and training to personnel at all levels of the Macy's West organization. Through live interactive broadcasts, edited training and communications videos, special events documentation, and multimedia presentations, the network:

- communicates clear and consistent messages to the stores, distribution centers, and divisional offices.
- reduces costs associated with travel. The network has proven to be an efficient way for buyers, vendors, and divisional management to clearly and consistently convey important information simultaneously to the entire Macy's West population, saving expensive travel costs and time.
- helps in the efforts to promote company pride and loyalty by creating an environment of open communications.

Figure 1.7 *Asymetrix Toolbox Instructor* offers a suite of tools to assist in the development of computer-based and Internet-interactive multimedia training materials.

Internally managed by Aaron Litwin, the staff includes ten full-time video production professionals and approximately twenty-five rotating independent contractors. The MSN consists of a series of downlinks (receiving sites) that simultaneously receive video and audio signals originating from their studio in San Francisco or from temporary remote locations. The network consists of 110 downlinks in six western states and is accessed by approximately 31,000 employees. Each downlink has a digital receiving disk, digital receiver, and several viewing locations (off or on the sales floor). The network delivers corporate training and communications, vendor information, and consumer targeted programming.

The network produces 45 live broadcasts a year providing an ideal way to distribute information to employees who work rotating shifts. Employees can interact with the live programs via telephone and provide program evaluation through fax transmission. MSN broadcasts to stores before they open, all personnel scheduled to open the store that day view the broadcasts. Other employees watch the broadcast on videotape within five days of the original broadcast date.

Each downlink has a Store Coordinator that has been trained in the operation of the receiver, VCR, and monitor. The Store Coordinator is also responsible for making sure their store's population is aware of upcoming broadcasts. He or she tracks their store's attendance and facilitates the evaluation of each broadcast.

Formal and informal evaluations indicate that audiences viewing the broadcasts as well as senior management are enthusiastically supporting the technology. It is recognized as Macy's main communication tool. Positive audience reaction coupled with direct increases in sales due to the network continually justify the technology.

There are many desktop video servers entering the market of training. Precept Software of Palo Alto, California (650-845-5200) is an example of a company that delivers video programming directly to the desktop through client-server software. Called *IP/TV*, it delivers real-time, full-motion video simultaneously to thousands of people at their desks through existing data networks without expensive hardware additions or upgrades. Multicasting delivers one multimedia stream of video and audio to many Windows viewers at once, instead of the traditional approach of each viewer downloading a complete file before viewing the video. It broadcasts live or prerecorded, fully-synchronized (MPEG, or Motion Picture

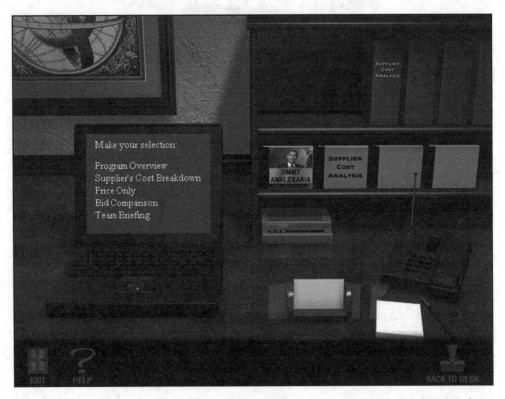

Figure 1.8 Screen capture from Interactive Multimedia Training Program (courtesy of The Learning Edge, Chandler, Arizona).

Expert Group, a standard digital video format) digital video programs to net-worked users. IP/TV captures and transmits live seminars and conferences, pre-recorded video-training programs, cable or network TV feeds, and corporate events to any networked PC.

Tucson Medical Center in Tucson, AZ is making their television program-ming available through the intranet/Internet link (referred to as converged dis-tribution networks by Jerry Freund, Technology Manager at TMC). In 1975, Jerry Freund created one of the first closed-circuit television systems in the country for patient and staff information delivery (first described in *Training with Video*). The MATV system incorporated VCR tape delivery, cable delivery to classrooms, and later, satellite programming to select rooms.

Through their MATV system they provide patient information and educa-tion, patient request channels, staff education, and employee request channels (providing mandated education such as corporate compliance). The satellite pro-vides three to four more request channels.

Now TMC reaches classrooms and conference rooms, office desktop com-puters, clinical unit computers, learning resource centers, and the medical library through their converged distribution networks. Through Ethernet, Cisco System routers merge digital video, voice and data from satellite, IP/TV, and the Internet. Multimedia (interactive video) is sent over data networks and the intranet/Internet has become the center for the way TMC delivers education. "Pre" and "Post" tests are administered over the system and individual educa-tion accomplishments are tracked.

Jerry Freund credits the converged distribution networks for saving costs by enabling multimedia (interactive video) over data networks, increased func-tionality of computers for education, and less need of capital equipment. From pushing VCRs and monitors around the hospital for program delivery to satel-lite and Internet delivery, TMC is clearly moving ahead in media technology.

Be forewarned, however, that videoconferencing on the desktop today can be very challenging to deliver successfully and thus not disappoint the viewer. Bandwidth problems can create poor video quality, causing blocky pictures and low frame rates. Low frame rates cause jerky pictures and unsynchronized pic-ture and sound. Audio and video both require a smooth, continuous flow of data to avoid problems. Narrow bandwidth also limits the size of pictures that can be transmitted; most Internet video sends pictures that cover only a quarter of your screen. Slow Internet access creates the same types of problems. We believe that quality, desktop video delivery—what our training market expects—is still a few years away.

Honeywell, Inc. of Minneapolis, MN is one company turning to the Web for training delivery. "Live" Web instruction delivers technical training worldwide. Students tune into the Web broadcast at their desktop computers. The training actually resembles traditional classroom delivery, with an instructor delivering the information. Students can interact with the instructor by typing responses or

speaking through their computer microphones. The key to success is scheduling (the training is "broadcast" live so students have to tune in at a scheduled time), along with built-in interaction to ensure student involvement with the material being presented.

The International Davey Tree Company uses the Web extensively for training employees all over the world. They also use an Internet program called "ask Dr. Davey" to help technicians identify problems with trees and shrubs.

An excellent resource that captures years of research in video communications is *Video-Mediated Communication,* edited by Kathleen Finn, Abigail Sellen, and Sylvia Wilbur. The book is published by Lawrence Erlbaum Associates, Mahwah, New Jersey. A comprehensive study of major research associated primarily with video conferencing, the book presents psychological and sociological perspectives, design approaches to the application of video in the workplace, and sections on new and innovative applications.

George Washington University's Website at *http://www.seas.gwu.edu* offers forty multimedia standards and definitions. For example, the Website describes the MPEG (Motion Picture Expert Group) standard as the standard for CD-ROM and DAT (Digital Audio Technology) compressed to fit into a bandwidth of 1.5Mbit/second. MPEG offers low-resolution pictures, often compared to VHS quality.

NEW EMPHASIS ON DIGITAL VIDEO

Digital video is certainly making waves in the video training industry. From digital cameras that capture electronic images in digital form, to computer-based video editing systems that create and manipulate high-quality images and deliver them to CD-ROM formats, digital video is quickly becoming the standard operating procedure for creating and editing images for training and communications.

By capturing images on computer chips and storing them on digital tape, video cameras offer compressed video at qualities exceeding broadcast standards. Camera and tape size are greatly reduced, simplifying the image acquisition process. And video compression technology allows complete video and interactive multimedia programs to be delivered on CD-ROM, DVD (Digital Versatile Disc), and even Web-based training systems called streaming video, as mentioned earlier.

Capturing video in the computer is a fairly easy process with compression hardware. Video needs to be compressed to create workable computer files. Compression hardware like the Targa 2000 by Truevision (800-729-2656) creates high-quality compressed video for either the PC or Mac. This compressed video becomes files that an editing software program, such as *Adobe Premiere* (*http://www.adobe.com*), can manipulate. Compressed audio files are created as

well, allowing you to edit the audio and full-motion video images on the computer. There are hundreds of computer-based editing programs and systems available and choosing one is no easy task. However, the prices of editing software programs and hardware-based systems are falling, and digital video is opening the doors for organizations to create and edit their own videos for training and communications.

Once the program is edited, it can be viewed on the computer or output to CD-ROM, Internet delivery technology, or videotape. As we outlined earlier, viewing video from CD-ROM or on the computer can be a tricky proposition. Appropriate decompression hardware and software is required along with a fast processor to see high-quality video. And delivering video on the Web is an even more difficult task. Current technology limitations often make Internet training delivery unattractive (small, jerky pictures) and impractical. The bandwidth and data transfer speed needed to deliver quality video and large graphic files is just not there yet, limiting the type of training that can be effectively delivered on the Internet. And with dozens of streaming video and proprietary video servers, compatibility becomes a serious issue for users. No format has emerged as the clear winner yet. However, software players for streaming-video technology can be downloaded for free and will install themselves as plug-ins to most common browsers on most platforms, making the technology more accessible to developers and viewers. Microsoft's *Active Movie* is an example of software that yields one-quarter screen, MPEG-quality video to the desktop without the added expense of video cards or MPEG decoders. Clearly, trainers want their video for training, and it's only a matter of time before the market settles and a clear delivery standard emerges.

Digital video promises to increase production efficiency, reduce costs, and add a great deal of flexibility to program delivery. As more and more demands are placed on training departments to deliver training to worldwide audiences, digital video will play a key role in responding to corporate needs of cost-effective training.

One organization that has responded to the training demands of a very large, diverse, geographically dispersed audience is the Office of Training and Education within the Central Intelligence Agency (CIA). This office provides basic skills, management, leadership, and technical training for staff stationed throughout the world. We cannot think of too many other training organizations that have such demanding, global requirements. But the Office of Training and Education seems to be responding quite well, providing excellent training with multiple delivery solutions.

At the CIA, each training program request faces a rigorous analysis to ensure cost-effectiveness and efficiency of delivery. Using the commercially available software program *Advisor*, instructional designers work through a thorough needs analysis including cost justification. Analyzing how many students need to be trained, the time available for training, the type of training

required (cognitive, skill, or behavior), media development resources, and student delivery equipment helps instructional designers select the appropriate medium of delivery. The Agency, however, often tries to keep the training delivery decision simple. Their position is that if they can deliver the training outside of the classroom (by way of technology), they do, saving precious classroom time for face-to-face practice and feedback interactions, or the in-depth questioning of experts.

Reaching such a diverse, global audience cannot be accomplished through traditional classroom means, nor can it be reached through the Internet or Intranet, CD-ROM, or videotape alone. A wide variety of communications tools are required, from interactive two-way television to CD-ROM, from videotape to Internet training.

Understanding that training development has many specialized disciplines, the CIA has instructional designers, video producers, multimedia, and Web-based developers all working together in creating highly interactive programs in a variety of media. Using simulations, video role modeling, graphics, animation, and interactive, electronic testing, developers tap into a full range of instructional technologies to accomplish training goals. As the CIA points out, developing multimedia is truly a team effort.

When the CIA is faced with mandatory, worldwide training, they increasingly turn to media technology to help them accomplish their mission. Mandatory training requires accountability, and new training delivery technology allows for feedback and tracking mechanisms to be put in place. On-line learning systems help with the organization, measurement, and management of training resources. The more multimedia courses are developed, the more testing and certification can be provided, because the technology will allow for the tracking and evaluation of learning activities. The collection and administration of data from students through various interactive, learning systems allows the Agency to assess training effectiveness and track costs.

The Global Classroom, as the CIA refers to it, involves scheduled, interactive two-way television and is growing in popularity with the Agency for refresher or mandatory training because of its question-and-answer capabilities. Presenters build in question routines that allow them to receive feedback from the field, and they can see what is going on in distant classrooms. This helps shape the curriculum to target their audience. The two-way system also provides viewer accountability by providing testing and assessment on the computer.

The Agency was quick to point out, however, that bringing training to the desktop through CD-ROM or Internet technology does not always work unless there is a strong incentive. Unless training on the desktop is tied to specific job requirements or becomes mandatory training for advancement, the motivation to take a training course is often lacking. With the massive amounts of information hitting our desks and computers today, self-directed, technology-delivered courses can go unused unless there is a compelling reason for people to take the training.

The CIA has a worldwide mission, and training within the Agency has a worldwide audience being served through the creative and cost-effective use of technology. They have proven that a large government agency can deliver training to a global audience in a cost-effective manner. We'll visit with this exceptional training organization again as we discuss designing training packages. But first, let's focus our attention on the training design process and instructional materials development, as our next chapter discusses in detail.

REFERENCES

Nadler, L., and Wiggs, G.D. 1986. *Managing Human Resource Development: A Practical Guide*. San Francisco, CA: Jossey-Bass, p.5.

NOTE

[1] Studies that deal with overall evaluation of computer applications or with design factors and computer presentation styles, including the *Journal of Computer-Based Instruction*, the *Journal of Educational Computing Research*, and the *Journal of Research on Computing in Education*. Individual examples include the following: Cartwright (1993, 1994) discusses the effectiveness of dynamic teaching technologies in higher education; Adam (1992) indicates why interactivity is such an important element in learning; and Barron and Kysilka (1993) analyze the effectiveness of audio in training. For more research listings, contact author Steve R. Cartwright at *cartwright@theriver.com*.

The Training Design Process

Our company Cartwright & Associates designs and produces custom training programs for organizations throughout the country. Over years of designing both video-based training and computer-based training, we have developed a *five-phase* approach to training design and development. By working through each phase and asking the appropriate questions, a trainer can streamline the design and development process and create effective training programs.

Experienced trainers will recognize the five phases of training program development described below. It is a tried-and-true method, well-accepted in the training community. Our approach streamlines the process through a series of questions that lead us to appropriate training and delivery solutions. We are in the business of *creating* training programs. We can analyze, design, and test until we are blue in the face and still not cover all the bases. AVOID ANALYSIS PARALYSIS. Our philosophy is to "get the program done" so workers can get the job done. The bottom line for us — as it should be for you — is to *create* effective programs.

The *five-phase* training development process includes the assessment phase, the program design phase, the materials development phase, the implementation phase, and the evaluation phase. Our development process follows the respected Florida State University's Instructional Systems Design (ISD) model created in 1976. Their classic ISD model works for developing training programs. We have modified the model to reflect what it takes to develop technology-based programs, our specialty.

Lakewood Publications (800-707-7794), also found at the Website *http://www.trainingsupersite.com*, offers an excellent resource for seminars, books, and videos on training design, development, delivery, and management.

PHASE 1: TRAINING ASSESSMENT

Assessment determines the need for training. The first and most critical step in the design process is that of assessment: what do you want to accomplish, and

how do you want to accomplish it? Interviews with clients and subject matter experts determine what problems exist and what training solutions are needed. Needs assessment determines whether performance is below required levels and whether training will be an effective means of improving the performance. Once the need has been identified, determine what the training should look like. A thorough needs assessment should identify performance standards as well as the differences between required performances and current performance. This difference is often called the "training need" or "performance gap."

Gaps are often attributed to "tools, time, and information"—a lack of appropriate knowledge or skills on the part the worker; a lack of appropriate work standards, incentives, and priorities; and poor working conditions.

Questions that should be asked during this critical phase are:

- What task or job needs improvement?
- Are there standards of performance?
- What is the required performance?
- What is the difference between good and poor performance?
- Is performance currently being measured?
- What impact does the problem have on the individuals responsible for the work and the organization?

We first do a thorough *task analysis* that clarifies the skills to be taught. The task analysis provides concise descriptions of each task to be performed and puts them into the proper sequence. Thus, actual activities and tasks are used as the basis for organizing and deciding on the content and sequence of the training program. The secret here is to break activities done into the smallest, measurable steps. These individual steps become the basis for interaction and branching in multimedia training.

The assessment phase will include the performance requirements and measurement strategy to assure that the training is on target and achieving the desired outcomes. A large part of the assessment phase is *audience analysis.*

Defining the Audience

If I had but one question to ask during the design phase, it would be: For whom am I producing this program? The more accurately you define the audience, the more chance you have to create a success. If the training experience is designed to create a change, who are you asking to change? To whom will the training effort, budget, and resources be devoted? The trainer should provide a clear audience profile. This profile will dictate the objectives to be written, and it will provide the program producer with valuable information for script development and media selection.

Audience Profile

The profile describes who the audience actually is. It will influence the design and eventually the script of the program. If training is to create a change, then the people it is to change must be identified clearly. When you form the audience profile some key questions you must consider are:

- *How much does the audience already know about the material being presented?* Content knowledge will determine if terms have to be defined, if preliminary reading needs to be assigned, and to what extent assumptions can be made about content.

- *Is the audience motivated to watch the program?* Motivation may or may not have to be written in. The question, "What's in it for them?" should be asked continually. Does the audience know why they are watching the program and what effect it will have on their jobs? If the program is asking them to change their performance, do they know what the performance standard is?

- *What are the age groups and education levels of the audience?* There should be a difference between the way you present the material to an older, "experienced" group and a younger, newer group. These characteristics may also influence your choice of music and talent, as well as the way you illustrate your presentation.

- *How large is the audience?* If you are planning a video training program to be presented to a large audience in a large room, video may not be the best media choice for the training. We know that television is a personal, one-on-one medium that works well when the viewer is relatively close to the monitor, alone or in a small group, and exercising a certain amount of control over the viewing experience. If the program is to be presented to large audiences, perhaps slides or film, with their superior image quality on large screen projection, would be a better media choice.

- *How will the audience access and see the program?* This question is often overlooked. The equipment logistics must be worked out in advance to ensure ease of training delivery. There is no guarantee that a well-produced program will be seen if viewing logistics are not worked out in advance. This applies especially to branch offices located around the country. Who will be responsible for showing the program to the intended audience? Distribution must be set up in advance.

Instructional and Production Analysis

Disciplines merge at this stage in the development of training programs. The instructional designer is analyzing the audience so that an educationally sound program can be created to bring about the desired change. At the same time, the program media producer is also becoming heavily involved in audience research,

so that a meaningful script can be written. In smaller organizations, these two jobs are often held by the same person. Whatever the case, it is important that the designer and the media producer get involved with audience analysis at a very early stage in the development of the program. Many programs that fail to reach their objectives have not merged these two disciplines early enough. Too often, the media producer is handed a script to produce that was written by an instructional designer who has sound educational principles but lacks good visual production principles. Each discipline contributes to the goal. Educational values and production values must be incorporated into one experience.

The importance of audience identification was brought home to me very impressively at a recent scripting session. My colleagues and I were designing a program that was to give the audience an overview of the hybrid technology manufacturing process, that is, the manufacturing of multiple chip devices. It became extremely important that we agree on the intended audience. Was the program going to be shown to engineers who basically knew the design and manufacturing steps involved? If so, then we could start at a more advanced level and go right into the sophistication of the circuits or the process of making the circuits. If, on the contrary, it were to be shown to a group of operators who had little education and were not knowledgeable about the design and manufacturing processes, a different knowledge level would be needed. This knowledge level identifies an entry point for the content to be presented.

Another key question that you should ask during audience analysis is: "What is the viewer's need-to-know level?" By that we mean, how important is the viewer's need for the information being presented? This is a significant element during the scripting stage because it will help determine the influence of motivation. The script may have to have motivation factors built into the program to persuade the viewer that there are advantages to viewing and learning the material. (We will discuss more about this in the scripting section.) The most important factor in defining the need-to-know level is the fact that it can help in the determination of just how substantially resources should be devoted to the training experience. The higher the need-to-know level, the less effort you have to devote to presenting the training. If the audience has a strong need for the information being presented, you do not have to present a sophisticated, expensively produced program. There is a place for the talking head! You have to measure the need-to-know level against the resources being devoted to the project.

Another key element during the assessment phase of development is to accurately identify the problem.

Defining the Problem

In most companies the decision to produce a training program is made before the problem is clearly identified. People tend to jump to solutions before defining the problem. But trainers should go through a series of questions to ensure that the

problem can truly be solved with training. Only after in-depth questioning can you make intelligent decisions about whether to create a training program or not.

Problem identification should identify a deficiency in performance and indicate a performance standard against which the deficiency may be measured. You must analyze the deficiency in behavior, attitude, or skill level, then design the program to correct it and bring it up to the accepted standard. The responsibility for this analysis usually is assumed by the training director, and the design of the program is often developed by an instructional designer. Nevertheless, media producers must also be acquainted with the process being corrected in order to fully appreciate the training need and offer appropriate media solutions.

Before a project begins, ask these four questions to identify the problem and put it in perspective:

1. *Can training correct the problem?* Training may not be the solution to all company problems. You must analyze the problem carefully to see if training is indeed the correct action to take. Better communication between the production line and supervision through weekly meetings might be a more effective, long-lasting solution, for example, or perhaps a set of new, simplified forms may achieve the desired result. In other words, what appears to be a training requirement may not be. There may be a simpler solution.

2. *Can the audience being trained solve the problem?* Do they have the needed resources? It may be beyond their means to solve the problem, and no amount of training will prepare them or create the resources needed to solve the actual problem.

3. *How are you going to evaluate the results?* A standard should exist, or one should be made against which to measure the results. Since the standard must be understood by the target audience, it should perhaps become a part of the training program as the accepted way of carrying out the new procedure. The audience has to recognize when there is a problem and should be able to relate to the problem. They need to understand whether the standard of performance has changed, or if they are not measuring up to the existing standard, or whether all the previous ways of doing things are changed. Establishing a standard will also help you create the evaluation tool to measure the program's results against the objectives.

4. *How important is the problem to the overall goal of the company?* The development of a training program, whether it be a classroom lecture, workbook, video, or interactive CD-ROM, is expensive. You should try, therefore, to calculate what the problem is costing the organization. You must decide how big the problem really is and determine just how high

a priority it should have. Will the solution or training affect a large number or just a few? How many people, products, or clients are going to be affected by this training? What is the extent of the personnel, money, and other resources that should be applied to solving this problem? This question must be worked through honestly before the resources are committed. Quite often the size of the problem and the extent of its influence are subjective. What one person may perceive as a big problem may in actuality be a very small problem. In most cases, it is worthwhile to get several people, even the target audience, involved in problem identification. Our energy should be devoted to identifying the problem clearly. You have to look at it objectively from all sides so that you can analyze the situation fairly and offer a just solution, whether it be through a video, a stand-up lecture, or a drink with the boss.

Task, content, and environmental analysis all contribute to and shape the instruction to be delivered. With the training needs identified and prioritized and the audience properly identified, instructional program design can begin.

PHASE 2: TRAINING PROGRAM DESIGN

Training programs are expected to create changes in behavior, attitude, or skill. In order to assess your success in meeting the objectives of the program, you must be able to measure the changes that result from the training experience that you create. The design of the program is the plan that you develop to ensure that you meet your goals—the design becomes the road map that you will follow through the development phase. The design should take into consideration an overall training experience that is developed to solve a particular problem, and create a method for evaluation. For example, videotape may be just one solution to that problem, or it may not be a solution at all. But before you begin producing that program, a clear, concise plan should be in place.

Setting Objectives

Since you are trying to create a change with training, objectives should be written in such a way as to describe the desired performance, the conditions of the performance, and the standards of the performance. Objectives should be described in terms that are measurable. They also need to be realistic goals that are achievable by the target audience.

Program objectives, when well-written, become the guidelines on which all further program development will be based. They force you to think through clearly and state exactly what you expect your program to do. Objectives provide

a clear statement of the results you are expecting the audience to accomplish. They also provide guidelines for media production decisions, as you will see in Chapter 5, "Production Design." Writing clear instructional objectives is not an easy task, and it is not the intent of this book to teach you how. But I recommend *Preparing Instructional Objectives* by Robert Mager (Belmont, CA: Pitman Learning, 1975). It is a classic reference for instructional designers and provides excellent guidelines for the preparation of objectives.

The objectives become the cornerstone of the entire project. Each decision you make during program development and media selection must be influenced by the objectives. Therefore, the objectives of the program should be explicit and written in measurable terms, as stated.

Clear objectives help answer some basic questions about the learning experience. What are you asking the students to achieve? How will you know if they have achieved it? What standards are you basing the performance on? The objectives really set the stage for the learning to be accomplished. They give direction to the instruction and provide guidelines against which to measure the learning that has indeed been achieved.

The objectives and learning strategy (how the training will be delivered to the student) are based on the type of learning that will take place (often referred to as "learning domains," as discussed in the next section). If the objectives are to teach facts, figures, and procedures, then perhaps graphs, charts, numbers, and word comparisons will be used. Attention to letter size and color will be important. This may require planning for graphics and design. With an emphasis on numbers and graphs, the material would lend itself to a medium that treats color, detail, and numbers well, such as high-resolution computer graphics or slides, as opposed to the low-resolution qualities of video.

In contrast, if the learning is primarily motor-skill development, where importance is placed on motion and modeling techniques, video will work well because it can convey motion and has the capability to model proper performance. If the learning sought is to be primarily affective, video would again work well, because it can evoke emotion and attitude through close-ups, action, and music. Video is often used in modeling human behavior.

Each medium has distinct attributes that treat such elements as motion, color, pictures, sound, and detail with varying capability. Matching the attributes with the learning requirements forms the basis of technology selection. You should thoroughly analyze all media opportunities before you make a final selection. Each medium has certain advantages and can treat objectives in unique ways. Too often, because of personal preference or budget, a medium is selected first and objectives are developed around its strengths or weaknesses. A training program that is less than fully effective results.

Although ideally the medium should be chosen for its instructional effectiveness, it must also be cost-effective. It is important, therefore, to analyze each factor for its impact on the media choice.

Developing Learning Strategies

The *type* of learning that will take place dictates how the teaching should occur. These instructional strategies include: lecture, group discussion, demonstration, role-playing, site visits, games, case studies, or computer-based training.

It is generally accepted in the education community that there are three types of learning, or *learning domains:*

1. *Cognitive learning* is associated with intellectual skills involving comprehension, analysis, problem solving, and evaluation. Cognitive learning is most closely related to the teaching of facts, figures, concepts, principles, and procedures.
2. *Psychomotor learning* is related to motor-skill development, muscular coordination, manipulation of materials, and objects.
3. *Affective learning* involves attitudes, values, opinions, and motivation.

Each type of learning requires a different strategy or activity. The strategy you select should be the most efficient way for the learner to achieve the

Figure 2.1 Video is an excellent training tool for teaching human behavior modeling.

desired learning objectives based on the type (or domain) of learning. As described earlier, the type of learning will also influence the instructional technology you chose.

As an example, cognitive strategies often take the form of steps, procedures, or activities to be performed by the student. The learning strategy would require the student to read the instructions first then perform the activity. In this case, printed materials along with a simulated activity would work well to achieve the learning objectives. Computer-assisted learning coupled with a computer simulation of the activity may also be an appropriate approach. Each "domain" will require analysis as to the most appropriate instructional strategy.

It is important not to confuse instructional strategy with instructional technology. The *strategy* is the method by which the learning will take place; the *technology* is the delivery system chosen to accomplish the strategy. A training event may require multiple strategies and technologies to accomplish its objectives.

Once the strategy has been selected, the learning objectives are sequenced to build on previous learning and to hold the interest of the learner. It is important always to keep the learner in mind when you are setting the objectives and developing the instructional strategy. The learner must have the resources to accomplish the objectives and must feel comfortable with the strategy chosen.

With the audience, objectives, and instructional strategy defined, you must next select the delivery system that will become an efficient training method. The delivery system should involve the learner in the training experience and help cause the learning to take place. The system becomes the tool used to achieve the result, and in most training situations a single technology is ineffective. The designer must choose multiple systems to accomplish the objectives. In industrial training, for example, designers may choose multiple technologies, such as videotapes combined with workbooks, or computer-based training combined with group discussions or practical exercises.

Let's sneak by security again and see how the CIA handled a complex training assignment utilizing interactive multimedia coupled with written support materials. The training program addressed an historical retrospective of some intelligence issues having to do with the proliferation of chemical weapons over the ages, from the Middle Ages up to current times. This program was designed as a primer for people who did not have that scientific discipline or had not been exposed to that particular subject area. Students were able to interact with the instructional material, read about specific examples, and be tested on comprehension. This was a very successful multimedia package because it brought people up to a level of understanding the topic to such a degree that they could come into a class and talk about specific applications related to their work. By using the self-directed, multimedia programming approach, the classroom experience was streamlined, thereby saving a great deal of actual classroom time.

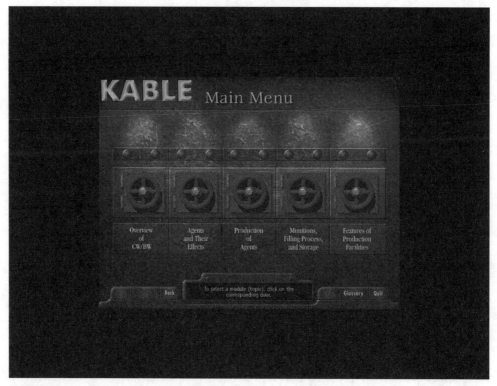

Figure 2.2 Screen sample from CIA interactive training program (photo courtesy of CIA Education Department).

Training Technology Selection

Learning research tells us that information obtained through multiple sensory channels is more likely to be acquired and retained than similar information available through only a single communication channel. Training can be more realistic, more engaging, and more effective if a variety of communication modes are used.

Training technology selection requires the designer to consider the relative values of instructional objectives, strategy, audience, resources, and budget. It is an imprecise process that often ends up being heavily influenced by technology preference and budget. Ideally, the program objectives, audience, and instructional strategy will influence the media selection significantly. One factor may outweigh others, but each should be analyzed fairly for effective technology selection. Too often, attempts are made to draw up fancy charts and graphs for the media selection process, but it is not that simple. The choice is really based on the resources and budget available in a particular situation, together with the objectives of the program and the characteristics of the audience. By understanding the advantages

of each technology, you can weigh your resources and budget against the other elements and make an intelligent decision.

Resources

Resources of staff, budget, equipment, and time will all influence the technology choice. Obviously, if the resources are not there or they are very limited, the choices for program delivery will be limited. It is costly to produce good, technology-based training programs, and the resources of program design and production have to be available, so this element dramatically affects the technology choice. You have to weigh the resources required to produce the program against the results you are trying to achieve. A one-time training event to a limited audience may not justify creating a fully-scripted video program. But if that one-time event has the potential of attracting new investors or if it will create large sales figures, the event may justify a substantial investment of resources. The evaluation process becomes an individual choice based on individual circumstances. Each training event will be different and will have different objectives, so each selection process will become unique to the particular event.

Equipment, staff, and facilities have to be addressed when considering resources for the technology decision. Quite often a delivery technology decision is made on the basis of equipment available to the target audience. A network of video players or computers may be in place throughout the organization. This network then creates an easy system to access for training program delivery and the technology choice is ready-made. But if the equipment is not in place, this becomes a serious issue to face. How will the target audience receive and see the program? Some kind of guarantee must be built-in to ensure that the audience can access the program.

Is there talented staff available for program development and production? Obviously, it takes talent to create effective programs, especially technology-based training programs. Staff resources have to be considered. Successful programs are created by talented teams of instructional designers, media producers, graphic artists, and interactive multimedia authors who know programming. With technology-based training development and delivery, a team approach is the best approach.

Facilities will play a key role in the technology selection process. Does your organization have the production facilities available to produce media? Cost factors of production, equipment operation, maintenance, and facilities upkeep will have to be figured into the decision process. If your organization does not have the facilities or staff to produce media, and it has been decided that a videotape is the best delivery method for the training program, outside resources will have to be contracted for production. If your organization does not produce many programs in a year, contracting with outside production resources may be the best way to go.

The element of time will play an important part in the decision process as well. The amount of time that becomes available to create a training event will

often dictate the technology choice. Technology-based training does take time to design and execute. If fast turnaround is dictated, a lecture or a video conference may be in order. Again, each event will have its own limiting characteristics.

Resources, budget, and deadlines all have to be weighed against the program objective. Surprisingly enough, budget is not always the single element that will influence the decision. If budget is available, time may not be. So each element will affect the route you take. You have to ask, What medium (given the time, budget, and resources we have) will create the results I want in the most efficient and economical way?

Adult Learning Theory

Adults react to teaching in varied ways, but most adults who respond positively to learning do so because solid learning principles were applied. It is important that we follow the basic rules of adult learning theory.

Let's look at several areas that must be addressed in designing and producing successful training programs; motivation, pace, active participation, conciseness, problem-centered, application of training, and climate of learning. If you consider these principles when programs are designed and produced, clearer communication will take place, and the producer will be closer to meeting the program objectives.

Motivation

In order to benefit from a training program, viewers must feel that there is something in it for them. Understanding the audience's *need-to-know* level is an important design step on the road to creating a successful training program. What's in it for the audience? What is the motivation to learn? Does motivation already exist, or does it have to be written into the program?

Accurate identification of the motivation level will affect the learning and acceptance level of the viewer. Some audiences are highly motivated to learn and accept the information you present. Others appear to turn off to everything that is said. In many cases, an audience will display a mixture of acceptance and rejection. Understanding the motivation level helps you create a concept of delivery, or a way of packaging the program, that increases the program's chances of success.

Pace

Adults learn most effectively when they are allowed to learn at their own pace. Individuals need time to accept new ideas and weigh them against their personal experience. Well-planned pacing allows this process to take place. This is especially true for video-based linear programs as opposed to interactive programs, which allow the viewer to *control* the pace of the program. When designing and scripting linear programs, you should be sensitive to the pace at which you deliver the information. You need to allow for slower acceptance by some view-

ers while at the same time being careful not to bore fast learners. This is a difficult writing skill to master, but it is crucial to the program's acceptance.

Active Participation

When possible, the learner should be involved in designing the learning experience. Select a few participants from the target audience and include them in the design process. Not only will this help assure you that your program is on the right track, it is a good way to create an evaluation instrument. Your target audience can help you decide on what can be evaluated in the program.

Remember that when writing and producing training programs, you may find it easy to work in a vacuum, closing out others in the process. This can cause serious problems. Instead, work as a team to solve problems, and let the training program be the product of the team.

Programs that elicit the audience's active participation are more successful than those that do not. In linear programming (video), it is wise to have stopping points in the tape to allow for an exercise of one type or another to take place. Because linearity does not offer the flexibility of interactivity, linear programs must be designed carefully to bring the viewer into the learning event.

Conciseness

Respect the fact that the viewer is devoting valuable time to the training program. No matter how motivated they are, audiences prefer short programs that address the problem accurately and deliver the message efficiently. When producing video-based training, I believe in producing several short tapes that focus on aspects of a lengthy subject, rather than trying to accomplish too much in one long, boring tape. I support the fifteen-minute program and believe that a well-designed, well-executed program of this length can effectively deliver a lesson that would take an hour to deliver in a classroom.

Problem-Centered

Programs that are problem-centered rather than content-centered are received better by adult audiences. By designing training programs that take a problem-solving approach, as opposed to delivering straight content only, the developer stands a better chance of communicating effectively with the audience. Of course, not all training programs will lend themselves to this approach, but, where appropriate, present training in such a way that the audience is taken through a problem-solving experience. This ties in with the active learning theory. The audience is apt to get more involved if problems are presented and solutions generated.

Application

Adults are eager to apply the new skills they have learned. Quite often this is difficult to control, especially for the training department, which often does not

get deeply involved in program distribution. If control of the application is impossible, then time to apply the new ideas should be built into the training experience. This can be written into the program by allowing for such activities as problem-solving, interviewing, or role-playing to take place as part of the training experience.

Climate

The proper learning climate must be created. It is important that the training department acquire information about how and where the program will be viewed, this is especially important for remote viewing locations. If the program will be shown in a positive, controlled learning environment, less program time will have to be spent fighting unwanted factors, such as poor viewing conditions, office politics, unrealistic training expectations, or time constraints. The producer of the training program must know the conditions of viewing in order to write a program that will address potentially negative conditions as well as teach the audience and meet its objectives.

PHASE 3: TRAINING MATERIALS DEVELOPMENT

Covered in much more detail in the following chapter, training materials development requires the blending of creative instructional design and media development. Starting with a good concept that will work for your audience through scriptwriting and the media production process, we will define training materials development for both video-based training and interactive multimedia development.

Scriptwriting and Storyboarding

The Concept and Treatment

The *concept* is the framework or theme you choose for delivering the content to the audience. For interactive training programs, the concept often becomes the *interface* design. We will discuss interface design in more detail in Chapter 7, "Interactive Multimedia Design Considerations."

Once you have researched the content and have an understanding of the audience, you can develop the concept you want to take in delivering the information. The concept sets the parameters for production considerations. The concept may take the form of an interview, game show, documentary, case study, humorous vignette, demonstration, and so on. It is important to create a concept that will be appropriate for the audience. What will the audience accept? Will they accept a humorous concept, interview, or documentary? It is important to create a concept that will satisfy the needs of your audience.

Once you have decided on a concept or combination of concepts, a *treatment* is created. The treatment is a narrative description of how the program would appear on the screen. It includes the program objectives, the audience profile, and the concept chosen to deliver the message. It describes a chronological sequence of events as you would see them developing on the screen, as well as major locations, actors, sights, and sounds that contribute to reaching the objectives.

After the content outline is approved, the treatment is often the next step in the approval process. It is important to get everyone's agreement on the approach you are going to take. The treatment describes the concept and sets the tone for the entire program to be produced: budgets, talent selection, music, graphics, and location decisions will all be based on the treatment. It may take several treatments before you come up with the best approach for your audience, budget, resources, and time constraints. The treatment will also provide the guidelines for script development.

Scriptwriting

Once the treatment or interface design is approved, you start the scriptwriting process. The basic scripting process follows a series of steps that will vary depending upon your knowledge of the subject, the complexity of the production, and the budget. You will first develop a working *content outline* that sequences the information you have to present and frameworks the amount of information to be covered. This is a point where approval is required.

Once you have approval on the content outline, script development or research on the content begins. As the script is being developed, visuals are being selected and the storyboard is developed. A storyboard is a visual representation of the "shots" or "pictures" you feel are needed to tell your story. The storyboard can be simple drawings on 3x5 cards or more refined drawings on printed storyboard forms. Often, rough sketches of the required shots will be enough to convey your visual thoughts.

A *rough draft* of the script is developed along with the appropriate visuals. Approval is given on the draft and the *final script* is written. The final script will have all the directorial elements, transitions, and effects written in, along with all audio effects and music cues. Once the final script and storyboard is approved, the shooting script is developed.

The *shooting script* will break down the script into the major production elements of locations, scenes, and major camera or talent movement. The shooting script will help you develop a shooting schedule and organize the script for the day of the shoot.

Please note that whether you are developing linear video or interactive, multimedia training programs, the scriptwriting and storyboarding process are very similar. However, as you will see in Chapter 7, "Interactive Multimedia Design Considerations," the storyboard and program flowchart become the key

VISUAL	AUDIO
FADE IN:	
1. Title Graphic: **Visitor Site Safety Orientation**	music
2. WS: Property (LOGO)	**Narration:** Welcome to...
3. **continue #2**	For the next few minutes, this video program will provide you with the information you need for a safe visit on this property. Please watch this program closely, your sponsor will be prepared to answer any questions you have at the end of the program.
4. WS: Smelter, crane aisle	The Smelter has many dangerous places, some of them are:
5. CG; Site Specific Hazards: (list) Hot metal, sulfuric acid, inhalation hazards, working at heights above six feet, cranes, and mix of vehicular and pedestrian traffic	Hot metal, sulfuric acid, inhalation hazards, work at heights above six feet, cranes, and mix of vehicular and pedestrian traffic.
6. CG: Hot Metal- - (ws: smelter crane aisle, anodes)	Temperatures of molten metal range from 2000 to 2500 degrees; exposures are most common next to flash furnace, converters, heating vessels or anodes molds; all visitors are required to wear long sleeve shirts and trousers inside all hot metal areas.

Cartwright & Associates

Figure 2.3 Example of two-column, split-page video training script.

VISUAL	AUDIO
7. CG: Sulfuric acid - - - (ws acid plant, truck)	High sulfur copper concentrate liberates sulfur dioxide during smelting process which is captured and converted to 93 to 98 percent sulfuric acid; burns skin and eyes upon exposure to liquids, mists and vapor; most common in acid plant; broken lines and maintenance operations.
8. CG: Inhalation hazards - - - (shots from crane aisle with gases present)	Processes produce several types of inhalation hazards. These are dust particles that contain heavy metals including lead, arsenic and cadmium; gases including sulfur dioxide; acid mists including sulfuric acid.
9. Computer Graphic map	Plant is divided up into designated zones for heavy metals requiring specific level of protection. Zone 1 is large risk of exposure. Zone 2 is small risk of exposure. Zone 3 is little or no risk of exposure. A properly fitting respirator will filter out dusts, gases and acid mists.
10. CG: Work at heights above six feet - - - (shots of exterior walkways)	The plant is of multi-story design. As a visitor, you are expected to stay out from under work in

Cartwright & Associates

Figure 2.3 *(continued)*

design elements for developing interactive multimedia, and the script is used primarily for audio and video segments within the program.

Logistics

The logistics phase of pre-production encompasses arranging for all the details of the video and audio production, such as acquiring the equipment needed for the shoot, arranging for props and talent, and getting approval to shoot at the locations. There is a long list of logistic considerations that will be covered in more detail in Chapter 5, "Production Design."

Video Production for Video and Multimedia

The *production* usually consists of focusing our attention on the equipment operation and on working with the crew and talent. At this point we are focusing all our energy and resources on obtaining the best possible performance with the best possible technical quality of sound and picture. Production is where your pre-production planning pays off. Your attention to the details of the shoot, your organization efforts and attention to script come together at production so you can devote your attention to performance.

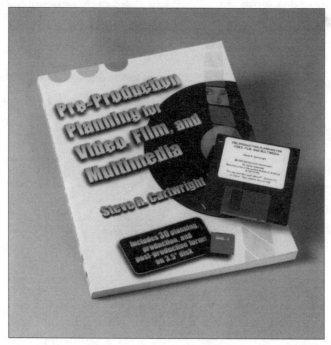

Figure 2.4 *Pre-Production Planning for Video, Film, and Multimedia*
by Steve R. Cartwright (Focal Press, 1996).

If we have done our job in pre-production planning, we can now concentrate on talent performance, crew performance, and getting what we want on tape—it is too late to worry about the right connector or cable or power. Details like these drain you of creative energy. Good pre-production planning will free you of the burdensome details of production and let you concentrate on talent performance.

I have devoted an entire book to the pre-production planning process. *Pre-Production Planning for Video, Film, and Multimedia* is available through Focal Press.

In the production phase, we record talent on location, graphic elements and slides, narration, music elements, and all sound elements. In other words, you place all the elements that you are going to edit onto tape.

After recording all of the source material on tape, post-production begins. Briefly, post-production involves script rewriting and editing of the program. The post-production process will require a lot of your time. Always plan for more time than you think you will need.

Script Rewriting and Tape Logging

Depending on what you actually shot on location, you may have to do a rewrite on the script. The shots on location may turn out differently than what you had originally planned, so rewriting the script is often necessary. This does not usually require a lot of time, but "tweaking" the script before you start editing is often necessary and will require new script approval.

Tape logs are notes taken during the production that reference footage recorded onto tape. (See Figure 2.5.) Tape logs are usually detailed lists of the shots that are recorded onto tape, showing the order they appear on the tape. Tape logs usually contain the scene number, shot number, and take number. Time code numbers identify each frame of video, usually written in hours, minutes, seconds, and frames. They provide an accurate source for referencing specific video shots and scenes. Many computer-based editing systems work with these numbers to provide very precise editing. Using time code numbers, the location of the scenes are registered on the log. The log will help you find the material you shot during the editing process. The more accurate the logs are and the more details they contain, the better the editing process will go.

During nonlinear editing (editing on the computer), logs are critical for the video digitizing process. From our logs, we'll select the shots we want to digitize. We can save a great deal of time during this process if we have good logs.

The Edit

The editing process consists of shot selection, arrangement, and timing. In editing, we arrange the shots in sequence according to the script, and in doing so we affect the pace of the program, the mood, and the visual flow. A very creative process, editing brings all of the random, recorded shots together into a coherent story that matches the script.

TAPE LOG

Production Title ___Rock to Rod_____ Project # ___003_____

Writer/ Director ___Cartwright_____ Location _Exterior Mine__ Tape # ___1__

Scene	Take	Time Code	Talent/Type of Shot	Comments
3	1	2:07:00:00	CU Pik-up driving	Bad
	2	2:07:05:00	,, ,, ,,	Bad
	3	2:08:03:00	,, ,, ,,	Good
	4	2:08:20:00	,, ,, ,,	Good
4	1	2:08:30:00	WS static b.g. mountains	Bad audio
		2:09:00:00		No audio
		2:10:20:00		Sun
		2:11:05:00		Good

Figure 2.5 Example of field video tape log for keeping track of shots and takes in the field.

We first perform a *rough edit* (often referred to as an off-line edit) that basically sequences our shots in the order required by the script. The rough edit gives us the scene lengths and a rough pacing of the program. Usually, in creating the rough edit, we do not add graphics, music, or special effects and transitions. This is merely a "working draft" of the program. The rough edit allows for approval of the scenes recorded (is the content of the scene correct?), the audio/visual continuity, and the sequence of the shots.

Once the rough edit is approved, the *final edit* takes place. This step is often referred to as on-line editing. During the final edit or on-line process, all the transitions, graphics, special effects, sound effects, and music elements are edited into final form according to the requirements of the script. New digital technologies, however, as described in Chapter 1, "Technology-Based Training," have created *nonlinear* editing. This form of editing often bypasses the rough-edit stage and allows the producer to begin editing the final version of the program right at the start of the editing process. Computer-based editing allows transitions, graphics, and music to be easily placed within the program, and changes can be made quickly before the final, edited version is recorded to tape.

Interactive Multimedia Production

The development of interactive multimedia is a highly complex, sophisticated process incorporating diverse and varied disciplines of instructional design, scriptwriting, graphics, video production, and computer programming—all of which is covered in much more detail in Chapter 7, "Interactive Multimedia Design Considerations." With its powerful interactive capabilities and its visual and aural impact, interactive multimedia development requires many skills and achieves many tasks. The actual development of a multimedia project, like that of video, happens in phases. The phases appear to be similar to developing linear programs, classroom instruction, computer-based instruction, or film projects. However, once you delve into the world of interactive multimedia development, you will find that it is many times as complex as traditional media development.

The first phase of interactive multimedia development is the front-end analysis or *needs assessment*. As I described earlier in this chapter, for any media-based project, you have to thoroughly define the problem, the

Figure 2.6a Artwork developed for interactive training program provides further use for computer-based, warehouse inventory control.

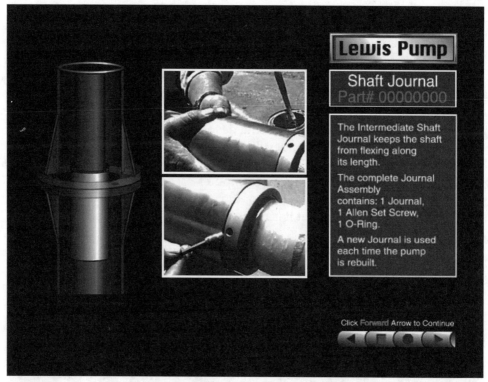

Figure 2.6b Actual pump disassembly/assembly procedures are printed from the computer (part of interactive training program) and available for use in the field.

objectives, and the audience. Once the problem has been defined, an approach to solving the problem is created. This I refer to as the *program design*. The program design is the road map (the developmental guidelines) that the interactive program will follow in achieving its goals. Such factors as the scope of the project, interactive models, user requirements, environmental factors and viewing conditions, evaluation considerations, and operating assumptions contribute to the program design.

The next step in the development cycle is *creative design*. I refer to this phase in Chapter 3, "Technology-Based Program Development Process," as the Production Design. Production Design encompasses all of the elements of good design theory as described in Chapter 7, "Interactive Multimedia Design Considerations," including navigation, or moving easily between topics and exercises, screen layout, and design conventions and flowcharts. Once the design is created, the *creative development* (production) begins; this is the creation of graphics, video/animation, and sound elements.

The creative design process also includes crucial decisions in screen layout and design, text selection, colors, icon design and placement, and many, many other considerations that are specific to the interactive process. When designing

graphics and screens for interactivity, you are not just creating images that enhance the learning process, you are creating navigational devices, images to help the viewer navigate through the program. These graphics become tools for interactivity, tools that allow the process of learning to happen.

Production

Production includes the management, design, acquisition, and creation of production scripts, text elements, screen layout, graphics, audio narration and music, animation, and video sequences. It also includes authoring, prototype disc creation, and optical media mastering.

One big difference between planning for linear programming (traditional videotape productions) and interactive productions is the *authoring process.* For multimedia projects, where the program participant interacts with computers and input devices to advance within the program, we have to plan for the authoring process. Authoring brings together all of the elements that the user interfaces with to advance through a program. Some of these elements are video, graphics, animation, still frames, digitized images, text copy, voice, and music. There are also devices that the user interfaces with like the mouse, touchscreen, keyboard, or joystick. All of these elements and devices, along with feedback mechanisms, user controls, menus, course maps, help triggers, and glossaries, have to work together and are orchestrated through the authoring program built into the operating software.

Authoring systems help you create interaction with the student, provide program control and navigation, and develop testing mechanisms without actually writing computer code. However, the more power—or options—the authoring system can provide, the more complex the system is. Selecting interactive multimedia authoring programs is covered in detail in Chapter 6, "Choosing an Authoring System."

There are many good multimedia authoring programs available commercially, such as *Action! Authorware Professional* by Macromedia, *IconAuthor* and *Multimedia Toolbook* by Asymetrix, and *Quest* by Allen Communications. Or, if you are versed in computer languages, you can write your own authoring software using multimedia software development tools for traditional programming languages. At any rate, the authoring phase of multimedia development is a sophisticated process that often requires the skills of a programmer adept at computer software languages. (Refer to Chapter 6, "Choosing an Authoring System," for tips on selecting among authoring programs.)

Each individual element of the interactive process has to be planned and thought out in detail to identify branching options, feedback for users, and any actions on the screen such as graphic reveals, animation sequences, and instructions for accessing the elements from storage devices. As you can see, interactive multimedia development is a complex process that takes tremendous amounts of planning.

Special care should be taken in creating video for use in computer-based, multimedia applications. Analog video is digitized and stored on the computer hard drive for editing and insertion into multimedia programs. The video segment becomes a computer file, as does audio, graphics, and text. As video is digitized, it is compressed to reduce storage requirements and decompressed for viewing from media such as VHS tape. This compression/decompression factor affects video in many ways. The rule here is to produce your video segments on the highest quality recording format possible. If you digitize a grainy, low-quality VHS or 8mm video signal, the result will be a very low-quality digitized video file.

Planning video production for use in multimedia programs involves considerations such as lighting approaches that do not add contrast to the picture and thus affect image quality (refer to Chapter 5, "Production Design"). Good sound recording techniques also reduce unwanted noise. Video and audio compression techniques often amplify picture noise from lighting conditions and poor sound recording. Busy backgrounds should be avoided, for they will add unwanted digital "noise" to the picture and drastically increase the data rate of the digital file. The compression process treats all picture elements as information, so busy backgrounds with much detail can overload memory and create "blocking" or choppy pictures. Motion in your shots, even camera movement, can create the same problem as well, slowing the compression process down and affecting picture quality. Plan slow, even camera moves, low-contrast lighting, and simple backgrounds for the best results for multimedia.

There are several good references that focus on video production considerations for multimedia development. One of the better books available is *Multimedia, Making It Work*, (1993) by Tay Vaughan and published by Osborne McGraw-Hill, Berkeley, CA. An excellent trade magazine that covers digital video production for multimedia is *Digital Video Magazine*, published by TechMedia Publishing.

Prototype

During the final phase of production, samples of the training program will be tested with target audiences. For multimedia development this is often referred to as *prototyping*.

It is important when producing interactive multimedia projects to create a *prototype* or sample working segment of the project. Certain authoring programs allow you to create sample flowcharts, screen designs, and interactive branching designs that provide feedback on the usability of your designs. A prototype CD-ROM (often called a "check disc") can be created on CD-R, or Compact Disc Recorders. These low-cost recording devices allow the designer to burn sample CD-ROMs for test purposes. The prototype becomes a working model of a segment of the program and allows everyone on the team to "test" the design early in the development process before too much work has been done. The prototype becomes an excellent "approval" tool for the project manager.

Mastering

In the last phase of production, the *mastering process,* the coded data of your multimedia computer program is placed onto a master glass disc for replication onto a video disc or CD-ROM. The first step in the process is *pre-mastering.* The data is prepared to go onto the master disc: original media from a hard drive is transferred to a storage media such as computer tape. This data is then placed onto the master glass disc that will eventually be used to create a plastic mold. The CD-ROMs will be "stamped" or replicated from this mold. After the disc is stamped, titles or graphics can be printed onto the disc.

Since multimedia represents an interactive process, the student controls the pace, sequence, and amount of information he or she wants to receive. The information (graphics, sound, video) is stored differently on the storage medium. It does not have to be stored in linear fashion, as does videotape or film, or in sequence according to the script. So storyboards become an important part of the flowcharting and authoring process. The multimedia storyboard becomes much more detailed than the traditional video or film storyboard because there are specific instructions needed on the boards to direct authoring.

Printed Support Materials

Printed support materials are essential for successful training results. Printed support materials are critical to ensure that the important points of the training are retained. Printed support materials are useful for both video-based training and interactive multimedia training.

Student Workbook

Typical student workbooks include:

1. An introduction that briefly describes the course goal, learning objectives, and prerequisites.
2. A description of each of the modules, their objectives, a glossary of key terms, reading assignments, lab exercises, and module quizzes.
3. Important diagrams and procedural information too detailed to include in the video program.

In designing a workbook keep these points in mind:

- Workbooks are similar to operation manuals. They provide a structure for learning, with introductory remarks, learning objectives, glossaries, instructions, and so on. Break the workbook down into specific job tasks with an objective for each task (the module approach).
- Provide detailed diagrams, charts, and photos that are appropriate for achieving the objective. Photographs help with the step-by-step teaching

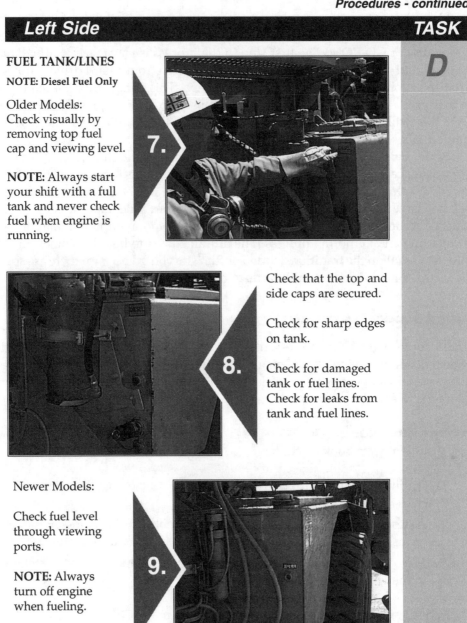

Figure 2.7 A "Task Analysis" student workbook shows use of photos for teaching step-by-step process.

of an operation. Remember, linear video is not appropriate for teaching step-by-step procedures because the student cannot control the amount of information being presented, the sequence or pace of the information (refer to "Adult Learning Theory" in Chapter 2).

- Include any pertinent safety information regarding the operation you are asking the student to perform.

- Provide a review of the specific steps necessary to perform the task. This can be used later as a review mechanism for specific jobs.

- Keep type styles, graphics, and the overall design style consistent with the videotape or multimedia program. The learning "package" should all be tied together with a cohesive look. The separate modules should be well-marked, and the instructions to use them easy to follow.

Figure 2.8a Example page from Kress Hauler Operations instructor guide.

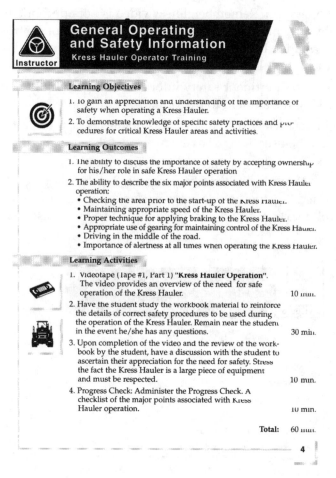

Figure 2.8b Example page from Kress Hauler Operations student workbook.

• If a multimedia program is designed, detailed instructions should be written for hardware and software requirements. Installation procedures should be included along with appropriate information about icons, menus, help screens, and license agreements. It is very helpful to have a printed version of the instruction icons used in the program and menus. Printed support materials help the student identify computer instructions and navigation procedures.

The student learning guide should be designed as a reference document for the student, with each learning objective and outcome clearly stated along with each major learning point. The guide is less a "script" than a "reference." The bulk of the teaching will be presented through the technology and exercises (or case studies). The guide will highlight each learning point, reinforce the instruction presented in the program, and provide the mechanism for information

Figure 2.8c Another example page from Kress Hauler
Operations student workbook.

transfer (learning activities). An appropriate glossary will be provided along
with special safety considerations.

An important element of the student guide are self-directed learning activ-
ities. These activities can include lab exercises (problems or formulas to work
on), case studies, role-playing, games, team tasks, extended reading, or "home-
work." These activities ensure information transfer and allow the participant to
directly apply what has been learned to an appropriate work situation.

Instructor's Guide

The instructor's guide should include appropriate instructions for carrying out the
learning event, including how to incorporate the videotape, slides, or photos; group
discussion topics; the certification process; and tips on managing the training event.
If the training package is designed for self-instruction, training management direc-
tions have to be worked into the video and workbook, such as the student "log on"

Figure 2.9a Example page from instructor guide reviewing
training activities to be delivered by facilitator.

procedure and the administration process of recording test scores. Training modules that teach specific operational procedures (as opposed to behavior modeling) will use video as an overview to the process being taught, showing the correct way to do the job, the working environment, and safety considerations. (Again, it is not usually appropriate to teach step-by-step operations with video.)

The instructor's guide provides a written teaching plan that includes all of the major learning objectives and learning points, the teaching activities, the training schedule, the discussion guide, and appropriate support materials.

The instructor's guide should include the following:

- An introduction that sets the stage for learning, including: an introduction to the topic and a justification of training; a definition of the learning goals and objectives; a description of the evaluation methods; and

Progress Check

Kress Hauler Operator Training

The following questions and activities are to be completed before continuing on to the next section of your workbook. Be sure that both you and your **Facilitator** are satisfied that you have a working knowledge of the material presented.

Name: _____ Date: _____

1. At the beginning of your shift, always look behind and around carrier for _____ , _____ , and _____ before moving.

2. Match _____ to road and traffic conditions. Anticipate _____ . Do not coast, always gear down.

3. True or False: Pumping brakes will lower air pressure.

4. Aid in braking by _____ _____ for long or steep down hill runs. When shifting between forward and reverse _____ completely and run at _____ RPM before shifting.

5. Match _____ with gear.

6. The recommended speed is _____ MPH.

7. Traffic is not allowed on the kress Carrier roadway unless cleared by _____ and _____ .

Figure 2.9b Example page of a "Progress Check" from student workbook.

points on the relation of training to work experience. A good introduction provides participants with information on what will take place and what is to be expected of them.

- Each topic to be presented, along with principle learning objectives, skills, and tasks
- Key points that should be emphasized
- Appropriate sequencing of the information being presented, along with group discussion and learning activities
- Instructional methods based on learning objectives
- Pace and timing of each major learning objective
- Appropriate summary for reinforcement

- Appropriate glossary
- Appropriate lab exercises and check points (quizzes, certification tests)
- Appropriate references to safety
- A copy of what the student will receive (the student guide)

PHASE 4: TRAINING IMPLEMENTATION

The implementation phase covers pilot program testing and training management organization. Implementation also includes site preparation, including site equipment installation and management; actual installation of the program at each training site; and training of the site facilitators on how to implement and monitor the program. Implementation should also include a plan for ongoing training support and maintenance of the program.

By way of example, when developing a videoconference, local on-site arrangements have to be made. Since there are multiple receiving sites for videoconferences, the local arrangements have to be made well in advance. These arrangements include meeting schedules, invitations to the events, room or receiving site scheduling, local sign-in or registration, lunch or coffee break arrangements, and local arrangements for the appropriate videoconference reception equipment, which could be through a local videoconference facility, consultant, or telephone company.

Often during a videoconference content, materials such as handouts, further reading, tests, slides, and written examples are made available at the local receiving site. The preparation, printing, and mailing of these materials have to be planned well in advance. Once the materials are received at the local site, arrangements must be made for the participants to get them. Often these materials need to be controlled during the videoconference and explained. Local arrangements for this control need to be planned. After the conference, evaluation should take place and thought should be given to awarding certification of attendance with conference certificates.

The implementation phase should also include carrying out the plan for training management. Computer software for training administration now creates systems for student class registration, on-line catalogs and course descriptions, and administration. Systems keep track of student records and transcripts and even plan student career paths based on available training classes. *OnTrack for Training* available through DKSystems of Chicago creates an on-line source for information on instructor-led training, certification programs, training and development planning, and even tuition reimbursement. *OnTrack for Training* lets you efficiently manage training activity, assess eligibility, review performance, review skills, and control reimbursements. This powerful program also

supports database management, which allows central control of data while distributing administration tasks to remote locations.

PHASE 5: TRAINING EVALUATION

The evaluation process always seems to be a very weak element in training programs. Thorough program evaluation of training is evidently not a regular occurrence. Most of the organizations we interviewed for the books we have written were not equipped to thoroughly evaluate the effectiveness of their programs. Although most training managers interviewed said their programs were well received and considered a success within the organization, very little hard data exist to verify their effectiveness.

Donald Kirkpatrick's excellent book *Evaluating Training Programs*, published by Berrett-Koehler, San Francisco, CA (1996), identifies this first stage of evaluation as Level One: Reaction. Level One measures how participants react to the training program. Kirkpatrick teaches three more levels. Level Two: Learning, measures attitude, knowledge, and skill changes. Level Three: Behavior, measures changes in behavior, and Level Four: Results, measures the final results that occurred because of the training.

As trainers we have to pay a lot more attention to the evaluation process, and Kirkpatrick provides an excellent model. In developing cost-effective programs, trainers must create good objectives that can be measured. They must also develop evaluation methods that measure effectiveness and demonstrate results so that return on investment can be proven.

The program evaluation process has come under much scrutiny, and there are many opinions and recommendations on how to evaluate training. *Evaluating Training Programs* is an excellent model to follow. We would like to offer a few additional suggestions for evaluating technology-based training programs:

1. *Evaluation starts with problem identification* and is an ongoing process throughout the development of the programs. It includes evaluation of the problem, program design, content outline, script, storyboard, final edit, and final distribution to viewers. Each major step of the development process should be evaluated for its effectiveness in achieving the objectives. Each step should be tested by the target audience and adjusted to meet the requirements and the needs of the audience.

2. *Objectives should be clear and measurable.* This leads to a good evaluation tool (there are many tools available) for measuring results.

3. *Training should effect change.* The evaluation process should offer a way to measure that change.

4. *Design effective Assessment Tools.* Competency-based training requires assessment tools that measure intermediate progress and summative assessment (demonstration of competency). Technology-based training allows for student testing (interim assessment) and summative evaluation through electronic simulation.

5. *Determine what should be done with the results of the evaluation.* Collecting evaluation data is great, but you have to have a mechanism by which to respond to that data.

The bottom line for technology-based training is that we will expend many resources for the development of the program, and we should be clear about how we are going to evaluate its effectiveness and measure the return on the investment.

3

Technology-Based Program Development Process

Whether you are producing video or computer-based training, the basic elements of program development are similar. This chapter will review the program development process as it applies to designing and producing video and interactive multimedia training and communications programs.

PRE-PRODUCTION

Needs Assessment

As described in Chapter 2, "The Training Design Process," a thorough needs analysis should take place before production begins on any training or communications program. A good needs analysis will accurately describe the problem and the appropriate solution. It will create a statement about the need for the production. This is important because everyone involved should agree that there is a problem and that media is the solution to justify the time and expense in solving the problem. What is first needed is a clear, concise statement of the problem and the proposed solution.

Budget Development

Estimating program costs is always a tricky situation. Doubly so if you are asked to provide a production budget without first having a script or detailed program plan. It is best to first place a value on the training in order to get a handle on costs. If indeed we are going to change the viewers' behavior, performance, or skill level, what is that change worth? If we produce a program that costs $20,000 and we cannot evaluate how much money the program saved or earned the company, or how the program changed the company, we could easily say that it cost too much. A value must be placed on the results the program

creates. By measuring the results, we can evaluate how much we should spend. *Know your return on investment.*

One major problem that always comes up in figuring a budget is not having a script or flowchart for interactive programs. How can you truly know how much a program is going to cost without the actual script or interactive plan? The video script will tell you how long the program will be, how many actors are required, how many shooting locations there are, how many camera setups, lighting and sound requirements, graphics, special effects, music, and the many special production requirements. Each of these requirements affects the cost of doing the program. It makes a big difference in the budget if the script takes two days to shoot or four, and if what you shot takes three days to edit or four.

Each of the script requirements will influence the cost of production, as does the flowchart requirements for an interactive program. Flowcharts tell us how long the interactive experience will be and how many screens will be needed, as well as graphic, animation, sound, and video requirements. So the best we can do in estimating the budget before the script is written is just that—estimating. For a video script we have to ask the client a series of questions about the talent, number of days of shooting, locations, graphics, and music requirements, and try to come up with an estimate. Not until you have an actual script or firm idea of production requirements can you actually tally the cost of production.

The budgeting process is quite sophisticated and takes experience to do well. For example:

- Do you know how to estimate the length of time that it will take to shoot a scene?
- Are you using professional talent, and if so, how many? (Nonprofessional talent will usually add to the production time.)
- Do you know how long it will take you to edit?
- How many edits are there in the program?
- If you are planning a computer-based interactive program, do you know how many interactions there are in each program segment?
- How complex is the branching, and will there be training management strategies?
- Are you going to incorporate graphics, animation, and full-motion video?
- Do you know how much music and how many sound effects are needed?
- Are you planning to produce printed support materials?

These are only a few of the questions that should be answered before we can get close to a budget estimate.

Program Design

As we learned in Chapter 2, the program design process is critical to successful programming. Program design consists of clearly identifying the problem you wish to solve through the program, setting measurable program objectives, doing a thorough audience analysis, and selecting the right media or combinations of media to reach the desired objectives. Program design should always take place in the creation of training programs, and it should take place for information and communications programs as well. With good design, you often find out that a video or interactive multimedia program is not needed at all, and that a group meeting, a series of audio tapes, or a traditional classroom training situation might be a better response to the problem. Program design creates the road map that the entire learning event will follow, and clear, measurable objectives allow for evaluation of the programming to take place. For educational events the video program is often only one segment of many learning elements designed to reach the overall learning objectives.

Production Design

We believe strongly in production design. Production design is the pre-planning of all visual elements and sound to enhance the program and reach the communication objective (refer to Chapter 5, "Production Design"). Designing all the elements ensures a coherent, comprehensive program that has aesthetic continuity. Good production design starts with a meaningful storyboard where the visual elements are chosen and designed for the biggest impact and educational value for the viewer. The design is integrated into shooting and affects the choice of camera angles, composition, lighting, pace, movement, color, and sound. In other words, all the aesthetic choices are planned for and designed to create a meaningful response to the message. Aesthetics become the "visual language" that we use to communicate with our viewers. A thorough understanding of this special language is critical for program success.

An excellent reference for aesthetic principles is Herbert Zettl's *Sight, Sound, Motion: Applied Media Aesthetics*, published by Wadsworth Publishing Company (1973). In his book Zettl states that the media acts not only as the distribution tool in delivering the message to our audience but actually shapes the message.

> *The media, such as television and film, are not neutral machines that represent merely a cheap, efficient, and accessible distribution device for ready-made messages. On the contrary, the media have a great influence on the shaping of the message, the way the original event is clarified and intensified. Television and film speak their very own aesthetic language; they have their very own aesthetic requirements and potentials. They are an integral part of the total communication process, not just the channel by which the communication is sent.*

As trainers and media producers we have the responsibility of learning as much as we can about our aesthetic choices and the impact these choices have on our viewers. Production design becomes a conscious effort on our part to make meaningful, aesthetic choices that contribute to our message and create a clearer understanding for our viewer.

Interactive Design Document

We will delve into the sophisticated world of interactive program design in more detail in Chapter 7, "Interactive Multimedia Design Considerations." However, there are a few program development considerations we need to learn about at this point in the development process. A critical step in developing interactive training is *the interactive design document*. Developed as a communications tool among the design team and client, the interactive design document describes what the planned program will be and what it will accomplish once it is developed. The document should include a statement of need (based on the needs analysis), the intended audience, and the approach the program will take. The document details the program goals, objectives, instructional strategy, navigation considerations, and evaluation plan. Also included are equipment considerations, schedules, and guidelines for deliverables or final product produced.

The interactive design document will outline the course structure, defining each module, and will identify learning activities. Implementation considerations will describe site preparation considerations, equipment and software installation, on-site training for the system, printed support materials, and ongoing support recommendations. The design document gives the development team members a clear picture of what the program will look like, how it will operate, and how it will be implemented.

Scriptwriting

Once the treatment is approved for the video program, you start the scriptwriting process. The basic scripting process follows a series of steps that will vary depending upon your knowledge of the subject, the complexity of the production, and the budget. You will first develop a working *content outline* that sequences the information you have to present and frameworks the amount of information to be covered. This is a point where approval is required.

Once you have approval on the content outline, script development or research on the content begins. As the script is being developed, visuals are being selected and the storyboard is developed. A storyboard is a visual representation of the "shots" or "pictures" you feel are needed to tell your story. The storyboard can be simple drawings on 3x5 cards or more refined drawings on printed storyboard forms. Often, rough sketches of the required shots will be enough to convey your visual thoughts. Refer to Chapter 5 for further discussion of the storyboard.

Script and Storyboard for Interactive Learning

The script and storyboard you develop for interactive programs should be closely related to the authoring program you plan to use. Good authoring programs will have multimedia storyboard and scriptwriting templates. These templates will guide you through the development process and provide essential elements you will need for the authoring process. Allen Communication's *CBT Starter Suite* (800-325-7850), Bernstein & Associates' *Design-A-Course* (800-511-5299), and Discovery Systems International's *Course Builder* (888-284-5389), all provide storyboard templates as well as needs analysis tools. The software helps the trainer with a thorough needs analysis then organizes subject material into outlines and flowcharts that work directly with authoring tools. Most of these authoring programs also offer Wizards and tutorials to assist in the design process. However, these tools still do not replace good instructional design experience.

As an example, *Course Builder*, by Discovery Systems International, is a cross-platform authoring tool available for the Macintosh computer. *Course Builder* provides the tools necessary to develop interactive presentations, training, and electronic testing. *Course Builder* is an exception rather than the rule when it comes to licensing authoring programs. The author owns the full rights to distribute and sell everything created with the program; no royalties or licensing are required.

An easy program to learn, *Course Builder* has a set of development tools called *states*. Each state (represented by an icon) has menus from which you can select various operations to build your program on the course map. States provide output devices that display information for the viewer, input devices that receive information from the viewer, tools for organizing and sequencing the course, flow states that control the flow of the program, tools to create and use mathematical calculations in the program, and links that allow *Course Builder* to communicate with applications outside of the program you are developing. A typical *Course Builder* application will be made up of many *states* connected to create a self-contained program.

A *flowchart* is helpful in the design stage to clearly show how all of the instructional elements, branching opportunities, and administrative tools connect. It provides the "big picture" of the project and then divides the overall program into individual instructional elements such as menus, course objectives, lessons, questions, and exercises. Since the path of the program is partially determined by the learner and partially controlled by the program, it is important to show branching possibilities at the individual lesson level. Branching provides greater flexibility and learner control than linear design. It provides options that can be made available to relate to individual needs, preferences, or abilities. The flowchart can be a helpful tool in calculating graphic, animation, and video requirements.

Figure 3.1 Screen sample from *Course Builder,* an interactive multimedia development program available from Discovery Systems International, Knoxville, TN.

Figure 3.2 Macromedia's *Authorware* and *Designer* are well-known and heavily used authoring tools.

As with video storyboards, multimedia storyboards are graphic and text descriptions of screens. Storyboards provide complete information about what will happen on a given screen in the finished program, and what will happen or where the viewer will go next. Storyboards should reflect the requirements of the authoring system you are using, but at the very least they should include: course title and number, individual lesson or module number, frame (or screen) number, last screen and next screen numbers, interactive control button locations, and a description of visuals and text or audio that is related to the screen. Storyboards should also include information about the backgrounds, screen colors, text styles, and positioning that appear on the screen; information about photographs (size and screen positioning), music cues, and positioning of video clips; and how to access videos.

Protocols should be set up for the program. The protocol governs the consistent aspects of all the modules with the interactive program. The goal is to have all of the modules look similar. Menus, color of headers and footers, text styles and placement on screen, photos, activities, and function keys are all outlined in the protocol.

Storyboards really force the design team to think through the entire path of the program and visualize what will be on the screen at any given time. The completed storyboards are then edited by the design team and content specialist for accuracy of content, language, grammar, punctuation, and spelling. After the storyboards, flowcharts, and interface design have been completed and reviewed, they often go to a computer programmer for "authoring" or input into the computer. The storyboard is a critical communications link for each team member.

Further information that may or may not be included in the storyboard is programming instructions for glossaries, word searches, bookmarks, student progression indicators, on-line help files, reviews, tests, credits, and student training management information.

Most multimedia programs share several common elements:

- the *title page* is used to set the tone of the program
- the *table of contents* provides a text-based overview of how the program is organized
- a *map* gives a quick, visual overview of how the different parts of the program relate to each other
- the *navigation system* provides a way to move from screen to screen, return to main menu, control video and audio clips, and so on
- the *index* or *browsing* capabilities allow the participant to search for information
- *installation* information
- *printed support materials*: references, student guides, instructor guides

Figure 3.3 Example taken from storyboard of Kress Hauler Operations, interactive multimedia training program designed by Cartwright & Associates for the mining industry.

Educating Special Learners is an example of a well-designed, interactive multimedia program, utilizing sight, sound, and motion to teach. Produced by Dynamic Knowledge Systems (*http://www.learning-tools.com*), it is a comprehensive software teaching package that provides information and exercises for parents, teachers, and other school and health professionals involved in the care of special learners. It is an easy, flexible way to gain valuable information about educating children and youth with disabilities. The computer-based program displays text, graphics, and sound segments and asks questions, or asks you to choose which material you would like to examine more fully. The viewer will answer questions and make choices, moving freely to other parts of the program for more information about various topics. Progress checks are provided for each section of each chapter.

Each chapter of *Educating Special Learners* is built in the same format: Overview, Objectives, Menu, Lessons, Reviews, and Quizzes. Many chapters also contain Case Studies. Each chapter contains a Main Menu that allows the viewer to choose what they would like to study. Topics include legal issues, visual impairments, hearing impairments, communication disorders, orthopedic and other health impairments, mental retardation, learning disabilities, and

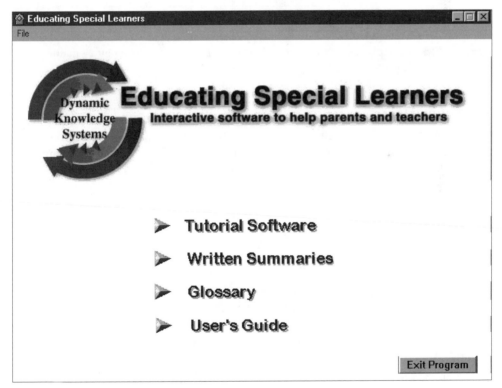

Figure 3.4a Example screen from *Educating Special Learners*, produced by Dynamic Knowledge Systems

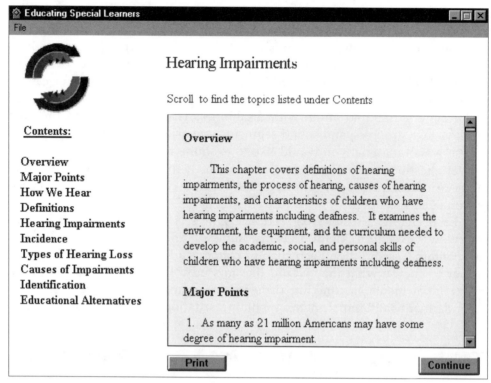

Figure 3.4b Example screen from *Educating Special Learners,* produced by Dynamic Knowledge Systems

emotional and behavioral disorders. The chapters each contain 60 to 120 minutes of material. There are twenty-three training modules, each providing about two to three hours of interactive instruction. There are approximately 250 to 300 screens per module, with 250 pages of script. The software is the culmination of many years of research and development. Over 25,000 teachers in twenty-five states have used the software during its many stages of revision and refinement.

Rough Draft and Shooting Script

A *rough draft* of the script is developed along with the appropriate visuals. Approval is given on the draft and the *final script* is written. The final script will have all the directorial elements, transitions, and effects written in, along with all audio effects and music cues. Once the final script and storyboard is approved, the shooting script is developed.

The *shooting script* will break down the script into the major production elements of locations, scenes, and major camera or talent movement. The shooting

script will help you develop a shooting schedule and organize the script for the day of the shoot.

Logistics

The logistics phase of pre-production encompasses arranging for all the details of the video and audio production, such as acquiring the equipment needed for the shoot, arranging for props and talent, and getting approval to shoot at the locations. There is a long list of logistic considerations that will be covered in more detail in Chapter 5, "Production Design."

PRODUCTION

The *production* usually consists of focusing our attention on the equipment operation and on working with the crew and talent. At this point we are focusing all our energy and resources on obtaining the best possible performance with the best possible technical quality of sound and picture. Production is where your pre-production planning pays off. Your attention to the details of the shoot, your organization efforts and attention to script come together at production so you can devote your attention to performance.

If we have done our job in pre-production planning, we can now concentrate on talent performance, crew performance, and getting what we want on tape—it is too late to worry about the right connector or cable or power. Details like these drain you of creative energy. *Good pre-production planning will free you of the burdensome details of production and let you concentrate on talent performance.*

In the production phase, we record talent on location, graphic elements and slides, narration, music elements, and all sound elements.

POST-PRODUCTION

After recording all of the source material on tape, post-production begins. Briefly, post-production involves script rewriting and editing of the program. The post-production process will require a lot of your time. Always plan for more time than you think you will need.

Script Rewriting

Depending on what you actually shot on location, you may have to do a rewrite on the script. The shots on location may turn out differently than what you had originally planned, so rewriting the script is often necessary. This does not usually require a lot of time, but "tweaking" the script before you start editing is often necessary and will require new script approval.

The Edit

The editing process consists of shot selection, arrangement, and timing. In editing, we arrange the shots in sequence according to the script, and in doing so we affect the pace of the program, the mood, and the visual flow. A very creative process, editing brings all of the random, recorded shots together into a coherent story that matches the script.

We first perform a *rough edit* (often referred to as an off-line edit) that basically sequences our shots in the order required by the script. The rough edit gives us the scene lengths and a rough pacing of the program. Usually, in creating the rough edit, we do not add graphics, music, or special effects and transitions. This is merely a "working draft" of the program. The rough edit allows for approval of the scenes recorded (is the content of the scene correct?), the audio/visual continuity, and the sequence of the shots.

Once the rough edit is approved, the *final edit* takes place. This step is often referred to as on-line editing. During the final edit or on-line process, all the transitions, graphics, special effects, sound effects, and music elements are edited into final form according to the requirements of the script.

Figure 3.5a Four interactive learning stations were part of the *Concept Pharmacy* exhibit produced by Mattingly Productions of Fairfax, VA for the American Pharmaceutical Association and the National Wholesale Druggists' Association.

The *Concept Pharmacy,* developed for the American Pharmaceutical Association and the National Wholesale Druggist's Association, is a *good example of a multimedia program* that delivers its message utilizing many forms of media. Produced by Mattingly Productions of Fairfax, VA, *Concept Pharmacy* delivers training to pharmacists, hospital pharmacists, and pharmacy students. The multimedia program explains the critical shift in pharmaceutical patient care through an introductory video, seven computer-based interactive segments, and

Figure 3.5b

an eighty-page booklet. The program was introduced using several interactive video kiosks stationed in a booth at the American Pharmaceutical Association (APA) show and is now available in kit form through the APA.

What makes this program unique is the multimedia approach taken by the producers. Understanding the strengths and weaknesses of each medium, Mattingly Productions selected different media technology for specific content delivery. The media was chosen to support the learning objectives, relate to a specific audience, and provide efficiency of delivery.

For a motivational introduction of the concept "pharmaceutical patient care," video was selected to carry the message. Through the use of strong visual images, stereo sound, and human behavior modeling, video provided the motivation needed to gain the viewer's attention and introduce them to the basic teaching concepts.

For an in-depth study of the new concepts, interactive CD-ROM was chosen. Viewers could select from seven different tracks based on their experience with the topics. An interactive track was provided for the video as well.

Grayson Mattingly, President of Mattingly Productions, explained that this educational approach was unusual for a convention of this type, which is mostly made up of sales related booths and vendors. The American Pharmaceutical Association wanted the introduction of *Concept Pharmacy* to be an educational experience and to include educational materials that the audience could take home with them. The motivational video attracted the viewers; and the educational,

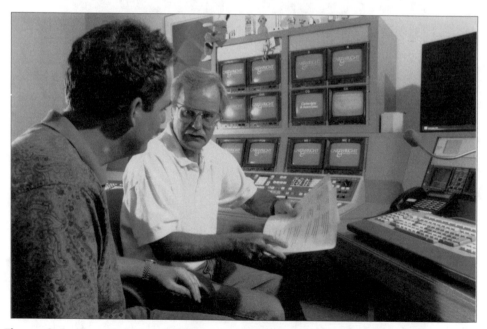

Figure 3.6 Co-author Steve Cartwright discusses script with editor Henry Rubin during on-line video-editing session.

interactive kiosks successfully provided in-depth study of the topics. This excellent example of multimedia programming provides a model for education delivery, utilizing the strengths of each media effectively.

COMPUTER-BASED EDITING

As digital video grows in popularity with trainers, computer-based editing will become the norm. Computer-based editing also referred to as "nonlinear editing," takes advantage of the computer for image manipulation and file management. Video and all media elements are digitized through video-capture and compression hardware, creating computer data files. The computer editing software program manages these files (text, audio, graphics, animation, video) much the same way a word processing program manages text. The editor moves data files onto a "time line," inserting video, audio, and graphics as the script requires. Changes to the length or sequence of scenes are easily made, and special effects for transitions are added with the click of a mouse. Once the program is approved, the computer outputs the data (through specialized decompression hardware) to tape or prepares the data for CD-ROM pre-mastering.

By way of example, the *Media 100* (800-832-8188; *http://www.media100.com*) nonlinear editing system is available on the PC or Mac platform. The *Media 100* is a complete editing system that creates excellent quality pictures in digital form and has numerous effects to use for transitions. Providing two simultaneous streams of video on the computer, the *Media 100* provides limited real-time editing, allowing the editor to make transitions between the two video tracks, with some special

Figure 3.7 The *Media 100* nonlinear editing system from Data Translation offers broadcast-quality, computer-based editing on the desktop.

effects without rendering (the slow process of "painting" each frame of video on the screen). Digital video editing, real-time transitions and effects, graphics creation, and audio production are all available on your desktop.

The *Media 100* digitizes the analog signal as it enters the computer at up to 200KB per frame, creating an excellent quality digital video. The editing computer interface is intuitive, easy to learn, and allows for real-time, render-free editing. Complete systems offer compatibility between software programs so you can edit video and audio, create special effects, and create graphics and animation on one computer. The goal of complete, integrated systems is to allow you to switch between programs (graphics packages and editing, for example) without interrupting the work flow.

DUPLICATION AND DISTRIBUTION

Duplication of the program is next. Getting the program ready for delivery to the viewer is usually referred to as dubbing or duplication. We should pay more attention to the planning and the duplication process because it ultimately affects what the viewer actually sees.

The duplication process for video programs involves preparing the master edited program for dubbing. Usually a dub master is recorded. This is a copy of the edited master. The dub master contains the final audio mix on two channels, a slate that identifies the program, and tone and color bars. This information at the beginning of the tape allows you or the duplicator to technically set up the duplication machines.

If there are only a few copies to be duplicated, the in-house video or training department may handle the job. This assures quality control, control over all copies, and speed in delivery. However, more often the request for the program is in such numbers that it does not pay for the in-house producer to take the time to make all the copies in-house, in which case the dub master will be sent outside to a commercial duplicator.

CD-ROM Duplication and Replication

After the *pre-mastering* process, CD-ROMs are prepared for duplication. This involves burning the data onto blank CD-R (compact disc recorder) using a laser beam. CD-Rs create a "gold master" or copy of the original source material. This process is usually reserved for small quantities of CD copies, prototypes, and test samples.

The replication process is used for large quantities of CDs, usually 500 or more. In replication, the original gold master is used to create a "glass master," which in turn is used to create the replication master or mold from which copies are manufactured.

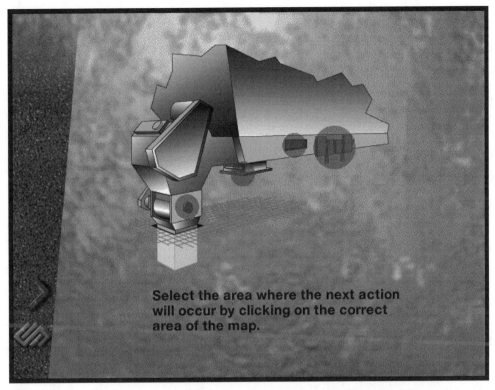

Inside the image: "Select the area where the next action will occur by clicking on the correct area of the map."

Figure 3.8 Screen sample from interactive multimedia operator-training program designed and produced by Cartwright & Associates shows how computers provide simulations for training.

Large video and CD-ROM duplication facilities like *Vaughn Communications* in Phoenix, AZ, offer complete duplication and replication services. Their services also include pre-mastering, graphics development for CDs, and stocking of popular CD-ROM and videotape packaging items.

ELECTRONIC ASSESSMENT

Electronic assessment is a new performance evaluation option that trainers may access through popular multimedia training development programs and tools. As we explained earlier in this chapter, assessment tools are designed to evaluate student performance. Electronic assessment goes beyond traditional testing of skills and behavior. It can present work-like environments through the use of multimedia and provide both summative and formative assessment. Testing has always been a popular feature of CBT (computer based training). Through the use of interactive multimedia, however, performance assessment takes on a whole new meaning. Students can demonstrate mastery of content through creative interactive

activities. Simulations of complex physical or psychological phenomena can be created through audio and video clips. By moving valves on the screen, manipulating switches and gears, adjusting controls, and doing calculations, students can be directed to demonstrate on the computer new skills in operating equipment very similar to what they would find back at the workplace. Video and audio clips together with graphics and animation manipulated through student responses allow trainers to assess mastery of materials.

BHP-Copper in San Manuel, Arizona, wanted to assess the skills of operators in closing down a valuable piece of equipment in case of a fire. After learning the shut-down techniques through a video training program, operators were then asked to demonstrate their skills by way of electronic assessment. The assessment tool (both the training and assessment were designed and produced by Cartwright & Associates) consisted of specific tasks the operator must perform in shutting down the equipment. Without jeopardizing the integrity of the equipment or endangering the operators, the student could go through the shut-down procedure through computer-based, interactive activities.

Students first had to identify the critical components of the system. Once they proved to be successful with the identification exercise, they moved on to the shut-down procedures. As they moved specific pieces of equipment, locating critical parts, valves, and controls, students were evaluated on their mastery of the training materials. This electronic assessment used graphics, photos, video, and audio segments to present real-life situations that would be impossible to present to students without creating extreme safety hazards. A critical task was taught and the skill assessed at a computer.

PROPOSAL

Proposals help define the scope of a project, the resources needed to accomplish it, and an estimated cost. They are essential to the planning process.

It is important to get agreement on what is to be done, how it is to be done, and how much it will cost. Proposals provide a vehicle to communicate the desired work and outcomes with clients. Developing media involves investing time, money, and talent. A commitment is necessary to begin the project, and the proposal provides the framework for this commitment.

Proposals identify the "need" for the project along with how the need is to be addressed. The proposal can provide an "approach" to the solution, but it is not the actual plan to carrying out the program, nor is it a detailed answer, script, or budget. It is simply a way in which the solution might be addressed. The proposal identifies the problem and suggests a solution. It justifies the commitment.

A simple proposal or request for services within an organization will usually contain a description of the problem, the audience that is affected by the problem, and a solution or an approach to solving the problem.

Statement of Work/Request for Proposal (RFP)

Often government and business organizations provide a "statement of work" that describes the work to be performed. Or request work to be performed through a "request for proposal." The statement of work usually contains the objective of the program; a description of the work to be performed with specific tasks to be done (e.g., research and scripting, production, locations of shooting, editing requirements, graphics, printed support material, and duplication and distribution requirements); the general requirements placed on the contractor (schedules, evaluation, deliverables); and the amount of flexibility the contractor will have to carry out the work. The statement of work can ask for a management plan that will require the contractor to describe in detail how he or she plans to approach the project and how it will be managed and controlled.

A statement of work usually will have the following components:

- *General Information,* containing purpose of work, how to submit proposals, response date, evaluation procedure, and information about vendor visits.
- *General Requirements,* containing the award date, contract information, term of award, warranty, product ownership, confidentiality, and proposal format.
- *General Description* of the work to be done, goals of the project, hardware and software requirements, pilot-testing requirements, and project evaluation requirements.
- *Deliverables,* specific deliverable requirements of the project (script, storyboard, budget, production schedule, interactive design, master program tape, copies, etc.).
- *Samples* of work to be done, proposal certification, and signature form.

Types of Proposals

There are as many different proposals as there are producers. Each producer has his or her own style, legal requirements, and details that he or she feels should go into the agreement. But usually there is a standard format that producers follow. A good proposal should have the following:

- *Client name,* main contact, or company name.
- *Producer* or name of person who has the overall responsibility of getting the project done.
- *Due date* or final completion date of the project; this section may also contain milestones, such as when the script is due, when the shooting

and editing is due, and deliverables (edit master, CD-ROM, and number of copies).

- Overall *length of program* or list of training modules.
- *Printed support materials requirements*, such as accompanying brochures and workbooks, and due dates, if different from the multimedia production dates.
- *Identification of the problem*, the audience, and the recommended solution.
- *Estimated final budget.* This section may be broken down into budgets for pre-production, production, and post-production, and may have scriptwriting as a separate budget item.
- *Production requirements.* This section usually covers the format the program will be shot on, number of shooting and editing days allowed in the budget, and music and talent considerations.
- *Special considerations*, usually covering travel related to the project and special shooting or special-effect requirements, along with distribution and delivery requirements.
- *Treatment or concept.* This section may cover how you intend to "tell your story." Treatment creation is a very creative process and can work for or against you. Be careful that your treatment is not selected and then produced by a lower production bidder. Protect your creative treatment.
- *Distribution and delivery requirements.* If special distribution of the project is required, such as satellite distribution, it should be spelled out, as should special duplication services, packaging, and printing.
- *Legal issues*, usually covering ownership of the completed project and the working drafts, including copyright. Identify the owners, not only of the copyright but also of the material objects contained within the project, such as the original footage, photos, or graphics.
- *Limitations* on the scope of use by the producer if the buyer retains ownership of the program, including the individual elements of the productions, such as video clips, music, and graphics.
- *Payment structure* tied to deliveries and approval/acceptance.
- *Approval process* describes the person or persons responsible for approving each phase of production and describes the right of the buyer (client) to demand alterations or corrections and additional fees, if any, to be paid to producer.
- *Description of credits.*
- *Warranties and indemnifications* between producer and buyer.
- *Insurances* to be obtained and who is responsible for those insurances.

(LETTERHEAD)

PRODUCTION AGREEMENT

RE: *[name of project or working title]*

[Date]

Ms. Client
XYZ Corporation
Address
City, State, ZIP

Dear Ms. Client:

This serves as a Letter of Agreement between XYZ Corporation, hereafter referred to as "Client," and Able Video Communications hereafter referred to as "Producer."

It is hereby agreed that Producer is to produce a videotape program on the subject of: *[working title or purpose of program].*

The estimated cost for production is based upon the Client approved treatment, and is subject to Producer review of the final approved script when available. The estimated cost is complete for all scripting, pre-production, production and post-production through submitted edited master videotape. The estimated cost includes and is subject to the following specifications:

- Finished length is not to exceed 12 minutes.
- Scripting up to and including a maximum of 3 drafts, from content materials to be provided by the Client.
- Producer/Director services for production prep; casting; live action production; graphics, music and narration production; and post production.
- One (1) day of studio production on a sound stage, including all associated crew and facilities and set up time.
- one (1) day of remote production at location(s) to be provided by Client, including all associated crew and facilities.
- Professional talent at AFTRA union scale for voice over narration and on camera roles.

Figure 3.9 Sample proposal

LETTER OF AGREEMENT
XYZ Corporation/[*Project Title*]
[*Date*] page 2

 - Production music, including all clearances.
 - Animated graphics (logos, etc.) and charts as required.
 - Off line approval edit for client review.
 - On line final edit on Betacam SP or equivalent quality.
 - Please Note: No duplication is included in this agreement.

The estimated cost for production (contract price) is
$41,350. and is not to exceed $45,485. (41,350. plus a 10%
contingency of 4,235.) without prior Client approval. This
estimate is itemized in the attached Production Budget, which is a
part of this Letter of Agreement. The contact price is based upon
the production parameters listed above (as suggested by the
approved treatment), and is subject to Producer review of the
final, approved script when available.

Terms of payment are One-Third upon awarding of contract;
One-Third at commencement of principal photography; and One-Third
upon delivery of submitted master.

Producer reserves the right to assign or sub-contract any
portion of this project.

Producer is being retained by Client as an independent
contractor. All work performed under this agreement shall be
deemed works made for hire, in accordance with the federal
copyright laws. Completed videotapes shall be owned outright by
Client.

Client acknowledges that Producer may refer to Client's name
in promotion of Producer's future business. Client also agrees
that Producer will receive one (1) copy of the completed
production and may thereafter use the program in the promotion of
Producer's further business.

Either party shall have the right to cancel or postpone this
agreement prior to completion of the agreement. In the event
Client initiates such cancellation or postponement, Client agrees
to pay Producer cancellation/postponement fees to be negotiated
based upon services performed, schedules already committed, and
sub-contractors already engaged up to and including the date on
which written notice of postponement or termination is received by
Producer.

* * * *

Figure 3.9 *(continued)*

```
LETTER OF AGREEMENT
XYZ Corporation/[Project Title]
[Date]        page  3
```

 If you acknowledge and agree to the above terms, please sign
and date this Letter of Agreement, retain a copy, and return an
executed copy to Producer. We look forward to working with you.

 Very Sincerely Yours,

 [*Producer*]

The above terms are agreed to and acknowledged.
Able Video Communications

By _____

Date _____

XYZ Corporation

By _____

Date _____

Figure 3.9 *(continued)*

LEGAL ISSUES

There are a lot of legal details that need to be worked out well in advance of a production. Producers should have a working understanding of the copyright laws and legal considerations for talent and music. Often legal departments get involved, and that may cause delays in production, editing, and project delivery. If company logos are involved with opening graphics or in printed support materials, their use often has to be approved by legal departments. Be prepared in pre-production to spend extra time with legal issues.

Thanks to Ed Hearn, an attorney in Palo Alto specializing in the entertainment industry, I have provided a brief statement about the copyright law and

notices that producers should be aware of. You should also check with your legal counsel for more details pertaining to your specific project, as well as with local talent unions about their requirements.

What May Be Copyrighted?

Works that qualify for copyright must past two tests. First, they must be original works of the author, meaning they must have been created by the author. Second, they must be fixed on a tangible medium, such as paper, videotape, or film. An idea for a training program would not qualify for copyright until it was put into writing or actually produced on videotape. The various components of a video — the script, music, sound, performance, soundtrack, or visuals — could be separately copyrighted once they are put on paper or tape.

Ownership of Copyright

According to the Federal Copyright Act, the copyright in a work belongs to the person who created it — in other words, the author. Only the copyright owner, or the owner's agent, may register a copyright claim.

The issue of ownership becomes less clear, however, when the work represents the combined efforts of many people, as in a video or multimedia project where one person may fund the project, another may write the script, another may produce it, and still others may direct, run the camera, or perform in the finished program. In such cases, each person who contributes to the work may claim to be the author and therefore the owner of the copyright, collectively if not individually. As a joint copyright owner, each of the owners may exploit the work in whatever matter he or she wishes. Each one is accountable to the other owners for his or her share of income from the video and may be held liable for any claims. It is usually best to simplify this situation by having all those who contributed to the training program agree in writing who will be identified as the owner of the program.

Commissioned Works and Work for Hire

Works that are made by someone other than the actual owner or user include commissioned works and work for hire. If you are commissioned by a company to create a video, you as the maker would retain the copyright — after obtaining in writing an acknowledgment from the other contributors. For instance, if a company hired you to produce a video describing its product, and there was nothing put in writing to the contrary, you as the creator of the video would own the copyright, with the company having an exclusive license to use the video for the specific purposes for which you were asked to create it.

Work made for hire includes programs produced by an employee for a company, as well as works that would be commissioned as part of a collective

work when the parties involved sign a statement that the work will be considered "work made for hire."

Copyright Notice

Any copy of the work that is disseminated to the public should contain a copyright notice that is clearly visible to the viewer in order to prevent the work from going into the public domain and the copyright protection being lost. The notice must include the word "copyright" or the symbol "c" in a circle, the year of publication, and the name of the copyright owner.

Adding the notice does not grant the copyright, since the copyright automatically vests once the work is created. But placement of the notice is important in preventing the copyright from being lost to the public domain. Under the former Federal Copyright Law of 1909, the omission would result in forfeiture of the copyright. The current Act, however, allows for some protection for five years.

As a producer, on behalf of the buyer of the video or multimedia production, you contract with third parties to contribute material to the production. You must make it clear in writing with those third parties who will own the work they are contributing to, and whether it is a commissioned work or a "work made for hire." Your responsibility is to provide the buyer with a finished product in which all rights to all elements have vested in a way that they can be transferred to the buyer for its use.

Should you not acquire outright ownership of any element in the program, you must try to obtain a perpetual and universal right for the use of the contributed element in the program in all formats and all media, so that there would be no restriction on the buyer's use of that material in the video.

Music and Clearance

Typically, musical works have the same copyright protection as other works, so it is not recommended to "borrow" a tune from your favorite CD to set the mood for your next educational program. Often copyright ownership belongs to the publishers, who collect and share royalties with the creators. This copyright generally covers the published sheet music, right of performance, and the mechanical rights or the form of playback, such as film, tape, or CD. Producers need to obtain clearance rights for performance of the music and a synchronization license. A synchronization license allows the producer to mix the music (that has clearance) into the film or video being produced. Performance licenses are usually granted from performing-rights groups such as ASCAP (American Society of Composers, Authors, and Publishers) and BMI (Broadcast Music Incorporated). Agencies such as the Harry Fox Agency in New York also have authority from publishers to grant producers music rights. *It is very important for the producer to understand copyright and clearance issues and obtain appropriate clearance for all music used in all productions.*

Arrangements between Producer and Performer

If your production requires professional talent, you should be prepared to provide the following:

- Statement of function and role of performers.
- Compensation agreement for performers, including overtime fees.
- Credits statement.
- Provisions of relevant guilds and unions.
- Clearance for the rights to use name and likeness of performer.
- Amount of time needed for the production.
- Payroll statement and time sheets required by union.

In summary, it is wise to become familiar with copyright and professional talent requirements. Often what starts out as a good relationship with a client or organization does not always end as a good relationship. Therefore, copyright ownership and talent issues need to be worked out in advance, so that there are no surprises and disappointments at the end of the production. For example:

> *I produced a series of video training programs on customer service for a very large cruise line, which changed the "rules" at the end of the production. It was agreed (verbally) at the beginning of the project that I could use excerpts of the program for teaching purposes in the seminars that I conduct. The excerpts I wanted to use were excellent teaching examples of using video for training and good acting examples. At the end of the production, the client decided that I couldn't use any excerpts and withheld approval of the final payment until I signed an exclusive copyright agreement, a document that was unusual and certainly not in line with industry standards. Avoid such last minute surprises and inconveniences by getting copyright agreements in writing well in advance.*

Technology-based training program development requires the skills and talents of many individuals. Versed in instructional design, media production, interactive multimedia design, and distribution, the production team develops interactive training through a series of developmental phases and combines the talents of many into a coherent whole that teaches, manages, and tests the skills of employees. Our next chapter covers the detailed process of scriptwriting and storyboarding, key elements in designing successful training programs.

4

Scriptwriting and Storyboarding

Scriptwriting can be a difficult chore for those who do not do it full-time. But scriptwriting, like most skills, improves with practice. In our experience with scriptwriting, we do very little actual writing but a great deal of interviewing and outlining. Our scriptwriting method is useful for people who do not intend to become full-time scriptwriters but need to develop some familiarity with scriptwriting. Writing is an individual, personal experience that cannot be learned from a book. But the mechanics of researching, outlining, visualization, and script development are activities that you must master before you can fashion a functional shooting script. And whether you are producing video segments for interactive multimedia, CD-ROM, or the Internet, good scriptwriting techniques are valuable for reaching your training objectives.

Most of us in the field of training and production have been hired for particular skills and not because of knowledge of a particular subject area or product. Scripting can be perplexing if the producer knows nothing about the content of the proposed program. It is your job to gather content, organize it logically, refine the information, visualize it to make it interesting to the eye, and in the end create a successful program that will bring training results. In the scripting process, the general rule of thumb is that after you have gone through a thorough design phase and a thorough scripting process, you will end up using only about 25 percent of your original, intended material. If you are doing your job correctly, asking the right questions, and designing the program for the right audience, this 25 percent will be refined into a concise, highly-focused presentation that makes the point and delivers the message with no extraneous material.

RESEARCH

The scripting process starts with research, and most of us are familiar with the common research techniques. Bill Van Nostran's excellent book *The Nonbroadcast Television Writer's Handbook* (White Plains, NY: Knowledge Industry Publications,

1983) has a chapter devoted to research methods. Van Nostran emphasizes that research will lead to answering the three-part question, "What do you want to say, to whom, and for what purpose?" It is important to have a direction for research, and this question will give you a direction to follow.

First, you need to gain a feeling for the total communication and training task: the initial question will allow you to focus this task. Second, it is important to know who the audience is. The nature of the communication or training task changes radically based on the client's intended audience. According to Van Nostran, "A significant portion of the research agenda may focus on gathering insight into the audience's level of knowledge or attitudes." And third, the answer to the important question of purpose "forms the foundation for delineating program objectives."

One of the best ways to do research is to interview individuals who are content experts or who will play an important role in program development. An effective technique for interviewing individuals is to record their responses on audiotape. The transcribed tape can actually become a working draft for the audio portion of the script, so you have almost immediately created words on paper. The interviewing process used for researching material leads to conversational information that usually would not surface in formal writing. This conversational style is important for creating a successful program. As you learn about style and approach, you will see that to be received well by the audience a good program should be delivered in a comfortable, conversational style. Television, for example, is a one-on-one medium that gets the best results when the program appears to address the viewer in an informal, personal manner.

Another research technique is the on-site visit. This is particularly useful when the subject matter involves physical or mechanical content like a manufacturing process, a new product, or a technical application. In these cases, seeing the process is vital. On-site visits usually include an interview on audiotape with the key people who will make the process work. It is also valuable to shoot photographs during the site visit. These photos aid in the storyboarding and visualization process. They can also assist in arranging for site logistics such as video equipment location, lighting requirements, staging, and prop requirements. On-site visits are extremely important when more than one content expert or narrator will be recording the program. If you plan to interview operators, salespeople, or trainers on-site, it is best to record on audiotape the gist of the interview, so you can get a feeling for the personality of the individual being interviewed. This will help you develop a script that will reflect important characteristics of the interviewee accurately. On-site visits always reveal valuable insights, historical detail, and personal perspective that sitting in an office writing a script just cannot do.

Quite often in the scripting process, you will receive written material from the content expert or from the project requester. This is usually in the form of an outline or formal description. If it is a detailed outline, a scriptwriter can then go

back and ask more questions to fill in the gaps. Sometimes a writer may receive a written speech describing the process to be covered in the program. For some reason, people do not have such a fear of writing speeches as they do of writing scripts. When I ask a content expert to write a script, he or she says, "No way. I'm not a scriptwriter. I can't write." But if I ask the scriptwriter to write a speech, the answer is, "Fine, give me a couple of weeks. I'll work on it." Actually, the two can be basically the same, and as long as you get the information that you need, either will do.

Another approach, if you have a content expert who does not have the time to write a speech, script, or detailed outline, is to have the individual recite content into an audiotape recorder. Talking doesn't seem like such a chore compared to sitting down in front of a blank page and having to write descriptions. The audiotape will help create a conversational tone because the content person naturally talks to you on the audiotape recorder in a more relaxed, informal way. The final suggestion, and probably the most difficult research technique, is the old library approach: going to the corporation library, the local library, or into the manufacturing area, sitting down, and researching information out of books, catalogs, or brochures. This approach usually does not generate the specific information you need, but it can supply you with general background data. During the research phase, you will also want to review what has already been written about the subject in the form of speeches, articles, and studies, as well as what media already exist. I would guess that for virtually every training subject, a program has already been produced. The Association for Educational Communications and Technology offers a four-volume catalog of programs from the National Information Center for Educational Media. It contains over 60,000 titles. The National Video Clearinghouse offers 40,000 titles, and The Video Source Book contains over 40,000 titles.

Most programs that are made available for commercial distribution are designed to be generic, but they are generally well-produced and may meet the media need for the training event. Even if you do not wish to customize the program to your particular situation, just reviewing titles that are available can provide a valuable resource in giving you a perspective, style, and approach for developing a new program that would meet your specific needs.

APPROACH

Once the research process has started, and as you become more familiar with the material, the content to be developed will start lending itself to a special approach for delivery to the audience. The approach will be the framework or theme that will deliver the content to the target audience successfully. Typical approaches for video training would be a voice-over describing a demonstration or a new product; an interview or news show concept; a documentary, dramatic

vignette, game show, plant tour, or problem-solution approach; and humorous scenes or the big talking head.

The audience is a determining factor in your selection of an approach. You have to understand what theme the audience will accept. You have to determine what will work and will not work with the target audience. What format of delivery will work best in reaching the target audience? The script will grow from the theme, and the mood, music, and talent will be developed based on the approach you select. In seminars that we teach on designing and producing technology-based training programs, we are continually asked, "What approaches work best for training?" It is always a difficult question to answer, because the approach depends on a combination of elements, each influencing the decision. The audience is, however, one of the most important factors that will help determine the approach. But resources, budget, and deadlines will also influence your decision. It may not be practical to create a formal script where actors are hired to sell new product ideas. Or deadlines may limit how much time can be devoted to the project, and a talking head, therefore, might be appropriate.

TREATMENT

A treatment is a narrative description of how the program will appear on the screen. It will include the objective and an audience profile, but more importantly, it will describe how the information will be delivered—the approach. The treatment is usually a single page, and for some organizations it will become an actual proposal. The proposal will be presented to the client and, upon approval, the project is set in motion. It is an important step in the process because approval of the treatment means that the objective, audience, and approach have been accepted. This will provide direction and clearance for the project.

Script Werx, a commercially available scriptwriting software program from Parnassus Software, (818) 464-7511, provides a research template that helps you through critical research questions for your scriptwriting assignment, and a treatment template designed to help you create effective treatments to be presented to clients. The treatment software includes "writing tips" that suggest how to design the treatment and what should be included, such as objectives, strategies, creative approach, time line, and investment. Here are some examples of Script Werx writing tips:

- Sample *writing tip* for the Objectives section of the treatment:

 Follow the goal statement with a list of three to ten behavioral objectives. These are the specific changes in thinking or behavior that must take place for the show to be effective in achieving its goal. For an example, see the treatment in the Script Werx example folder.

- Sample *writing tip* for the Strategies section of the treatment:

 The Strategies section begins with a short statement of approach: how the medium will be used. This initial statement is followed by a list of what is essentially a creative specifications sheet, stating what will be done, in terms of structural elements, devices and techniques you will use.

 Script Werx answers basic questions concerning "What will the show be like?" These may include: "What's the format? What and who are seen on camera? What provides the continuity? What devices are used to position the organization, product, service, or idea? How are music, sound effects, and graphics incorporated?"

- Sample *writing tip* for the Creative Approach section of the treatment:

 The creative approach is a word picture taking your reader step by step through what you envision for their presentation. It's a present tense, active voice description of what will be seen and heard [and] that demonstrates the style and tone intended for the finished presentation.

Each Script Werx writing tip has examples. The template approach offers a basic structure that can easily be customized for your particular needs, following the simple prompts and menu instructions. They are very helpful for beginning writers and provide a professional guideline for the experienced producer.

Interface Design

Chapter 7, "Interactive Multimedia Design Considerations," will cover interface design in more detail. For the production of interactive training, the interface design and navigation strategy are key approval points. Once the design philosophy, interface, and strategy have been agreed upon, scripting and storyboarding can begin. The secret here lies in using a good interactive authoring program (refer to Chapter 6, "Choosing an Authoring System," for tips on selection). Depending on the interactive authoring program you use, the scripting process will need to match the authoring approach.

Most multimedia developers use authoring systems. An authoring system is an integrated set of computer programs that allows the user to produce complex interactive training programs and presentations. In general, authoring systems facilitate the integration of graphics, animations, video, and audio into presentations and allow the student to interact with the program elements to acquire new skills and information.

We have identified several important design elements you should consider as you develop an interactive multimedia session (detailed further in Chapter 7). These are:

- Splash or Title Page
- Acknowledgments

Figure 4.1 Simulation of adjusting valve for steam and water flow from interactive multimedia training program designed and produced by Cartwright & Associates.

- Log-in
- Contents
- Overview
- Objectives
- On-line Help

The scriptwriting process begins by developing content to meet these critical design elements. Video scripts will be written in a linear fashion following a specific sequence. Interactive programs do not have to be written in linear style; students will interact with information presented to them in different ways, that is, randomly. Therefore, less emphasis is placed on writing complete, sequenced scripts, and more emphasis is placed on storyboards with "bits" of information attached. Navigation maps are developed along with the storyboards. Navigation maps outline the connections or links among various areas of your content. The *user interface,* a blend of the graphic components and the navigation system, guides the student through the content. The interface should be intuitive; it should be obvious to the student what he or she should do to move between screens or sections of content.

When writing for the computer screen (for CD-ROM distribution), keep in mind that you will follow the same instructional design process as with classroom instruction or other media development, but your writing style will change. The computer screen is physically different from the TV screen or the printed page. The physical size and quality of the computer screen affects the amount of information you can present. Therefore, limit text to one concept at a time, keeping sentences and paragraphs very short—between one and three sentences, with lots of "white" space on the screen. Write as you would speak, using a conversational style, because the interaction between the computer and the student is that of a dialogue. Sentences should be brief with a simple structure. Be consistent with your presentation style; for example, format similar questions consistently and use consistent type style and colors (multiple type styles are hard to read and confusing, as are multiple colors). Provide lots of interaction; the viewer should "interact" with the program every two to three screens. And keep the viewing experience personal; refer to the viewer as "you," much as you would in the case of video scripts. Refer to Chapter 7, "Interactive Multimedia Design Considerations," and Chapter 8, "Training Design and Production Tips," for development of text, graphics, animation, video, and audio for computer-based training.

CONTENT DEVELOPMENT

The content you have gathered now has to be organized into a logical sequence. Training scripts can be organized in three ways: in a temporal or chronological order, a topical order, or a problem-solving sequence. For example, with sales training you could organize the information into a problem-solving sequence. The objective and concept of delivery will help in the selection of the organization of the material. Remember that with the linear video experience, the viewer will have only one chance to receive the message. The organization of the material becomes critical for successful reception.

As the outline is developed and content is defined for the target audience, the script will start to grow into a logical chain of events that will help your audience achieve the objective. But as the script grows it is important to start asking, "What exactly does the audience need in order to achieve the objective?" Content can grow and grow, and the content expert, who is very close to the subject, will keep adding information that may not be necessary for the target audience. As the writer, you must continually edit content and include only what is absolutely necessary. A video training tape should be precise and to the point. You should respect the viewers' time and provide them with only the essential information. As pointed out earlier in Chapter 1, "Technology-Based Training," video has the capability of condensing time. Through concise writing and transitions you can present the required information in a very short time. Do this by honing down the information and presenting—through visuals and the spoken word—only the information that is needed to reach the objective.

There are two schools of thought on how to proceed at this point. One is that you write the script first and then you visualize it. The second is that you visualize the information first and then write the script. We believe in the latter. After all, you have chosen video because of its visual impact, its ability to condense time and space, and its effective combination of the spoken word and pictures. Therefore, I do not believe in creating videotapes that are glorified audiotapes. Often visuals are placed into a script to support the audio, and if you turned off the video you would still receive the message. If this is the case, why not save money and just produce an audiotape?

If videotape is the chosen medium of delivery, use it to its fullest advantage. You should, therefore, think in pictures, pictures that will tell the story. In other words, think visually. Create a script that is strong visually and the pictures really will tell the story better. To this end, the writer should address exactly what it is that must be seen to tell the story effectively. We approach this by jotting down visual ideas and picture sketches that we feel are needed to get the message communicated to the viewer. We actually create a storyboard or a sequence of pictures that depict the training event. Then we write words that support, clarify, and enhance the visual experience. Of course, not all video training tapes lend themselves to this technique. But when you need a sophisticated training tape, think visually and let the pictures carry the message.

Whichever approach you use to create the script, remember to place yourself in the viewers' position and continually ask what they need both visually and narratively to receive the message and accomplish the objectives. The script will be influenced by the design, audience, and objective. The writer will use the approach to tie the content together and, through careful organization, will create a logical flow of information that the target audience can follow. The visuals chosen will accurately tell the training story in an interesting and lively way. The words spoken will enhance the message, direct attention, and help with transitions. Bringing together all of the individual elements of sound, pictures, transitions, and music called for by the script creates the whole—and the training tape comes to life as a viewing experience that should motivate and teach.

Scriptwriting Tips

- Write with an emphasis on pictures. After all, we are creating a video program not an audio program.
- Use words to support and enhance the visual message.
- Don't get wordy. Let the visuals carry the message.
- Use words that the audience is familiar with. Be prepared, depending on the viewers' familiarity with the content, to define words and provide an additional glossary in printed support materials.

- Use an informal, conversational style. Video is a personal, one-on-one medium. Direct narration to one individual in the audience.
- Use "you" and "we" whenever possible to establish an informal one-on-one experience for the viewer.

For reference, you should know that a double-spaced, typewritten page will equal about one minute of programming, depending upon how much visualization there is. So, if you are counting, you need to type about twenty double-spaced pages for a twenty-minute program.

PAGE FORMAT

A popular page format to use for video scripts is the "split-page format," which breaks the page vertically into two sections or columns. One third of the page, usually on the left side, is devoted to visual information and is labeled "video." The other two-thirds of the page is devoted to the audio portion of the program and is labeled "audio." At the top of the page include the page number, program title, the client, writer, date, project number, and so on. The date at the top of the page will change as the script goes through the approval process.

Type the words the narrator will read in upper and lower case, as if you were typing a business letter. This makes it easier for the narrator to read. All audio cues, however, such as music and sound effects, should be all uppercase to separate it from the narration. The audio column will also be used to identify sound sources such as on- or off-camera talent, music mixes, sources of sound effects, and direction of off-camera audio. The video column contains descriptions of scenes and shots. It will also contain directing cues for transitions, camera moves, graphics and animation, lighting cues, and all essential visual information that will be needed to carry out the video portion of the program.

STORYBOARD

The storyboard is a sequence of simply-drawn pictures that visually represent the program. An important element in the design process, it allows the producer to share visual choices and creative approaches with the client, get a feeling for the pacing and timing of the program, and "edit" the program for visual continuity and clarity of message. It also allows producers to "direct" the program on paper for overall visual and aural effectiveness. For interactive multimedia programs, the storyboard often becomes the "script."

Storyboards also help in determining camera positions, lighting requirements, and talent staging. They serve as visual guides during production for camera moves, lighting, and directing the talent.

Converter Operations #2 Storyboard **Version 1** **10-27-98**

4

The first reaction occurring in the slag blow stage is iron sulfide reacting with oxygen to produce iron oxide and sulfur dioxide.

ANIMATION

5

Iron Oxide is created from iron sulfide...this oxidation also produces heat, enough heat to keep the material in a molten state throughout the process.

6

The reaction also produces sulfur dioxide, referred to as off-gases. The acid plant processes these gases into sulfuric acid which is sold as a by-product.

Cartwright & Associates

Figure 4.2 Storyboard example showing graphics and animation elements used in "Converter Operations" video training programs produced for operators.

The producer, often enlisting the talents of an artist, depicts through simple drawings the script as it will appear visually on the screen, frame by frame. The audio portion of the program will be typed in under each picture. The storyboard will have a picture of each significant visual event that fairly represents the script. These events include video locations, shots, angles, graphics, and transitions. The storyboard visualizes the completed program on paper. For the first time, the clients "see" the visual images that tell the story. Graphics and effects can be presented to be checked for placement, clarity, and effectiveness. Location, props, scenery, and talent placement can all be checked before final decisions are made. Some approaches, such as the "talking head" or interview programs, will not require a storyboard, but more creative programs usually require at the very least a simple storyboard. It is best to communicate visual ideas on paper — paper is cheaper than tape.

One approach we often take during this critical phase of production is to read the script out loud with the client viewing the storyboard. Another approach is to record the script onto audiotape and play the audiotape while the client views the storyboard. This approach will allow the client to "hear" the program as it is intended to be presented to the audience. After all, the audience will never read the script, they will hear the program. Often clients get distracted in reading a script with punctuation, grammar, and insisting that every detail be verbalized, not recognizing the importance of the impact of the visuals. These approaches can help alleviate that problem.

USING COMPUTERS FOR PRODUCTION

The first step in producing training and communications programs, as we have detailed in Chapter 2, "The Training Design Process," should always be a needs analysis. A good needs analysis will accurately describe the problem and the appropriate solution. In other words, a needs analysis will create a statement about the need for the production. In the past, a producer might go into the initial project meeting armed with pad and pen, ask a series of questions about the project, and leave the meeting, often forgetting to cover a few important points.

Today, that important meeting can be better handled through the use of a laptop computer loaded with needs analysis templates for every question you could ever want to ask of any production. Before each meeting you can simply customize the template for that particular project and get all your questions answered. These templates are easy to create using simple word processing programs that allow you to create custom templates. *Microsoft Word for Windows*, for example has several templates already installed, including templates for outlining material, as well as for proposals, reports, and cover sheets. *Script Werx* available through Parnassus Software of La Cañada, CA, as mentioned above, offers

templates for creative treatments, storyboards, and questions for research and on-camera interviews.

Concept Development

The needs analysis defines your clients needs and helps form the objectives and goals, but it is up to you to put all that into a concept that will be successfully received by the audience. There are dozens of story-development software programs on the market that can help you create concepts. These programs are designed primarily for the film industry but can be applied to video programs as well. These programs include story analysis tools that help you define story structure, outlines, characters, plots, and resolutions. Some let you have access to thousands of plots, and others let you compare your plot and outline to those of famous movies. Most are set up to walk you step-by-step through the writing process, including concept development.

There are a few idea-generating programs out that help you unlock your creative juices by taking you through creativity exercises. These programs are great when you are stuck on a particular problem with a concept or script. An example would be *Corkboard, The Idea Processor,* available from The Whole Shebang (205 Seventh Street, Hoboken, NJ 07030, 201-963-5176). Another example of this type of program is *Inspiration*, from Inspiration Software, which is based on the "mindmapping" concept. This program turns the computer screen into a blank slate and lets you enter ideas and concepts. It organizes the ideas, lets you edit, rearrange, and modify your ideas, and provides a graphic link for the ideas you generate.

Script Development

The advantages of using computers to write your treatments and scripts are so numerous it doesn't make sense to do it any other way. With computers you have the advantage of advanced editing capabilities on any written document. You can cut, paste, copy, and move your text; you can check your spelling, grammar, and sentence structure; and you can import pictures, graphs, databases, and other documents—and even include audio and video segments. If you are writing scripts, the advantages become even greater.

The majority of high-end word processing software contains enough customized features to allow you to do basic formatting for split screen and screenplay type scripts. These full-function programs include a spelling check, thesaurus, and style sheets, and are very user-friendly. It is easy to create your own custom script formats with title pages, client and project information, split audio and video pages, and scene-numbering systems. Corrections are easy with the editing capabilities of today's word processing programs, and they are flexible and easy to use.

The obvious problem with this type of software is its limitations in regard to formatting. You can set up a split-screen format, but you can't make it disclose scene or shot numbers, mark revisions and omissions, remember character names, or continue scenes to the next page. Stand-alone scriptwriting software was designed to do one thing, write scripts. Most will handle feature film, sitcom, and stage play formats, while a few will also allow split-screen formats. These programs combine word processing power with formatting intelligence, allowing you to write, format, edit, and print scripts. They are not as flexible to use as the word processing programs (very few can really be customized for your particular need or style). Some of the most popular scriptwriting programs include, *Movie Master, Scriptware, Final Draft, Script Master,* and *ShowScape* by LAKE Compuframes.

Dramatica, a new software program released by Screenplay Systems of Burbank, CA, is designed to aid writers in the process of story creation and analysis. The program will define what elements are present in all well-structured stories, how these elements are related, and how they interact. The software program promises to help writers actually analyze and *write* better scripts.

In between the word processors and the stand-alone scriptwriting software are the script formatters. These programs work with the most popular word processors and give you the formatting tools and capabilities at a fraction of the cost of the full-blown stand-alone scriptwriting software. Adding these programs to your word processor lets you keep the power, flexibility, and all the special features of your word processor software without adding the cost and complexity of single-purpose writing programs. Since they work on the word processor you already know, the learning curve is dramatically shortened. They are very flexible in creating customized formats and are easy to use. One of our favorite scriptwriting programs is *Script Werx,* an enhancement package that makes it easier to both learn and use Microsoft Word 6.0 for writing scripts and script-related documents. It includes templates for several versions of screenplays and two column-format scripts for video (the preferred video training format), plus templates for multimedia, storyboards, creative treatments, and questions for both research and on-camera interviews. Screenplay formats include feature films, corporate and informational videos, live-tape segments, and three-camera TV scripts. *Script Werx* customizes Microsoft Word 6.0 and above into a versatile tool kit for writing film and video scripts. Whether you're writing a screenplay or a corporate video, you won't have to worry about margins, styles, or formatting. *Script Werx* also creates shot lists (all visual descriptions from video scripts), scene lists (scene descriptions from any format), a TelePrompTer file, and a storyboard. In addition to built-in, industry-standard styles, every script template gives you up to three new toolbars, a *Script Werx* menu, and pre-assigned key combinations, making it easy to enter character cues with a single click or key combination, and compile often-used words or phrases that can then be used in your script by pressing a single key combination. *Script Werx* is available for both Windows and Macintosh

Figure 4.3 "The Ruling Glass" by Grayson Mattingly.

and can be purchased and downloaded from the Original Vision Website (*http://www.originalvision.com*).

Like scriptwriting software, there are a number of storyboard formatting software products that are integrated, stand-alone, or add-on programs. Again,

the one you choose to use will depend on your need, budget, and the amount of memory you have. Storyboard programs link to scriptwriting programs. The script and storyboard work together and can be linked together through talent, crew assignments, props, and scenes. You do not need to be an artist to create storyboards. Example storyboard programs such as *StoryBoard Quick* and *Storyboarder* have built-in predrawn characters (through clip art), locations, and props. With the click of the mouse you can move predrawn characters around within a full-color scene, move props, or bring in graphics and photos from other graphics programs. *StoryBoard Quick* also offers you a choice of aspect ratios for television, feature film, or wide-screen formats.

THE VISUALIZATION PROCESS

The visualization process, which is important to the development of linear video programs as well as interactive multimedia, is the key to successful, media-based, training programs. A traditional approach to scriptwriting, as mentioned earlier, is to write words first then come up with pictures to accompany the words. What we end up with are very boring, narrated "slide programs." We must analyze the content we are presenting thoroughly, and plan how to convey it visually to make it meaningful to the viewer. Often, we present inappropriate or quite possibly false information. This occurs when we fail to design good visuals. We must thoroughly analyze the content and create appropriate visuals to convey the message effectively.

The visualization process includes creating an overall visual concept or design, which is the "vehicle" to carry the message to the viewer. This visual design helps create the mood of the program, and establishes standards for graphics, animation, screen, and interface designs, and develops a coherent "look" to the entire program. The visualization process—through storyboards— also helps in the design of lighting and video scenes that work together.

Visualization is the selection, creation, and editing (i.e., modification and sequencing) of images. Visualize the program first, then write words that support the visuals. Think visually! When you are developing the content, images will pop into your head immediately. Record these images on paper or with a still camera, and this will become the beginning of your storyboard. Your program will become visual-based instead of word-based. This takes practice, but develop the ability to "see" the program, using the strength of the images to carry the message.

Good visualization increases program interest and content retention (the majority of us are visual learners). As learners, we like to *see* how a process works rather than being *told* how a process works. Take advantage of the visual process in training for more successful programs.

By establishing and maintaining dominant images, the center of interest is maintained. Consistent, quality images help move the information along and

provide logical flow for the viewer. Standard, universal images communicate clearly to audiences, and color enhances emotional communications. Be concise. When developing visuals and graphics for your training programs, limit visual information to single concepts or single points. Don't clutter the screen with information the learner can't use, and keep the backgrounds simple. Avoid visual distractions; focus the viewer's attention with appropriate visuals and create consistency with visuals. Limit your use of colors; colors should be used to organize and reinforce information, to clarify, highlight, and focus attention. Multiple color combinations can cause confusion. Please refer to Chapter 8, "Training Design and Production Tips," for visual and graphic design considerations.

Keeping in mind that most of us are *visual* learners, the visuals we choose to present to our audiences are very important in reaching our training objectives. Quite often, simple line drawings are more effective than photographs. In addition, the compositional structure of the picture influences understanding. The more orderly the composition, the easier it is to "read." Too many details will cause confusion, and viewers will waste valuable time deciphering what is important. Allow time for the viewer to digest the information presented. The

Figure 4.4 Graphics and animation designed for training reveal interiors of complex equipment.

length of shots and scenes are determined by content and how much time is needed to "read" the visual presentation for understanding. And remember, the viewer often brings prior experience and knowledge to the image; therefore, always consider the amount of information the viewers have regarding your picture. Never assume a visual alone will convey the intended message —*Know your audience!*

John Morley has written an excellent book on scriptwriting called *Scriptwriting for High-Impact Videos* (Wadsworth Publishing, 1992), which has a good chapter on visualization.

Creating effective images for training is an art form not to be taken lightly. Visualization goes far beyond the selection and editing of still images. It involves the selection of color, moving images, lighting, staging, camera composition, and screen direction. Effective visualization combines all visual elements into a powerful, coherent message, capable of communicating successfully with the audience. Working with the numerous aesthetic choices we have in production requires a plan or design. We describe this planning process as *production design:* the pre-planning of visual elements and sounds to enhance the message and reach the communication objective. The more we learn about *production design*, the more successful we will be at reaching our training objectives through technology. Chapter 5, "Production Design," delves deeper into the fascinating art of creating effective visuals and sound for training programs.

Production Design

Whether you are developing videotape-based training programs, training for CD-ROM delivery, or interactive computer-based training for Internet delivery, video provides the dynamic, attention-getting characteristics that you as a trainer want. It is this "dynamic" quality that makes video such a special communications tool. Good training programs that move our audience to action, as well as teach or inform, take full advantage of all the special characteristics of video—light, sound, motion, composition, and continuity. Therefore, the trainer must have a thorough understanding of these elements to use the medium effectively. The training program producer must plan and design these elements into the communication experience to achieve the objectives. Often these elements are referred to as the fundamental *aesthetic* elements, and working with them in developing video for training is referred to as working with the "language of video." We must understand and plan for this special language to communicate effectively with video.

Creating a well-crafted video segment in a training program may appear easy. Quite the contrary. A well-crafted video segment that moves the audience to action or clarifies a training objective takes a thorough understanding of this "language of video" and a well-thought-out plan.

Working with the numerous aesthetic choices available in video production requires a plan or design. We describe this planning process as *production design:* the pre-planning of visual elements and sounds to enhance the message and reach the communication objective. Although it is not our intent here to provide a detailed study of aesthetics—there are volumes already in print on the subject—we would like to review some of the typical aesthetic choices we have as they apply to the training program design process. For more details in planning for each video element, refer to Chapter 6, "Pre-Production Considerations," in *Pre-Production Planning for Video, Film, and Multimedia* (author Steve R. Cartwright).

In the design and production of video training segments, the actual recording of the tape often receives the least amount of planning. We think of video as lights, camera, action! Much energy is put into the action part, but perhaps not

enough energy is placed on planning it. Much emphasis is placed on turning on the camera and recording pictures that we hope will tell the story. But as we turn that camera on, have we actually thought through what we are trying to do with that picture? The script leads us down the path of the story line, but what about the actual pictures that we are creating? Are the camera angles, talent movement, lighting, sound, and graphics that we are recording actually effective? Are they adding to or detracting from the message?

Video is a visual medium. We consciously or unconsciously stress the picture. But video really is a combination of production values that all come together to form the program. These elements are light, sound, composition, camera angles, movement, music, pace, special effects, graphics, color, and talent. All of these affect the message. The trainer tries to capture them all on tape to create a successful training program. But for what purpose? Why are all these elements coming together? Are they coming together for the sake of creating video, or are they all being orchestrated to deliver a message? This is where production design comes in. The information presented here applies equally well to videotape-based programs, video segments for CD-ROM production, and video for Internet delivery.

The *Focal Encyclopedia of Electronic Media* on CD-ROM is an excellent reference that explains the various technologies and methods. Containing 4,000 entries, the CD offers definitions, illustrations, professional articles, and audio and video clips to define technologies and applications.

LIGHTING

Lighting for video is used primarily to illuminate the subject so that the camera can "see" it. The video director uses light to create images that the camera will record. Light is an aesthetic element as well because it helps in composition, creating shadow, color, texture, and form. Lighting can also be used to create a mood, a psychological state that would not naturally be present.

The television screen is a flat, two-dimensional medium made up of only height and width. Lighting—along with staging, color, and sound—can create the illusion of depth. Lighting creates this illusion by separating the subject from the background, and by giving an impression of roundness and texture. As with the other aesthetic elements, it is important to control lighting so that it does not interfere with the intended message and cause confusion to the viewer. If the scene is lit "flat" with no highlights, shadows, or contrast, the viewer will have a difficult time discerning what to look at in the scene, what is or is not important in the picture. Good lighting focuses the viewer's attention, brings out picture detail, and creates a realistic picture.

Lighting the video program requires much advanced planning so the intended lighting objective can be accomplished with the least amount of effort

and expense. The video producer/director decides in advance the "look" of the program and plans the power and lighting equipment to accomplish that look.

Video vendors take pride in their equipment and frequently make the point that video cameras will make good pictures with practically no light. Yet it doesn't take long before the dedicated amateur looks at the footage shot with his new "low light" camera and says, "I want better looking video." The only way to improve the look of such footage is through better lighting techniques. A more costly camera is not the answer.

Two excellent references on lighting for video is Ross Lowell's book *Matters of Light and Depth,* published by Broad Street Books, 1992, and Tom LeTourneau's book *Lighting Techniques for Video Production: The Art of Casting Shadows,* 1987, available through Focal Press. The following definitions provide a basic vocabulary to help you learn about basic lighting techniques covered in this chapter.

Light refers to that portion of the electromagnetic spectrum that makes things visible. It does not refer to a device that projects light. *Instrument* is the term for a lighting fixture. A *spot* is a type of instrument, not a type of light.

Lamp is the term for the source of light inside an instrument. Usually people refer to such sources as light bulbs. (Bulbs produce tulips and other plants.) The term lamp can also refer to a type of lighting instrument such as a table lamp or a floor lamp.

There are several different types of lighting instruments used to create the desired video lighting effect. They fall into three main categories. One category refers to instrument *design* or *type,* such as spot, flood, and so forth. The second category deals with instrument *function,* or what particular job the instrument performs in any given lighting setup. The third category refers to light *output,* dealing with the quantity and quality of light produced.

There are three basic types of lighting instruments that make up 3-point lighting. The first and most widely used is the *spotlight* or *focusing spot.* It is designed to concentrate light into a relatively small area. Spotlights are designed as open-face units, without a lens in front of the lamp, or as Fresnel (pronounced fir NEL) units with a lens. Because of their lighter weight, lower cost, and smaller size, open-face spots are used more frequently for location lighting than lensed instruments. Light from these units is specular in nature, meaning highly effective.

The second basic type of instrument is the *floodlight* or *broad.* These instruments are open face and designed to provide an even coverage of light over a relatively large area. They can also produce specular reflective light or diffused light depending on their design.

The third basic type is the *softlight,* designed to produce very diffuse light. This is accomplished by placing the lamp in a large fixture that bounces the light from the lamp onto a textured white or silvered surface that, in turn, redirects it toward the subject. Unlike spots or floods, the light from a softlight is never projected directly toward the subject. This results in nearly shadowless light.

Backlight

Talent

Fill Light

Key Light

Camera

3 Point Lighting

Figure 5.1 Three-Point Lighting diagram
shows backlight, key light, and fill.

At the top of Figure 5.1 is the *backlight*. This instrument serves to separate the subject from the background and create a third dimension to the normally two-dimensional television picture. It should only be bright enough to create a slight glow of light around the head and shoulders of the subject. Subjects with dark hair and clothing require more backlight than subjects with light hair and clothing.

The backlight should be placed directly behind the subject, in line with the camera. As a result, it cannot be mounted on a regular stand, since the stand would appear to grow out of the subject's head. Mount it on a boom with its base off to the side of the subject, out of the shot, or mount it on the wall or ceiling with one of the special mounting devices available for this purpose.

The most important instrument is the *key* light. It should be placed on the right or left side of the subject, depending on the location of the main light source in the room. If there is no obvious light source in the room, place the key on whatever side of the subject results in the most pleasing look. It should be positioned carefully above and to the side of your subject. The idea is to position the light so it casts the small shadow of the nose near the smile line of the subject's face and have the shadow fall about midway between the nose and the upper lip, creating the most attractive lighting for the face.

Place your subject far enough away from the background so the shadow created by the key will fall on the floor, or outside the area of the background included in your shot. If such separation is not possible, position the key so the subject's shadow is connected to him in the shot. If there is a space between the subject and his shadow, each time he moves, the viewer's eye will be drawn away from him to his shadow. When the shadow and the subject are one mass, attention stays with the subject.

Once the key is in position, the *fill* should be placed. It could be a softlight or well-diffused specular source. It should be placed on the side opposite the key. Generally, it should strike the subject from a lower angle then the key and be placed closer to the center line of the subject than the key. It should provide just enough diffused light to reduce the density of the shadow created by the key. It will also fill in some of the darker areas on the unlit side of the subject and prevent a sunken look in the eye sockets.

A low-intensity fill creates a more dramatic or *low-key* look. Higher intensity fill results in a less dramatic *high-key* look. Under no circumstances should the fill be of equal intensity with the key and create shadows of its own.

In more involved setups a fourth and fifth instrument function is added to the setup. One additional function is *background* light. Background instruments illuminate areas or objects in the *background* of a shot to give them special emphasis or bring out detail. They could also be used to add color to an otherwise blah surface. Background lights should not be confused with backlights.

The final function is that of the *effects* light, which projects a pattern of light on the background and/or the subject to create the illusion of an offstage effect such as a fire, or reinforce some visual element of the scene such as a window. The most common effect projected replicates slats of light, like those seen when sun shines through venetian blinds. There is a tendency to project such patterns on set walls only, but placing effects light in front of the talent and allowing the projected pattern to strike the talent as well as the set will greatly enhance the realistic look and interest of your set.

SOUND

Sound is another aesthetic element that is used to shape and enhance the message. Sound can become a confusing, distracting, disorienting element in the program. It must be tightly controlled to add realism, depth, and interest to the program, as well as credibility and emphasis. Good sound recording techniques should separate the voice of the main speaker from the natural background noise, add mood or emotion to the message, and add to the overall rhythm and pace of the program. Sound and music also add movement to the program and smooth transitions. Often overlooked in the excitement of video production, audio contributes significantly to the overall program objectives. As with lighting for video, the process of

Figure 5.2 Video production crew captures sound with shotgun microphone mounted on a "fish-pole."

recording good sound should be planned in advance, and most of the sound elements that are captured in the program should be designed in.

Good sound recording relies heavily on controlling the environment in which you are shooting; therefore, location scouting to check recording conditions, as well as recording equipment and microphone selection, must take place well in advance of the actual production. Control of the ambiance (natural room sounds) and dialogue is a critical production responsibility, and the selection of appropriate, believable sound effects can make or break a program. Music selection, often left until the last moment during the edit, can significantly add to the mood and credibility of the program—or it can be an added distraction.

Preparing for the audio side of video is an important step in the planning process. Sound design becomes the art of planning, recording, and mixing all sound elements so that they blend naturally and complement your visual message.

Music

Music adds emotion, movement, and mood to a video program and helps with transitions. Music is usually obtained from music libraries that you can own or from music studios that rent their libraries out. Video facilities that provide editing often provide music libraries as well. Good music libraries will provide you with samples of the type of music they have, will assist you in setting up your library, and will

work closely with you in making music selections. Good libraries provide extensive catalogs and have computer searches of their music. Network Music (800-854-2075; call them for a free CD sample) is a professional leader in the music library business. They have an excellent music library with extensive sound effects and special effects libraries as well. Their music has a creative, contemporary sound, and they are always adding new sounds in production music, classical music, and sound effects. A full list of music libraries can be found in Chapter 9, "Resources."

In reviewing the script for sound reinforcement and music, consider adding music at the beginning of the program to set the mood and at the end to help bring the program to a conclusion. Look at where sound could reinforce and draw attention to what the narrator is saying and where sound effects could add realism to the scene. But don't over do it. Music can distract the viewer and get in the way of the pictures and narration. I've seen many good video programs ruined because the producer felt that music was needed throughout the program. This is usually the sign of an amateur production.

Music helps with transitions and changes in the script. It also helps create movement on the screen, adds the element of excitement to a picture, and helps with camera movement such as tracking. But like special effects, it can be overused and interfere with the message. Stopping the music behind the voice draws attention to the voice, and adding sound effects or ambiance adds credibility to a scene. When people see pictures of a car moving on the scene, they expect to hear the car. Sound adds realism to your pictures and creates a presence in the scene for the viewer.

CAMERA ANGLES AND COMPOSITION

Screen composition, camera angles, and depth of field are all aesthetic elements that require advanced planning. Each element affects the way in which the message is received by the viewer.

Camera angles and composition are usually described as the arrangement of pictorial elements within the scene. We place and move objects and talent within a scene to create the most impact for the message and viewer. You choose what to "show" the viewer with composition and angles; by placing objects and subjects at key locations within a scene or frame, we can emphasize or de-emphasize them. By moving our talent toward the camera (movement attracts the eye) and increasing the size of the image, we draw attention to the subject. Likewise, if the talent moves away from the camera, the viewer loses interest. Again, control is the key. By controlling placement and movement, we control the message we are presenting to the viewer. And the key to control is planning. We *plan and design* the scene and everything within it.

By designing and planning each scene, we remove the element of distraction. Are backgrounds, such as trees, wallpaper, pictures, telephone poles, or windows, interfering with the foreground subject? Are backgrounds too busy so

that they make viewers hunt for the important subject? There should be one center of interest within a scene. The scene should be designed so that all elements within the scene support that center of interest. The idea is to control the viewer's eye through composition. The intended message, subject, or center of interest should clearly stand out, and the viewer should not have to wade through distracting, unimportant clutter on the scene.

Composition has a language of its own with lines, forms, masses, and movements all contributing to factors that affect the message. Rules and conventions, mostly from painting and still photography, have developed audience expectations. The training program producer should fully understand the impact these conventions have on his project so that he can properly plan for them shot by shot.

Composition also applies to graphics creation. We have devoted a complete section on planning for graphics later in this chapter.

Camera angles can also add to the message or distract from it. The camera angle determines the viewpoint and the area covered in the shot. You must decide what viewpoint will best depict your message and how much area of the scene the viewer must see to understand what is going on. It is not just a matter of selecting a close-up medium shot or wide shot, you have to select the angle of view as well. The angle you select will determine how the audience will view the action.

Camera angles are carefully planned frame by frame. Angles are usually depicted in the storyboard, where each shot and scene are carefully drawn out to assure that the best possible picture is created. This advance planning allows for experimentation on paper to test the best idea for a shot and the best composition, saving valuable time in production. Shot composition is thought through in advance so that during production we can concentrate on performance.

Carefully compose the shot, selecting point of view, angle, and depth of field. Especially when working with talent, the angle a director chooses can distract viewers or interrupt the message flow. A camera angle slightly above eye level, which causes the talent to look up, can imply inferiority to the viewer. Likewise, an angle below the talent eye level can imply a dominant posture to the audience. Camera angles must be carefully planned and chosen to portray the subject best under positive light and create the best viewing angle for the scene to be interpreted by the viewer.

There are two accepted points of view: *objective* and *subjective*. The *objective* camera angle positions the audience as observers only. The audience doesn't see the action from within the scene or through anyone in the scene. It is as if the viewers are sitting in a theater audience, observing the play that unfolds in front of them. The *subjective* camera angle, on the other hand, actually takes the viewers inside the scene and lets them participate in and experience the action. An objective camera angle would observe a roller coaster ride from the ground. A subjective angle would actually take the viewer for a ride and the camera would become the "eyes" of the rider! Let your instincts work for you in providing the viewer with the best angle that makes your message clear.

Figure 5.3 Storyboards are often used to select camera angles and communicate camera positions with crew.

COLOR

Colors evoke response and feeling. As you are shooting in video, you should become sensitive to what colors add to your message. Reds, oranges, and yellows appear to be closer to the viewer and have a stimulating effect. Blues and greens appear to be distant and have a calming effect. Colors can be combined to create depth and contrast within the picture. However, if colors are too bright, they can draw attention to themselves and distract from your picture. Too many colors in a scene can also distract the viewer and become too busy. This is especially true of backgrounds. When you are shooting people talking on camera or are shooting objects, it is best to keep the background simple. If possible, choose a background that is a nice contrast to your subject. For instance, blue and gray backgrounds are nice complements to all skin colors.

You will have to experiment shooting different colors with your camera. Different cameras react differently to colors. Some cameras will have problems recording bright reds or blues, and others will not record the true color of objects. Also remember, as mentioned in the lighting section, that objects will pick up the colors that surround them. If you are shooting objects in a room where the walls

are painted orange, the objects may take on an orange appearance. This will be true for reflecting light as well.

MOTION

Video is often selected to communicate a message to an audience if the message requires motion. When deciding if video is appropriate for a particular message, I look at two requirements: is the message visual in nature and does it require motion? Unsuccessful programs often lack these two basic requirements.

The aesthetic element of motion adds a great deal of complexity to the medium of video. It is one thing to create an aesthetically pleasing still picture and quite another to create an aesthetically pleasing *moving* picture. Video should be a continuous, logical flow of visual images. It shouldn't be a collection of individual still images. Moving images combined with sound become a coherent message. By combining a series of shots, scenes, and sequences, video becomes a controlled rhythm of moving images that create a whole message.

All the factors that affect movement—the movement of the subject; the camera movement through pans, tilts, dollies, or zooms; and the movement of the story through editing—must be well-planned in advance, because they all help clarify, reinforce, and carry the message to the viewer. Through individual shot and scene planning with storyboards, through blocking and talent direction from the director, and through pacing and rhythm established by the editor, motion is controlled and presented in a manner in which the viewers interpret the movement in their overall understanding of the message.

The pre-planning process through storyboards involves planning for movement on the screen. By camera placement relative to the subject, we can control screen direction. Planned camera moves and subject moves help in the editing process. One of the objectives in the editing process is to create a smooth, transparent message, a logical development of shots and scenes. To create a logical flow of movement so as not to confuse the viewer, movement within a scene should be consistent.

If we were shooting a scene in which we had a wide shot of our talent getting up from a chair and walking toward a flip chart to write something, the flow of movement or action in this case could be from the left of the screen to the right of the screen.

If we were to plan to cut from the wide shot to a medium shot of the talent approach the flip chart, the action would have to continue from left to right within our medium shot in order to make a good edit and have consistency of motion. This is a very simple example; these decisions become more complex as the talent "moves around" within shots and scenes. Screen direction should be consistent and well-thought-out before you start shooting so that you have the appropriate direction of movements for the editing process. Learn to see and plan for motion in terms of its direction on the screen.

DEPTH OF FIELD

Depth of field is created by the relationship of the subject to the lens. If you shoot several objects that are different distances from the camera, some of these objects will be in focus and others will be out of focus. The area where the objects are in focus is considered the "depth of field." Different lenses will have different depth of field capabilities. Light will also affect depth of field. If there is not much light on a subject and the lens has to be opened to a wide aperture, this will decrease the depth of field and "flatten" the picture out. Likewise, if the aperture setting is small, the depth of field will be increased. Depth of field is a creative tool for the camera operator because it can be used to focus attention and create the illusion of depth on the screen.

CONTINUITY AND SEQUENCE

While editing a program, continuity of shots, lighting, sound, and motion come to life. Through editing we start to understand the importance of continuity and planning for continuity. Angle changes, cuts, motion of the talent and camera, lighting and sound between scenes, should all be transparent to the viewer. They should not notice the techniques you use to move the story along. A cut from a wide shot to a medium shot should be motivated by the subject and therefore not noticed by the viewer. Good continuity will create uninterrupted action; there will be no jarring jump cuts and changes in lighting intensity or sound levels between shots.

Good continuity comes from good planning. The storyboard helps you think through angles that will cut well together, that will match well the action at the beginning and end of each shot, and that will provide correct screen direction, eliminating jump cuts caused by missing or mismatched action between shots. Video is a continuous sequence of moving events; think in terms of sequences of shots and scenes, not individual shots. Continuity ties the shots together into sequences that flow well together. Always plan the shots to work together, creating a continuous sequence of movement. Planning allows you to "pre-shoot" the sequences on paper, relieving you of the task of trying to match action while you are actually shooting. Know where you are going with the shots at all times, where the edit points are, and how the shots will edit together.

Be aware that it is easy to misuse video and cause confusion. *You must understand the power of video and its overall impact on the message and the audience.* You must use special effects, graphics, and sound so that they work for you and not against you. Through good production design, we plan video to enhance the message and create a clearer understanding for our audience.

Don't get carried away with the fancy special effects video offers. Use them only when they are appropriate for the message. Don't throw in effects because

they appear to make the program more professional or because you feel obligated to use your expensive special effects switcher. Think through the program objectives and plan special effects that will help you achieve these objectives. How can split screens, freeze frames, slow motion, or dissolves contribute to the message? Planning creates effects that belong in the program and do not appear "tacked on" or used for "dazzle."

The dynamics of motion affect pace, rhythm, and continuity of a program, as the following discussions show.

Pace

The *pace of a program* is created by how long the scenes or shots remain on the screen. If a shot remains on the screen for a long time, it tends to slow the program down. This length is, however, also affected by the length of the shot in front of and behind it. If there are a series of shots that are short in length, the program appears to move faster. The dialogue, acting, and motion within the shot also add to the pace or feel of the program. We pre-plan the pace of a program by expanding or shortening the shots.

Rhythm

The *rhythm* of a program is determined by the overall pace or speed of the program. All programs or sequences within programs contain a certain rhythm that we consciously created based on the context of the message and the rate at which the action within the frame occurs. While we create the rhythm of the program in the editing process, however, the way we shoot a scene can affect the rhythm, so we have to plan for this rhythm in our shooting.

Continuity

If the *continuity* is wrong, if the shots don't follow a logical sequence—other than for shock value—they become confusing to the viewer. Poor continuity causes jarring jump cuts and wrong screen direction.

Therefore, we plan an establishing wide shot, followed by a medium shot, followed by a close-up—the logical flow of shots that the viewer expects. The wide shot creates a "point of view and an establishing location" for the viewer; often the physical surroundings in the wide shot are as important as the talent within the scene. The medium shot focuses attention to the subject (talent) and eliminates the unnecessary pictorial information that appeared in the wide shot. The close-up emphasizes a particular point the subject is making. Don't overuse the close-up; like the zoom, it can be overused and thus lose its impact. Think of the close-up as an exclamation point! Save it for those occasions that are important for the viewer for understanding a phrase or procedure.

GRAPHIC DESIGN

Graphics can help visualize the abstract, illustrate the invisible, and demonstrate the complex. Graphics can create a visual style for a program that will differentiate it from all others. The color scheme, typeface, logo design, and other graphic elements provide additional information through their visual approach, whether it be informality, humor, sophistication, boldness, or subtlety. The training producer, graphic designer, and multimedia developer must decide which visual approach will provide the most appropriate subject matter for the audience.

Mark McGahan, a computer graphics designer and multimedia developer, heads Design Interactive in Dallas. McGahan lectures on graphics design at numerous conferences across the country. His lectures provided the basis for the following section.

Fundamentals of Graphic Design

Before we can discuss planning for graphics, it would help to have a brief exposure to basic graphic design. Further study of design will assist you in understanding the basics of good graphics design, which will help in the planning and creation of graphics for video. Your best resource is your TV set: watch television with the sound off and to try to analyze what you are watching.

The graphics used in video are limited by the video medium in areas such as contrast ratio (video has low contrast ratio), coloration predominance, and screen resolution (video has low resolution). The video producer should be aware of these specific limitations in order to plan effective graphics for video and multimedia production.

All visual information and visual style are created through the use of the seven basic elements of graphic design — point, line, polygon (regular and irregular), shade, color, texture, and typography. These elements are arranged in a 3:4 format on the screen, three units high, four units wide, referred to as aspect ratio. Static graphics, depending on their arrangement, can relate a sense of regularity or randomness, direction, motion, and speed. All objects exist only in relation to the space around them.

Lines are the simplest directional graphic element. Characteristics of lines include length, width, and whether they are straight, curved, flowing, or broken. Lines can indicate moods such as relaxation, excitement, stability, and can create the illusion of depth.

Other elements of graphics include *shape, circles,* and *ellipses*. These elements can convey a feeling of closure, wholeness, and completion. The triangle represents the most stable form in nature, and the circle the most complete. Multiple polygons can simulate a third-dimensional view on a two-dimensional screen.

Shading implies the existence of a light source, and it illuminates a graphic with directional light. Along with converging lines, overlapping shapes, relative size, and perspective, shading adds the illusion of fullness, depth, and a third dimension to a flat, two-dimensional element. Three dimensions are more interesting and visually informative than two.

Color in graphics brings highly subjective information to the viewer, and since no two people interpret color in exactly the same way, graphic designers should be sensitive to the mood or frame of mind they are creating with the colors they choose.

Patterns and textures applied to shape are used to impart surface characteristics that reveal more visual information than can flat or shaded color alone.

Typography can broadly be divided into serif and sanserif. Generally, sanserif type such as Helvetica, imparts a factual, impersonal message. Serif type, such as Times, can convey a wide range of feelings due to its varying design factors, such as contrasts in line thickness, heights and widths of letters, and shape of the serifs (or "little feet").

Symbols are groups of graphic elements that together convey more information than the individual elements do separately. Symbols can also contain a metaphorical aspect that text alone can not convey. They represent a powerful, direct form of communication.

Types of Graphics

Two-Dimensional Static Graphics

This type of graphic includes textural data, data-driven and diagrammatic information such as bar charts, maps, diagrams, line graphs, and organizational charts, as well as graphic illustration.

Three-Dimensional Graphics

Personal computers have made three-dimensional graphic design more accessible to the video producer. The computer software creates a "real" object that exists in the computer. It can be lit by different types of lights. Three-dimensional solid modeling computers use different types of rendering methods, and once an object is in a 3-D graphics computer, it can be resized, rotated, and lit as well as viewed whenever desired.

Animated Graphic Sequences

Animated segments can be created by sequencing individual graphic frames. Graphics animated through time can show process-oriented subjects. A moving object, even if it is small and moving quickly, commands more visual importance than any larger stationary object. Because video functions through time, your audience expects each frame on the screen to contain some movement.

Figure 5.4 Graphics will appear much differently when viewed on the computer screen as compared to viewing the same graphics on the TV screen.

Three-Dimensional Animation

Generating successful three dimensional animation is a highly complex process requiring the careful integration of a number of procedures, such as the careful integration of line, color, composition, and movement. The artist then defines key frames, where the objects are placed in critical positions. Often they will use wire-frame or low-resolution models to determine the start, pivot, and end points of each major animation movement. Next the surface rendering or skin is placed on the wire-frame. The next step, called "tweening," is to produce all of the steps in between the key frames.

As an example, *3D Studio MAX*, available from Kinetix, is a powerful three-dimensional animation suite that combines many different modeling and scene composition techniques for the creation of 3-D computer graphics and animations.

Graphics Style

Planning for graphics begins with communicating to the artist the artistic style of the graphics you are looking for in your program. An initial consultation with

Figure 5.5 2-D graphics produced for CD-ROM training delivery developed on *Illustrator* and *Photoshop*, available through Adobe.

the computer graphics artist in which you show examples of the graphics style you are looking for will help in the planning and production of the graphic elements. Bring examples of type styles, art layouts, colors, and textures that you like and that you feel will contribute and enhance your message. Examples can be brought from print ads or other video and CD-ROM programs. With this style reference, the artist can begin to start forming a specific "graphic look" for your program.

The artist will be concerned with what part the graphic elements or segments will play in the overall program. What do the graphics need to do or what concepts do they have to show? What type of audience are you addressing? Are there just a few charts, or are graphics an integral part of the overall "look" of the program? Will opening graphic sequences set the "tone" of the program for further graphics, lighting, and packaging? Will workbooks or printed support materials be needed, and will the programs graphic theme carry through to the

Figure 5.6 3-D graphic for animation designed for *Quicktime* VR delivery on CD-ROM.

printed page? What has been budgeted for graphics, and does this include creation of printed support materials, packaging, and printing?

The artist will need a clean list of graphics that are to be generated with correct spelling and suggested ideas for layouts. A graphics production schedule will be worked out, a budget set, and review dates for each phase of the production process will be scheduled. Try to negotiate a fixed rate, not hourly, if you are using outside graphic services.

Determine early the type of graphics to be created. Will there be specific typefaces needed? How many elements are there in total? Are there 2-D graphics needed, or 3-D graphics and animation? If there are logos involved, color examples should be supplied for reference, and camera-ready art work of the logos is usually needed to create the computer-generated logo for video. Be sure to check with the legal department about the proper use of the logo (often companies have very strict rules about using logos, such as size, certain color backgrounds, etc.). Try to communicate as much as possible early on with the artist or graphics production house.

For 3-D animation develop a schedule with milestones for review, revisions, and approvals. The animation production sequence usually follows the development of a storyboard for the design, the modeling of the elements, a motion test (that may be wire frames or low-resolution), and color tests with full resolution of key frames of the animation for review and full animation. If 3-D

ANIMATE #2

Figure 5.7 Example page from storyboard used to communicate with artist for developing animation sequence.

animations are to start and/or end static, make sure that "holds" (or freeze frames) are put into animation, extending the in and out points sufficient for editing. Often animators only render a few frames at the beginning and end of the animation and this is insufficient for editing.

If your graphics and animations are produced at a different place than where you are editing, make sure that the tape formats used and the time code (there are several time code formats) is compatible with the post-production house. That is, the producer should make sure that the graphic artist is recording graphics to the same time code format as the post-production facility is using for editing. Be sure to make frequent reviews of the graphics being created—daily checks, if possible. Don't let the designer work for long periods unsupervised without your input, or you may not get what you expect. And be sure to check your graphics on a composite video monitor, not on an RGB (Red, Green, and Blue) computer monitor, as they are being created. RGB monitors will always look better. The graphics may fall apart on video. Also evaluate graphics that are to be keyed over video in the edit. Check for color compatibility, readability, and the quality of the key.

Figure 5.8 2-D video graphics are used in training programs to simplify complicated processes. Arrows and words on the screen help highlight teaching points.

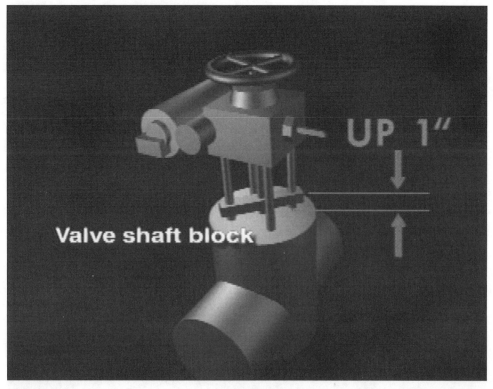

Figure 5.9 Graphics help to create a consistent "look" for video and CD-ROM training programs and printed support materials.

After the final edit be sure to make clear agreements about the disposal of graphic elements and files. Are the data files to be archived? Are tapes to be held with masters? Do you retain possession of this material, or are these the property of the design house?

Graphic Tips

- Always apply the *KISS* principle—Keep It Simple Stupid!—add clarity not confusion.
- Each screen should be self-contained, with a balance between content, space, and complete idea. Only use key words.
- Use progressive disclosure; control what information the viewer sees.
- Ragged right lines are easier to read than right justified. Avoid hyphenated words
- Organize along the eye-movement path—top to bottom, left to right. Avoid placing new information on the lower left side.

- Text display techniques such as labeling, highlighting, and illustrations assist students in (a) the task of focusing on important points, and (b) selectively processing the text.
- Lists do not work well in linear video. If you must list items, do not go beyond three or four items.
- Graphics illustrations are useful to maintain viewer interest, but more importantly should be utilized for retention, acting as memory cues or to summarize information.
- Do not have the narrator read the graphics word for word.
- Keep illustrations as realistic as possible — they must be recognizable without supportive text. Eliminate unessential details. Critical attributes can be highlighted with arrows and color
- Assist the viewer with content organization by visually structuring the graphics with consistent headings, subheadings, and colors.
- Text presented in all CAPS tend to be less legible and give the screen a very solid appearance.
- Color can be used to distinguish between different kinds of information, highlighting and offering contrast, but keep this use to a minimum.
- Provide a consistent "look" with graphics for video and printed support material.

WORKING WITH TALENT

In most training programs produced by organizations, nonprofessional talent is used to demonstrate products or processes or to explain new techniques. Quite often training programs contain both nonprofessional talent to demonstrate a skill or new product and professional talent to record the narration. This is because familiarity with both the product and process is important for the visual demonstration whereas a pleasant and authoritative voice is important in reading the script. But you will soon find that working with nonprofessional talent can be very difficult. The time it takes to work with in-house staff to demonstrate a product on camera or to deliver a few lines can often be reduced by using a professional who is used to the television production process, can learn quickly, and can be depended on to deliver lines believably. The justification for using outside talent should be looked at seriously and not just thrown out as an unwanted expense or frill.

Nonprofessional Talent

When working with nonprofessional talent, consider the following issues.

Credibility

Does the talent you selected have credibility with the target audience? A person who knows a great deal about the new product may nevertheless have zero credibility with the audience. This is guaranteed to slow down the learning process and will influence the reception by the audience.

Is the person delivering the message as important as the message itself? Quite often a person selected will enhance the program a great deal just by his or her appearance on tape.

Good Communication

Patience and *good communications* are keys to working with nonprofessional talent. Corporate staff appearing in front of the camera are out of their element. Patience with their nervousness and lack of familiarity with the video production process will create a better working relationship. Your job is to make them look their best on tape. Good communication with them and the crew is important in accomplishing this goal.

Appearance

Nonprofessional talent may not realize how much their appearance may influence their message. It is important to coach first-time talent on what to wear for the production. Conservatism in dress is a good general rule. Plaids, thin strips, and herringbone fabrics can cause moiré patterns on video. Solid-colored sport jackets and suits worn with plain, contrasting shirts and ties are smart choices. Avoid white shirts or blouses: they may cause lighting problems. Too much contrast can "wash out" the face. Women should be careful not to wear too much jewelry as this may cause reflections. Flowered, "busy" dresses or blouses can direct viewers' attention to the dress rather than to the person.

Direction

First-time talent needs more direction than does professional talent, especially about how to look natural. Have them look directly into the camera when delivering the information. Nonprofessionals have a tendency to look off-camera at someone in the room. They feel more comfortable talking to a real person than to a camera lens. This off-camera eye movement can look like insincerity. We often place someone next to the camera so that the talent has someone to talk to. Eye contact with the audience may not be best this way, but the more relaxed delivery may make up for that. If an interviewer is involved, be sure to have the talent respond to the interviewer and, where appropriate, make main points to the camera. Directing information to the camera keeps the audience involved. Also, be sure to inform the first-time talent that movements should be slow and deliberate. Sudden moves can be exaggerated by the camera. Quick moves can prevent the camera from following the action properly. Crossing legs, fixing eye

Figure 5.10 Suzanne Mattingly of Mattingly Productions applies last minute touch-up of makeup for talent.

glasses, or adjusting in the chair can appear to be nervous gestures. Have the talent find a comfortable position in the chair before the tape rolls. If they must shift, fidget, or adjust, encourage them to do so between takes. A relaxed, natural appearance is what you are after. Informative communications with the talent will help create this illusion.

Professional Talent

The opportunity to work with professional talent is a rewarding experience. Professionals are usually easy to work with and do not bring with them the politics of the organization, or chain of command, and inflated egos that often accompany executives who appear before the camera. Professionals usually become immersed in the production, not having other office responsibilities to worry about. They understand how important the program is to you and devote enough time to create the desired result. They do not guarantee that they will always get the lines right the first time, but they do guarantee consistency and compliance with the director's instructions. Professionals are aware of the details of production and how long it usually takes to get the

scene right. They usually are understanding when it comes to the rigors of production.

The decision to use professional talent quite often is a budget decision. But before you make the decision, think through the situation thoroughly. Professional talent can save a great deal of time during production because they learn fast and can deliver lines believably without too much extra rehearsal time. They are able to look and move naturally, and often the entire production becomes more efficient. The time saved during production can often make up for the extra fees of professionals. The same goes for narration; professionals can read a script so it does not sound stiff, and they can add emphasis and excitement through trained voice inflections. Talent like this can add to the message, allow for correct and unbiased interpretation, and enhance the program. This enhancement alone often justifies the cost.

DESIGN RESPONSIBILITY

The medium of video appears to be a deceptively simple communication tool. In reality, it is a very sophisticated medium that offers sound, motion, and color to

Figure 5.11 Video crew readies camera for next scene during shoot for retail sales training program. Small camera dolly adds movement to shot.

enhance the training experience. The trainer has to be aware of each element and its influence on the message.

The trainer should have the entire program envisioned in his or her head. Each sound and image that is important and that could alter the message must be thought through. In order to make its most significant contribution, each visual event, each color or motion that could affect the message, must be understood in advance, planned, and executed.

The trainer or video director has to control all of the dimensions of sound, light, color, motion, and talent effectively, throughout the program. During the production, the director should know which scenes and shots will be edited together so backgrounds, lighting exposure, audio, colors, and action can be combined during the editing process and result in a flowing program that is easy to follow. The audience should not be jolted by a mismatch of action, exposure, or audio change. An abrupt change of audio, for example, causes confusion and interrupts information flow. Likewise, the audience should not have to hunt for action on the screen, or have to try to find important subjects. Backgrounds, exposures, and colors should blend smoothly from shot to shot so that they do not draw attention to themselves and interrupt the message. Transitions from scene to scene should be smooth, so the transition technique does not draw attention but allows the message to remain strong. All of the ele-

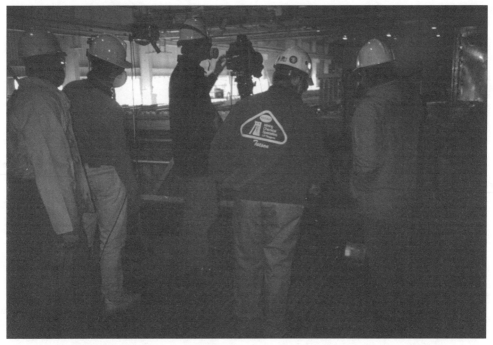

Figure 5.12 Extreme shooting conditions in large copper manufacturing facility challenges crew and talent.

ments come together in a plan that, when executed in production, edits together smoothly.

Designing production is the art of combining all the elements into a message that reaches the audience . . . light, sound, motion, continuity, and composition have a direct effect on how the viewer receives the message. Planning the design of these elements must take place so the intended message is correctly received by the viewer. Our next chapter will provide helpful tips in the selection of authoring programs for multimedia program design and production.

6

Choosing an Authoring System

Are you an expert computer programmer? Do you feel competent enough in C++ or in Visual Basic to program a series of menu screens and to provide the links to audio and video files? Can you program the computer to display a complex animation? Do you have the skills to produce a computer program that will handle a diverse set of questions and trainee responses?

If you can answer with a confident "Yes!" to those questions—Congratulations! You belong to a select group of people who may not need to use an authoring system. However, the chances are that you are an ordinary mortal who does not possess this sophisticated set of skills. Or you may have the skills but want to avoid hundreds of hours of tedious computer programming. In either case, if you want to develop even a reasonably simple interactive training program, you are much better off to spend some time mastering one of the many authoring systems available to help you. This chapter defines authoring systems and examines some of the important factors to consider when selecting an authoring system.

AUTHORING LANGUAGES AND SYSTEMS

Authoring Languages

Dozens of computer programming languages have been developed in the relatively short sixty-year history of computers. *General purpose languages*, such as C++ BASIC, Pascal, APL, and PL1, are character-based general control languages. Trained computer programmers write code in these high-level languages that translate human readable commands into machine-readable commands. Authoring languages fall into a class of *special purpose languages*. These are computer languages that are designed to work best in the development of very specific applications. For example, COBOL is geared toward producing business applications, LISP toward list processing.

In the early days of computer based training (CBT), CBT developers worked first with off-the-shelf languages like FORTRAN or Pascal to laboriously craft CBT programs that would appear crude by today's standards. Researchers soon developed more specialized authoring languages to deal with such issues as the presentation of questions and the evaluation of trainee responses. Examples of early authoring languages are *Coursewriter, Pilot, Planit,* and *Tutor.*

Authoring Systems

Most contemporary CBT developers use authoring systems. An authoring system is an integrated set of computer programs that allows the user (the author) to produce complex interactive training programs and presentations. In general, authoring systems facilitate the integration of graphics, animations, video, and audio into an integrated presentation and allow the end-user—trainees, in most cases—to interact with the program to acquire new skills or information. Often, authoring systems provide ready-made templates or objects. The CBT developer can use a template to quickly insert a preprogrammed function or activity in a program or presentation. The templates may be simple question-and-answer formats, or sophisticated objects that carry preprogrammed code to

Figure 6.1 Asymetrix's *ToolBook Librarian* is a full-featured training management system that allows you to test and track the performance of trainees.

allow the trainee to interact with the training programming in a sophisticated way. *ToolBook*, an authoring suite marketed by the Asymetrix Corporation, offers a wide array of pre-prepared menus and "widgets." A widget is an object that carries a piece of code with it. For example, one useful widget is a set of playback controls that permit the trainee to control the playback of an audio or video clip. As the CBT author, you simply copy the desired widget and place it anywhere in your program. It is then available for immediate use with no additional programming.

The leading full-featured authoring systems are Asymetrix's *ToolBook* and Macromedia's *Authorware*. Most of these systems contain special purpose authoring languages, often referred to as scripting languages, to permit the author to tweak a program or to develop interactions for which no widgets or templates are available. *ToolBook's* scripting language is called OpenScript. The scripting language used in Macromedia's *Director* is called Lingo.

There are several styles or approaches to authoring systems, which we will address later in this chapter. Contemporary, high-end authoring systems are quite versatile, especially as you become comfortable with the imbedded scripting language. Be wary of the low-end systems. You may find that you are limited to very few kinds of presentations and interactions. In general, authoring

Figure 6.2 Asymetrix's *ToolBook Librarian* is designed to keep track of trainee data, whether training is offered by CD-ROM or over the Internet.

Figure 6.3 The latest versions of Asymetrix's *ToolBook* are geared to develop and offer interactive multimedia training via the Internet or local area network.

languages are more flexible than authoring systems, but the latter are more efficient and require less development time. Authoring languages make CBT programming much easier than general purpose languages, and offer more flexibility than authoring systems. Authoring systems eliminate most if not all computer programming, offer a structured environment for development, and produce the same outcome with lower developmental costs.

Products of Authoring Systems

What can you do with an authoring system? Just about whatever you want to do. The following summarizes the most common purposes for which authoring systems are used.

Computer Based Training (CBT)

The original purpose of authoring languages and systems was to produce interactive computer based training. That is still the dominant use, but the versatility of authoring systems has encouraged their use for other kinds of products.

Figure 6.4 Allen Communications offers *Designer's Edge*—a tool to help you with all phases of their version of the instructional design process.

Speaker Support

Many business speakers today use computer presentations instead of the traditional overhead transparencies. Speaker support software packages such as *PowerPoint* are an important subset of authoring systems. All the functions are there to give the speaker support and control of his or her live presentation. Furthermore, the presentation can be distributed on diskette or over the World Wide Web to permit others to view and control the presentation at their leisure.

Kiosks

You've seen them in airports, shoe stores, colleges, corporate offices, and a lot of other places. Authoring systems are used to develop the interface to allow the end user to interact with the information stored in the kiosk computer. Kiosks must be easy for casual walk-in use and must have a very user-friendly interface.

Electronic Publishing

Systems such as *Adobe Acrobat, HyperTies, Abiogenesis Lexicographer,* or *HyperWriter* are used to produce electronic publications and on-line catalogs as well as printed publications. Authoring systems are used to produce most of the CD-ROM titles, offering quick easy access to a vast array of information.

Visual Front End

Some authoring systems have built in "hooks" to allow easy access to other types of programs. A good example is a visual, easy to use interface to a complex database.

Interactive Web-Based Programs

Generally speaking, any interactive CBT program can be ported for delivery over the World Wide Web as well as on CD-ROM. Most contemporary high-end authoring systems have built in functions that permit the author to quickly and easily convert the CBT program for delivery over the Web.

Prototypes

Authoring systems can be used to produce quick prototypes or proof of concept programs. Once the utility of the concept is shown, developers may move the final production to more highly specialized software such as *Guide* from InfoAccess.

Intended Delivery System

As you think about developing a training product, one of your first considerations is a description of the intended audience for the product. Among other things, you will need to know the degree of technology sophistication of the audience and whether or not you will expect them to be passive viewers of information or active participants in an interactive session. You will also need to know where they will receive the training. These points determine how you will deliver your training program and to what audience.

If your audience will be working on their own machines at home, you will have a more limited set of options than if they will be receiving training at a corporate training site. In the latter case, you will be able to use lots of bells and whistles and will need an authoring system to support a wide range of media types and peripherals. Some authoring systems will deliver training only on Windows platforms; others only on Macintosh. If you want to build training materials to run on both platforms, your options are limited to two:

1. Develop the materials in parallel with two different systems.
2. Develop your software on a platform such as Macromedia's *Authorware*.

The second option is a much more practical solution, for then you can develop your training on either platform and offer it to the trainees on either platform.

There are three dominant ways to deliver CBT training today: CD-ROM, local area network, and the World Wide Web. Most high-end authoring systems permit you to develop your training programs for any of these three delivery methods.

CD-ROM

CD-ROM can deliver training programs in one of two ways. One way is an installation disc. The CD is used to install the entire program on to a computer to be used for training. The second way is to run the program off the CD. In the first case, the CD is no longer required after the installation. In the second case,

the CD must always be available when a trainees wishes to interact with the training program. It is usually important for management to know who completed what training, how long it took, and what scores were obtained on tests. A disadvantage of providing training on individual computers is that such data on individual trainees is difficult to collect.

Local Area Network

As more and more companies, large and small, install local area networks (LANs) training is delivered over the LAN. The LAN is sometimes referred to as the Intranet. An Intranet is a LAN that is restricted to a single company site (which may consist of several nearby buildings). The advantage is that any employee with a computer on the network has access to the training. Another advantage is that trainee data is easily collected and maintained at a central site.

World Wide Web

The fastest growing segment of the CBT training market is training via the World Wide Web. Just about any training that can be offered by CD-ROM can also be made available over the Web or on a company's network. Web-based training is available to employees all over the world who have access to the Internet. Some companies have installed linkages between their LANs on sites in different states or countries to form an "Extranet" — essentially a private Internet. In either case, trainee data can be collected easily in the same manner as in the local area network.

Sophistication of Author

As you contemplate embarking on a training project, you need to consider the technology sophistication of the author who will have primary responsibility for using the authoring system. Most high-end systems have a fairly long learning curve. If your needs are simple, stick with a low-end system like *HyperCard* or *SuperCard*. These systems are fairly easy to get started on. If you are already computer literate and comfortable with the use of complex software, you are better off jumping into a more sophisticated program right from the start.

Tasks Required of the Authoring System

An authoring system is a set of integrated special purpose programs that perform a variety of different tasks. One major purpose of an authoring system is to allow the author to bring together a diverse set of resources or assets under an umbrella program. Assets or resources refer to video or audio clips, animations, graphics, or other discrete programs. Although many authoring systems provide some reasonably good tools for such functions as developing graphics or editing

video, typically, other independent programs are used to create graphics, video, audio, and animations. The umbrella program manages these assets, offers the trainee display or playback control, provides the interface between the trainee and the program, manages trainee responses, and keeps track of trainee progress throughout the training course. Thus, essential elements of a good authoring system include the following.

Screen Building and Editing

A good authoring system must be able to help the author manage and display a variety of text, graphics, audio, and video formats, as well as animations. The authoring system facilitates the precise placement of text and graphics on the screen, and the precise timing of graphics, animation, audio, or video events to occur. Some systems are object-oriented, meaning you can move text boxes, graphics, video viewers, and so on quickly and easily around the screen for best placement. The objects can be copied and moved from screen to screen without losing any of the properties associated with them.

Navigation

It is crucial that the trainee be able to move around the training program—from screen to screen or section to section—with a minimum of difficulty and confusion. Good authoring systems help you set up easy-to-use navigation systems to help the trainees navigate the course content. Menus and submenus are necessary, as are easy-to-understand interaction buttons. The latter permit the trainee to move from screen to screen, backwards and forwards, get help from a glossary or on-line help screens, play video or audio clips, jump to a different section, return to main or section menus, and so on. Also, a good authoring system should make the transitions between screens or sections seamless and fast.

Sequencing

As far as sequencing sections and components of a program, most good training programs are organized into manageable "chunks" or sections of content. An authoring system must allow easy movement among sections, usually through a menu structure. However, there will be cases in which trainees should not be permitted to move to a new or different section until they have demonstrated mastery of important prerequisite material. In test sections, most likely you will not want trainees to be able to bounce around the program or glossary to find answers to test questions. Again, navigation between and among program components should be easy and intuitive.

Program/Trainee Interactions

In almost all multimedia-based training programs, you will want the trainees to interact with the program. The authoring system should facilitate a variety of interactions, ranging from simple menu choices and branching, through glossary

or searchable database functions, to sophisticated judging of complex trainee responses to questions or simulations.

Simulations

Another very critical part of contemporary CBT programs are simulations of complex physical or psychological phenomena. Interactive CBT programs that can simulate what a trainee will be expected to do on the job are exciting and effective training tools. A good authoring system should be capable of producing such simulations. We have produced numerous simulations, ranging from simulating the fitting of athletic shoes through the proper steps to take when a fire breaks out in a smelting plant.

Record-Keeping and Management

An authoring system should be capable of keeping and managing information collected from trainees. Test scores are one obvious example, both for demonstrating that a trainee has mastered certain concepts as well as controlling whether or not the trainee should proceed to the next section of the program. Another component of record-keeping is keeping track of how much time each trainee spends with different sections of the program, and providing documentation to management or outside certifying agencies that an employee has indeed completed certain types of training with suitable proficiency. In addition to managing information about individual trainees, an efficient data management system should facilitate aggregating data across trainees for program evaluation. Finally, the authoring system should provide a secure means of identifying the trainee by name and user identification, and for protecting the confidentiality of information about the trainee.

Testing

Authoring systems should provide a means for constructing and administering tests. Most authoring systems will include a series of preprogrammed question/answer templates for testing and evaluation: True/False, multiple choice, matching, and fill-in-the-blank are the most common question types. Also, you should expect to find options for feedback to the trainee. Some will be a simple, "No, please try again." Others will allow for sophisticated program linkages to direct the trainee to review a section pertinent to the test question missed. All systems should provide a means to link the test results to a module that manages information about trainees.

File Management

The main function of an authoring system is to assemble assets—text, graphics, audio, video, animations—into an interactive program. Each of these assets may be available in several different file formats. For example, common graphics formats are .bmp, .jif, .tiff, .jpeg, and .pcx. A good authoring system should be able to

handle a variety of file formats, either by importing them directly into the program or using them in their native formats. No system can handle all the proprietary or standards-based formats, but a good system should be able to accommodate the most common audio, video, graphics, and animation file formats.

Documentation

Finally, a good authoring system will include an excellent documentation package consisting of easy-to-read, well-illustrated instructions on the overall approach to developing products in the system, as well as detailed references to each of the features and commands supported by the system. Most systems also will include an on-line tutorial to help you get started with the software.

Authoring Metaphor

An authoring metaphor or paradigm is the approach the authoring system uses to assemble the components of a CBT program. The metaphor or model is rather like a template or guide to help the author express his or her ideas. Metaphors are based upon familiar tasks or environments like file cards or slide shows.

Word Processor

The most rudimentary approach is the authoring language or scripting approach. The author writes line after line of code, much the same as developing a script using a word processing program. Each line of code or sets of lines specify files to be handled or actions to be taken when the program runs. Unfortunately, the author cannot see what the program will do until it is run. Debugging such a program can be tedious. Typically, only computer programmers skilled in writing complex computer programs follow this approach.

Slide Show

One of the most common approaches used by first-time developers as well as for creating linear presentations is the Slide Show metaphor. *PowerPoint* is probably the most widely used system of this type. The procedure for developing and running a *PowerPoint* presentation is analogous to creating a 35mm slide show. You create individual slides with a built-in text processor and graphics program. Once a series of slide images has been constructed, you can use a simulated light box to sort the slides into the order you want them. PowerPoint will accept clip art images and can play audio and video clips. User interactivity is limited, but the Slide Show metaphor is very popular for developing business presentations.

File Card

Another very popular tool for beginners is the File Card metaphor. The leading systems are *HyperCard* and *SuperCard*. The File Card approach is analogous to creating a set of file cards, each containing text, graphics, animations, video, or

audio clips, and integrated combinations of these media. The File Card metaphor is almost synonymous with hypermedia — the capability of immediately jumping from one card to another in any order to bring up various types of media. Both simple and complex presentations with interactivity can be developed using this type of authoring system.

Book

A slightly more sophisticated authoring approach is the Book and Page metaphor. *ToolBook* by Asymetrix is the leading system of this type. In *ToolBook*, the author creates an on-line book, page by page. The pages are made up by creating a series of objects. The objects can be video and audio clips, graphics, text, and animations. This is an object-oriented approach: Each object is automatically programmed by the authoring system to execute simple or complex functions. The code or instruction set stays with the object, even if the object is moved around the page or copied onto another page of the book. Pages are assembled into chapters and books. Although complex interactive programs can be built quickly and easily, *ToolBook* also provides a scripting language called *OpenScript*. The Page Metaphor is well understood by trainees, so the use of such a program often is more intuitive than other approaches. Indeed, *ToolBook* ranks with Macromedia's *Authorware* and *Director* as the most popular authoring systems.

Time Line

This approach is also known as a Scene and Cast metaphor. The author establishes a scene or stage setting and places cast members or objects on the stage. In a fashion similar to objects in *ToolBook*, the cast members are text, graphics, video clips, or animation events that can be programmed to carry out a specific action. The entire performance by the cast members is orchestrated by the time line; it holds everything together and facilitates the precise timing of events of each of the individual cast members. Multiple scenes can be created, and all of the cast members will faithfully remember their lines as they move from scene to scene. The very popular Macromedia *Director* exemplifies this approach; it is especially good at synchronizing complex multimedia clips, and for producing animations. The scripting language underlying *Director* is called *Lingo*. *Director* is usually the first choice of developers who are more experienced with video production than computer programming.

Icon Flow Chart

Along with *Director* and *ToolBook*, Macromedia's *Authorware* is by far the most often-used CBT authoring system. *Authorware* (and its competitor *IconAuthor*) uses the metaphor of dragging icons from a palette and placing them on a flow-chart. Each of the icons is preprogrammed by the authoring system to carry out certain functions, such as showing a video clip, or setting up an interaction with the trainee. The icons are placed on a flow line, and very complex inter-

active programs can be built relatively quickly. Once a series of icons has been assembled, that entire series can be copied and used as a template in other parts of the program. *Authorware*, like *ToolBook*, is an industrial-strength system that has a staggering array of options and features. It provides excellent data management features, which are lacking from some of the less robust, lower-end authoring systems.

PRACTICAL ASPECTS OF AUTHORING SYSTEMS

In addition to choosing an authoring system that matches your own creative style, you must also be concerned about some practical issues. For example, you may fall in love with a particular system only to find that it is too expensive, too difficult to learn, or has other restrictions you can't live with. Here are some pragmatic concerns to be addressed early on in the selection process.

Cost of Authoring Programs

We've seen low-end authoring programs advertised for as low as $99 (all amounts are U.S. dollars). *PowerPoint*, a powerful presentation development system, is bundled in with *Microsoft Office*. Other systems range from a few hundred dollars to $50,000. The most popular development systems are *Director*, *ToolBook*, and *Authorware*. These range in price from about $1,100 to $5,000.

What do you get when you choose a $1,100 or $5,000 package instead of a $400 program? Primarily, you get power and flexibility. With a low-end package, you are usually restricted to a few preordained templates. If you are satisfied with the minimal flexibility, by all means go for it. The chances are, though, that you will soon outgrow the restricted approach and want something with more flexibility. Low-end packages usually do not have the power to create complex, lengthy training packages. Also, they lack record and data management capabilities

If you decide to go with a low-end package or with a general purpose language, you will be saving money up front. You can get some general purpose and authoring style languages for $200. In the long run, however, your projects will cost more because it will take you longer to produce the products. Consider it a labor versus materials issue. What you save on materials (the development program) you will expend on much higher labor costs. It will take you a lot longer to develop even moderately complex programs using a low-end system than it would take you using one of the more popular programs.

Learning Curve

We get dozens of software packages sent to us every year that vendors would like us to review. We find that if we are just experimenting with a package, we don't

really learn it. On the other hand, if we need to get something accomplished, the learning seems to go a lot faster and we actually learn how to use the product. We are most successful with a new tool if we actually have something important to do.

If you've been under pressure to develop a *PowerPoint* presentation, you know that you can learn a lot in just a few hours. The same holds true with authoring packages. In just a few hours, you can probably learn to build a few rudimentary screens with some simple navigation, play a video clip, and construct some simple questions. However, to get the maximum power and flexibility from a high-end authoring system, you must commit to gradually learning the many features of the systems over a period of several weeks.

The best way to approach learning a complex system like *Authorware* or *Toolbook* is a five-stage approach.

1. Spend a little time—a day or two—going through the tutorials that come with the system.
2. Attend a formal training session. *Authorware* offers introductory, intermediate, and advanced sessions, each lasting two or three days.
3. Work on a real project—one that you have to complete.
4. After you've worked with the product for a few months, attend a more advanced training session.
5. Finally, practice, practice, practice.

Distribution

In the haste to select an authoring system and get started on a project, don't overlook the way you will distribute your final product. Some authoring packages are not very user-friendly when it comes to making your product available to your project end-users. You need to investigate several factors when you are considering an authoring system.

Runtime Module versus Entire Package

Be certain that the authoring system you select offers a way for the end-user to run your training program easily once you have completed it. Some of the lower-end packages do not include a runtime module. A runtime module is a subset of the authoring package that does two things. First, it allows the end-user (the trainee) to run the training program without acquiring the entire authoring package. You can't expect the trainees to equip their computers with a $1,000 authoring package just so they can go through a one-hour training program! Second, the runtime module packages or compiles your program in such a way that the trainee cannot get at the source code (the underlying program) and make changes in the program. He or she can only execute the program in the manner you intended the trainees to interact with the program.

Fee Structures

As you pursue the selection of an authoring system, you must consider more than just the initial purchase price of a single copy of the software. If several people in your organization will need to use the same software package, investigate the availability of multiple licenses at a reduced rate, or a site license. A site license will cost more than a single-user license, but less than the aggregated cost of several independent copies of the software. Often, a site license will be offered for, say, five or ten simultaneous users, but only one set of documentation will be provided. This is a workable solution if the documentation can be stored in an easily accessible central area. If you depend upon a local area network, investigate mounting the software on the network. A network license works in a fashion similar to a site license.

Some vendors of authoring systems require licenses for each of the users of each of the programs you develop. Thankfully, most vendors now offer these end-user licenses at no additional charge. Be alert, though, that some vendors may require you to pay a royalty or license fee for each end-user of your product.

REFERENCES

Cagle, Kurt. 1995. "Choosing an Authoring Program." *Computer Shopper,* August. *http://www5.zdnet.com/cshopper/features/9508/sw1_9508/*

Locatis, G. 1992. *Authoring Systems.* Lister Hill Monograph: LHNCBC 92-1. Washington, DC: National Institutes of Health.

Luther, A.C. 1994. *Authoring Interactive Multimedia.* Boston: Academic Press.

Multimedia Authoring Systems. 1998. Version 2.13. June 22. *http://www.tiac.net/users/jasiglar/MMASFAQ.HTML*

7

Interactive Multimedia Design Considerations

In the last chapter we defined an authoring system as an integrated set of computer programs that allows the user (the author) to produce complex interactive training programs and presentations. In general, authoring systems facilitate the integration of graphics, animations, video, and audio into an integrated presentation and allow the end-user — the trainees, in most cases — to interact with the program to acquire new skills or information.

Suppose you have chosen an authoring system, and you have your content specified and your audience described; you've gone through all the preliminary steps of analyzing needs, and perhaps you've even done some storyboarding. Now what do you do?

This chapter introduces you to those instructional design considerations you must be aware of when you start putting it all together into an interactive training program. First, in Part One of the chapter, we discuss the theory behind the use of interactive multimedia for training. Then, in Part Two, we look at many of the tips and techniques that characterize successful interactive multimedia training. The general principles we describe are relevant not only to interactive training delivered by CD-ROM, your company Intranet, or the World Wide Web, but also to other applications such as kiosks and interactive catalogs. These principles are applicable to just about any situation in which someone is asked to interact with a computer to receive or exchange information. Part Three is an overview of the complex issues of testing and evaluation.

By the way, we tend to use the terms computer based training (CBT) and interactive multimedia training synonymously. The distinction between these two terms is fuzzy at best. We also include Web-based training in this mix. Don't agonize over terminology. It is sufficient to say that the principles we offer you are valid in all three of these training methodologies.

PART ONE: THEORY AND PHILOSOPHY

Design Philosophy

Don't get turned off by theory and philosophy. Theory guides your design and approach to training; philosophy helps you define your approach. Whether you call it a philosophy or a set of guidelines, you carry around with you your own ideas and principles that you believe characterize good training. Take the time to think through and write down your philosophical approach. It will help you make instructional design decisions. Following are some of the design principles that underlie our philosophy of interactive multimedia training.

1. Learning can be accomplished more effectively and efficiently if the training environment simulates the behaviors and outcomes expected of the trainee in the work environment.

2. The training environment is enhanced by the use of multimedia — sound, motion, color, animation — and interactivity.

3. Trainees should interact constantly with the training by answering questions, making decisions, and modifying information.

4. Mastery of the material is expected of the trainee. Mastery is approached first by assisting the trainee to achieve lower-level objectives of identification, recognition, and matching of content. Mastery is then assured by assisting the trainee to achieve higher-level objectives of constructing and generating responses, much the same as would be expected in a work situation.

5. Practice is essential to assure that the actions of the trainee are automatic and an integral part of his or her language. That is, the responses to situations and the activities must become second nature, and must become a way of providing immediate and accurate responses to situations.

6. Trainees should have immediate access to context-sensitive help screens and to supplementary materials for study and review. When appropriate, trainees should control the pacing and sequencing of their training.

7. Interactive training is aimed at learning, not entertainment.

8. Interactive training affects both short-term and long-term learning.

9. Interactive multimedia training is most effective when the learner feels that he or she — not the computer — is in control of the situation.

Some Key Learning Principles

Good interactive multimedia training is based solidly on human learning theory. There are many different theories of human learning — any good Introductory

Psychology textbook will tell you more than you want to know about this topic. There are some important principles that appear in most of the major, accepted theories of learning. This is not the forum for a full explication of all relevant principles, but here are a few we feel are crucial for you to use when you design interactive multimedia training.

1. *Active Learning.* The learner must be actively engaged in the learning task. Active, interactive learning, not passive learning, is the key.

2. *Knowledge of Results.* When a learner answers a question he or she should know immediately whether the answer is correct.

3. *Overlearning.* "Practice makes perfect" sounds like a cliché, but it is vital in the learning process.

4. *Sequencing.* Specify learning objectives so that the learning accumulates in a logical fashion.

5. *Spaced Practice.* Numerous short training modules yield better learning and retention than long modules.

6. *Learner Characteristics.* Training modules must be geared to the interests and abilities of the learners.

Purpose of Multimedia Training

Always keep in mind WHY you are offering multimedia training. The purpose is to encourage changes in learner behavior; to assist in the acquisition of new skills or information. You need to focus on effective training, not the glitzy use of media. Multimedia training is effective because it is multi-mode—text, audio, animation, graphics, video. Any one of these media can be effective by itself. Taken in combination, these various media offer a powerful promise for dynamic, extremely effective training. The options they provide afford you the opportunity to say things in different ways in different combinations of media to get your points across.

Functions of Interactive Multimedia

Interactive multimedia training, whether it is offered over your internal network (Intranet), via the World Wide Web, or by CD-ROM, is used for three primary functions. As you develop interactive training, you always need to know at which of these three functions or levels you are working.

1. *Acquisition of Knowledge and Skills.* This function enables learners to gain new knowledge about a particular topic or to gain new skills. The major modes here are presentation and tutorial instruction. Presentation means just that: presenting information to the trainee. The tutorial or

Socratic mode is much more complex and is the essence of multimedia training. The computer acts as a tutor to guide the trainee through a systematic approach, of which the end result is the acquisition of new knowledge or skills.

2. *Maintenance of Knowledge and Skills.* As learning principle number 3 above indicates, practice is an important component in the learning process. Practicing what you have learned is essential to transferring your newly acquired skill or information from short-term memory to long-term memory. Periodic practice is necessary so your new skills won't get rusty. Some of the earliest forms of computer based training were drill and practice modes. They failed to distinguish between these two functions of acquisition of information and maintenance. Consequently, they acquired poor reputations as training methods.

3. *Application of Knowledge and Skills.* Point number 1 in our design philosophy stated, "Learning can be accomplished more effectively and efficiently if the training environment simulates the behaviors and outcomes expected of the trainee in the work environment." The most effective and most exciting training method is simulation. In this mode the training requires the trainee to apply or generalize what he has learned and practiced in an environment that simulates the activities he is expected to perform on the job. The more realistic the simulation, the more likely the trainee will be able to perform the task in the real-life situation. This is the highest form of interactive multimedia training — and the most difficult to develop.

Critical Components — The *I*'s Have It

There are several distinguishing characteristics of interactive multimedia training. Interestingly, they all start with the letter *I*:

- Interactive
- Individualized
- Informative
- Interesting
- Imagery

Interactive

The sine qua non of multimedia training is interactivity, for the reasons we described above. Without interactivity you are back to the old "Stand and Deliver" lecture mode. Interactivity means the student and computer conduct an interchange. Key components of interactive instruction are rapid interaction

between the trainee and the subject matter, active learning, and response-contingent feedback (more on feedback below.)

Individualized

Interactive computer based training adapts to the unique needs of learning. No two learners follow the same path through an interactive branching training program. Quick, well-informed learners move rapidly through the material. Others may require additional time, deeper forays into explanatory material, and additional practice. True individualization of training means that different trainees may proceed at different rates; the pacing of the training may very among trainees. Similarly, there may be differences in the level or depth of instruction, sequences of instruction, and length of time to complete a given section. Training may be offered at different times and places for different trainees.

Informative

Clearly, the training must inform the learner. The emphasis is upon acquiring new skills and information, not just entertainment.

Interesting

The training program must hold the interest of the trainee to motivate her to continue the training. The training should be captivating to the learner and result in a positive attitude toward the content and the training program.

Imagery

Most interactive multimedia programs rely heavily upon the visual medium. Imagery is very important. It maintains attention, is easily remembered, adds drama, and models behavior. Text may describe a concept, but an image provides a two-dimensional representation.

PART TWO: APPLICATIONS AND TECHNIQUES

Imagine, if you will, a typical one-hour training session in an instructor-led session. There are thirty trainees in the class. The instructor has a detailed set of notes that she will use to explain the material she needs to cover. She has a series of overhead transparencies that illustrate some of the information. She has a video clip that shows an important concept. The instructor has a dilemma: She can either move through the material, making sure the content is covered, or she can try and engage the students by asking them questions. Suppose she asks each student one question. On the average, it takes about two minutes for the instructor to ask the question and for the student to respond. At the end of the one-hour session, the instructor has covered little or none of the material and the average student has been fully involved for only two minutes of the hour.

Now consider a typical one-hour interactive multimedia training session. In this session, each student will be fully engaged for the entire sixty minutes. The trainee will interact with an average of sixty screens, view dozens of graphics or animations, view a video clip or two, and answer at least twenty questions. At each screen, he or she will interact with the system and will engage in some sort of intellectual activity—choosing an alternative path of study, answering a question, reviewing a video clip or an animation. He or she will feel in control of the situation and will be able to choose to review, jump ahead, or seek help from an on-line help system, dictionary, toolbox, or database. This full engagement with the content coupled with a sense of control is what makes interactive multimedia training so powerful.

As you continue through this chapter, please keep that typical scenario in mind. That is, in a one-hour training session, the trainee will interact with approximately sixty screens, see dozens of graphics, view and control audio and video clips, and answer at least twenty questions, for which he will receive feedback tailored to his response to the questions.

Design Elements

Since computer based training (CBT) is primarily a visual medium, what will trainees see as they proceed through a typical program? In Chapter 4, "Scriptwriting and Storyboarding," we identified several important design elements you should consider as you develop a CBT session. These are: Splash or Title Page, Acknowledgments, Log-In, Overview, Contents, Objectives, and On-Line Help. You may not need to use all these elements in this order, but you probably will want to use some variation of most of these elements.

Splash Screen or Title Page
The initial opening screen should be simple yet flashy enough to engage the interest of the viewer. It should contain sufficient information to let the trainee know he or she has reached the appropriate training program or information source.

Acknowledgments
Some programs put the acknowledgments up front to give credit to writers, artists, copyright holders, or sources of material. We recommend that such credits be at the end or bookmarked in such a way that they are unobtrusive but easily accessible to the trainee. Some authoring systems vendors, such as Macromedia, require that their logo be prominently displayed for at least four seconds at some point during a training session.

Log-In
The minimum log-in procedure asks for two items: user name or "user id," and password. In some cases, the initial log-in screen may also ask the user to

choose the training program or session. There are several reasons for a sign-in procedure. At one level, the training program will keep track of the user's progress in a complex training sequence, and maintain a record of the trainee's bookmarks, or any special templates or configurations required by the individual trainee. For example, upon log-in, the program will direct the trainee to the point where the trainee quit at the previous session, or it may branch the trainee to the next logical module in a complex program. At another level, the training program will maintain a record of the trainee's performance and progress for the benefit of the training director or coordinator. The performance data may be simple, perhaps only a record of completed sections or modules. Or it may be highly detailed and record every response or keystroke for review and analysis.

Overview

An overview is a high-level, conceptual description of the training course, session, or module. It contains advanced conceptual organizers to help trainees get the big picture of what the training is intended to accomplish. In one sense, it is the first of the classic Three T's:

- Tell 'em what you're *gonna* tell 'em.
- Tell 'em.
- Tell 'em what you *told* 'em.

The Overview should be brief—no more than a paragraph or two, and not longer than what can be viewed on a single screen.

Contents

The Table of Contents is the screen where trainees select the module or training component they will engage. Often this design element is referred to as the Main Menu. In some cases, the log-in procedure provides this function and trainees do not see a contents page. However, complex training programs usually require some kind of choice page to permit trainees to choose sections to study. We prefer a conceptual map rather than a standard table of contents. Often, the trainee does not have the freedom to choose any module. Rather she is limited to ones that are highlighted, indicating ones for which she has met the prerequisites.

Objectives

Specific objectives for modules or units should be easily accessible to trainees. In some programs, trainees will be permitted to opt out of modules if they believe they can meet the objectives. Other programs will not permit this option. In either case, the objectives serve as advance organizers to help the trainee understand what is expected.

Screen Design

The design of the screens to be viewed by the trainees is an extremely important process. Unfortunately, there is no secret formula that you can use to automatically guarantee a successful design. Although screen design is as much of an art as it is a science, we've developed our own bag of tricks that should guide you in the process. The purpose of good screen design is to help the trainee interact with the content of the program. Poor screen design forces the learner to concentrate on what to do, or where to go. It diverts his attention from the main purpose of the training session: learning the skill or content.

Our goal is to provide screen designs that are Simple, Consistent, and Intuitive.

KISS

The axiom *Keep It Simple, Stupid* is really very good advice. In screen design, simplicity is a virtue. A simple, clean display is easier for trainees to follow than one that is cluttered with unnecessary graphics, floating banners, crawlers, useless animations, and a variety of type fonts. Keep in mind that what you want the trainee to do, then provide no more information than is absolutely necessary for that particular screen.

Being Consistent

Consistency in screen design means that the important pieces or types of information are placed in the same place and in the same fashion from screen to screen. For example, navigation buttons (see below) such as "Continue" or "Go Back" are always in the same relative location—usually at the bottom of the screen. Question-and-answer formats remain the same between screens and different modules. The purpose of consistency is to allow the trainee to concentrate on learning the content or skill, not which button to click. The trainee should not have to reorient herself to each new screen display and waste time trying to figure out the layout of new screen designs.

Types of Screens

There are three main types of screens to consider as you develop interactive multimedia training. Of course, there are other types of screens and variations on the ones we suggest. However, if you get a good handle on these screen types, you will be able to use alternatives and variations as required. Knowing what type of screen you are developing guides you in its design and what you will expect the trainee to do. Consequently, you must always know the primary purpose of the screen you are designing.

Information Screens

The most common screen design is an Information Screen. It is much the same as a page in a conventional book. An information screen is just that—a screen that

displays data or information but does not require anything of the trainee other than a button press to move on. The purpose of this screen is to provide information to the trainee. The information may be generic, such as how to log in or use certain navigation features. More often, it is content-specific. A content-based Information Screen gives the trainee specific information about the content he or she is studying. It may speak to the importance of a particular concept, or it may offer explanation about a concept. It may offer the trainee an opportunity to view a video clip or watch an animation. In this type of screen, the trainee is not expected to make a specific response to what he sees or reads, or answer a question about it. Rather, the trainee is expected to absorb the information and remember it for use on a later screen.

Navigation Screens

Navigation screens are learner-choice screens to permit the trainee to move to other parts or modules in a training program. In some cases, it may be a simple choice such as reviewing a previous screen or section, or moving on to the next logical section in the program. In other cases, the trainee may be asked to choose which of several different modules or program sections to view. In the latter case, not all modules may be available. Some may be "dimmed" to indicate the trainee has not yet completed other prerequisite modules.

Interaction Screens

Interaction screens are at the heart of interactive multimedia training. These displays require a thoughtful response from a trainee. The three major purposes of interaction screens are:

1. Maintaining the attention of the trainee.
2. Branching to other sections of a module or program.
3. Evaluation of the trainee's responses to questions and tasks.

At one level, an interaction can be simply choosing to play a video clip, an audio clip, or an animation sequence. The trainee should have the option of replaying the clip or animation several times, or stopping it at any time. The trainee may occasionally have the choice of branching or jumping to another section or module. More frequently, the trainee will be asked to answer a question or to choose the correct answer to objective questions. He or she may be asked to match a piece of equipment with its correct name or function, or to point to the correct location of a critical component. The trainee may be asked to drag a series of steps into the correct sequence, or to click machine components sequentially to indicate the correct order of starting up or shutting down a piece of machinery.

Tricks for Good Screen Design

Our bag of tricks is largely intuitive and largely common sense. These are important aspects of screen design, and you will find them quite helpful as guidelines.

Subtle Screen Changes

Having said that consistency in screen design is important, it is also important to cue the trainee as to what it is you want her to do. This is especially important if you have been displaying a very similar set of screens, such as information screens. After a series of these information screens, it is better to break the pattern somewhat to guide the trainee to the fact that she must now answer a question or select from a choice list, or some other activity different from pressing the "Continue" key. This may sound obvious, but you'd be surprised at how much time is wasted by trainees who miss subtle screen changes and are forced to retrace their steps.

Avoid Page Turning

Page turning means the trainee is required to look at a series of information screens and is asked to do nothing but turn the page or move on to the next information screen. This is the worst kind of training. Don't waste expensive trainee time and expensive equipment asking a trainee to use a computer to do something a book can do much better and much more cheaply. Our research shows that trainees start to lose interest after two such screens. On the other hand, trainees get annoyed if they have to answer a lot of trivial questions just to avoid page turning. We have found in research studies that the ideal ratio is to require the trainee to make a deliberate, intellectual response no less often than one screen in three.

Avoid Sensory Overload

You may have heard the expression, "When you have a hammer in your hand, a lot of things start looking like nails." The tendency is to use that hammer unnecessarily and too often. An analogy exists in contemporary authoring systems. Good systems have a lot of tools available—tools ranging from dozens of type faces in all sizes and colors; ready-made icons and graphics; easy-to-use video clips and sound bites; blinking, shimmering graphics and crawlers; photo effects—the list goes on and on. Don't be tempted to use a special effect just because it is readily available. Most of these special effects are effective only once or twice. After that, they get in the way of the content. Be simple in your design and avoid cluttered, busy screens. Think through the educational value of each element you place on each screen, and don't use it unless you can justify its instructional relevance.

Follow Natural Eye Movements

Most of us in the Western Hemisphere have been conditioned to look at a book, newspaper, poster, or other visual display in a top-to-bottom, left-to-right manner. Use that natural inclination to your advantage and avoid requiring the trainee's eye to move from bottom to top or from right to left to interact with a screen.

Avoid Scrolling Text Boxes

It is very easy to put large amounts of text into scrolling text boxes. Avoid that easy path, especially for critical information. Scrolling text boxes are fine for documenting, archiving, or providing dictionary entries, but don't use them as substitutes for the printed page.

Balance

Keep the important elements at the center of the screen. Reserve the top and bottom inch for static informational or navigation icons or choices. There has been a tendency in some Web pages to use vertical or horizontal panels, each with scrolling capabilities. This may introduce some confusion in the trainee's' mind as to which is the more important, and where in the scrolling box the critical information is located. Keep the critical information front and center.

Colors

Just because your computer can display a million colors, don't feel you need to show off that capability. There are many different combinations of colors and graphics levels available to different machines. Color-graphics combinations are subject to change, especially in cross-platform applications. Your end-users may not have the capability to display all these combinations. Gradations of colors on a high-level graphics display may show up as a series of lines on a less capable machine. Unless you can control precisely the machine your trainees will use, it is better to be conservative in the use of colors and levels of graphics.

If you are going to be using printed materials or booklets to support your computer based training, be especially careful of color combinations. What you see on the screen is not necessarily what you see when you print the screen. If an exact color-match between on- and off-screen materials is essential, use the industry standard color charts for proper color matching.

Use light, very simple backgrounds, especially if you are displaying text. Text is easier to read if it is a dark color against a simple, light-colored, untextured background.

A small number of people have varying levels of color blindness. Generally, they distinguish one color from another by the contrast between colors. Thus, it is preferable to avoid very subtle color differences in text, graphics, and backgrounds. Most of the rest of your trainees will benefit from this approach as well. It avoids undue eyestrain.

Typefaces

You may recall the early days of word processing and desktop publishing when it became easy to use different typefaces on a single page. Some newsletters were published that contained a dozen or more typefaces on a single sheet. The result was an amateurish, hard-to-read product. Stick to as few typefaces and sizes as you can. Two typefaces is usually plenty considering the options of font size,

bold, underline, and italic. Also, stick with standard typefaces that you are sure will be present on low-end trainee computers. Use color sparingly to accent or draw attention to a word or phrase.

Video

This topic is well covered in other sections of this book. As with other media and design elements, keep in mind exactly why you are using video. Using video because you happen to have some great footage is the wrong reason for including video. Better reasons are to add realism to a simulation, show the human element, and demonstrate a complex process. In a CBT course, be aware that video and audio clips take up an enormous amount of disk space. Consequently, video and audio must be used sparingly. Also, end-users may have low-end computer configurations that do not display video or reproduce audio in a professional manner.

Video is best used in brief bursts to show a process or protocol that is difficult to describe or reproduce as animation. An ideal use for video is to demonstrate a process and to overlay graphics to isolate components or point out critical elements. Video has much more excitement and realism than print or animations, and should be used to precisely illustrate critical aspects of a production process or skill. Ford Motor Company's guidelines for use of video in its interactive training programs restricts the length of video clips to no more than two minutes (Adhikari, 1998). Remember to use conventional video control layouts so trainees can start, stop, slow down, step through, and rewind video clips as they wish.

Audio

Audio can add realism and drama that can never be achieved with simple text and graphics. Audio, like video, is best used in brief bursts. An ideal use is to explain a complex process as it unfolds in a video clip or animation. Audio is also effective if the target audience is trainees who do not have good reading skills. Audio can have an arousing effect to draw attention to errors or particular parts of a complex process. Always include standard cassette-like controls to encourage the trainee to start, stop, or replay an audio clip. Be aware that audio can be annoying and distracting to other trainees if the instruction takes place in an open computer laboratory environment. In such a case, you will need to provide earphones for trainee use.

Graphics and Animation

As with other design elements, know exactly why you are using graphics or animations. The ready abundance of clip art tempts many naïve designers to

include meaningless clip art graphics into every screen of a program. Only use a graphic if it has an explicit educational value. Use graphics sparingly and consistently. They should be used to focus attention, to deliver a critical message, or to reinforce a point made by the text or other means. Be careful that your graphics complement and do not compete with other messages. Avoid sensory overload and clutter.

Media Acquisition

The acquisition of pertinent media — audio, video, graphics, animation — is an important, nontrivial task. It is hard to conceive of a really good interactive training program that is text based and uses no media whatsoever. It would require a very healthy imagination on the part of the trainee. On the other hand, media acquisition is an expensive, difficult task. There are four ways you can go about this process.

1. *Use existing public domain materials.* This is the least expensive option. If you search diligently, you can find print media and graphics, and occasionally video and audio, from public archives or sources such as the Library of Congress. You can also obtain materials by searching the World Wide Web. The advantage is that they are free and in the public domain. You may be able to use them royalty-free in commercial applications as well as in-house programs. (Be sure you get appropriate clearances.) The disadvantages are that they are not easy to locate; public sources are usually not as well indexed as commercial sources; and you may not find exactly what you want.

2. *Acquire the media you need from stock houses.* These enterprises have thousands of photos, graphics pieces, audio and video clips that you can license. The material is well-indexed and it is generally easier to find pertinent materials through these sources than through royalty-free sources. The drawback, of course, is the expense.

3. *Develop your own materials.* If you are in a big shop with your own artists, videographers, audio specialists, and animators, this is probably the way to go. You can precisely control the process and get exactly what you want. Once you build up a collection of materials you can "repurpose" them by modifying them for other purposes.

4. *Get the work done by outside professionals.* Even very large development houses often do not carry a full complement of media development specialists. They go outside, especially for highly professional video development. Costs can be high, but they can be cost-effective if you consider the wage-and-benefits costs of maintaining a full-time staff of media specialists.

Development Team

Speaking of in-house staff, the most effective interactive multimedia is built by a team of people. Few of us have all the skills necessary to pull off a complex multimedia program. Here are the suggested team members for a sophisticated professional level CBT project.

Content Specialist

This person is responsible for the content of the program. He or she is an expert in the subject matter you want your program to teach.

Project Manager

A team leader coordinates the activities of the various people involved in the project. The team leader likely will have a specialty, such as content or media specialist, programmer, or instructional designer.

Author-Programmer

Years ago, we used computer programmers to pull all the pieces together. Now we use authoring system specialists—who also may do some programming within the authoring system. These individuals often are trained instructional designers.

Media Specialists

Audio, video, graphics, and animation specialists are essential in the multimedia design endeavor. As pointed out above, these services may be acquired by outsourcing.

Menus and Navigation Systems

The purpose of menus and navigation systems is to allow the trainee to move quickly and easily among different screens and different parts of the program. A good menu structure should permit the learner to jump rapidly to other key menus and critical screens. Menus and navigation systems should be intuitive; that is, it should be obvious to the trainee what he or she should do to move between screens or sections.

You probably have experienced the situation when searching the Web in which you have jumped around so much that you lost track of where you started. The same thing can happen in a menu-driven program if you are not careful. When dealing with menus, avoid too many layers. Always have an "out" so trainees can get to a major menu level with a single mouse click.

In addition to the obvious screen and module navigation procedures, your program may require additional icons to encourage the trainee to use auxiliary help screens or tools. Examples are a context-sensitive Help screen, a Glossary, a

Dictionary, or a special Toolbox containing tools to help the trainee solve a problem or carry out a simulation. Other standard tools, such as a simple word processor, calculator, or spreadsheet, might be pertinent for certain applications.

PART THREE: TESTING

Testing and evaluation are big issues in CBT. There are volumes written on the theory and application of testing and evaluation. We will concentrate on ideas with particular relevance to CBT. Evaluation is a broader concept than testing. Traditionally, there have been two major forms of evaluation: formative and summative. Formative evaluation means collecting data to improve a product or process. It is very process-oriented and uses data to look at exactly how trainees are responding to specific questions or presentations. Data are collected during the course of developing a program and especially when the program is first used on a trial basis. The emphasis is upon evaluating the program, not the trainee. Summative evaluation focuses on how well the program met its stated objectives. Data are collected at the end of the program. In this section, we will focus on determining how well the trainee met the instructional goals. Did the trainee pass the minimum level? Is she entitled to the certificate that is awarded to people who successfully complete the program?

First, let's define the relationship between "questioning" and "testing." Clearly, one way to test whether or not someone has learned something is to ask questions about the topic. Thus, questioning is a critical part of testing for knowledge gained. Questioning can also be used for other purposes. For example, at the beginning of a new section or module, you may pose a series of questions. You don't really expect the trainee to answer the questions at that point. Rather, you are using a rhetorical device to cue the trainee about what to expect in the section module. The questions serve as advance organizers to the material and alert the trainee that he will be learning material that will help him answer those questions. These questions, stated in declarative fashion, are essentially the objectives for the section or module.

You may ask a question as a hint or guide to help the trainee solve a problem. You may ask a question in an attempt to better motivate or involve the trainee. In these cases, you are asking questions not to test or evaluate the trainee but to motivate her or to help her move in the right direction toward the material to be learned or the skill to be acquired.

Testing, on the other hand, demands a thoughtful response from the trainee, and the computer evaluates that response. The trainee must answer a question, and here we are using the word "question" to signify that the student must type in a response to a question or situation, or use the mouse to click or drag an object or button. The computer evaluates the response and some decision is made. The decision may be as simple as verifying that the trainee has

indeed dragged the simulated part to the correct location on the machine, or has dragged the various steps in a process into the correct sequence of steps. Testing always involves some sort of response analysis.

Testing is done for two purposes: (1) To provide information *to* the trainee; or (2) To provide information *about* the trainee. In the first case, the testing may be strictly for the benefit of the student. For example, you ask questions, the student responds, and then the computer provides tailored feedback to the student to help him or her get a better grasp of the material. The questions may be for self-help quizzes or progress checks, which then encourage the student to review certain sections. This approach does not maintain permanent data on the trainee, nor does it act as a gateway to additional or more advanced training.

In the second case, the questions are used to gain information about the trainee and used to make decisions about further training. The test may be pivotal and act as a gatekeeper. If the student "passes" this test, he or she advances to the next section or module, for example. Or the test may be used to direct the student to additional study on a topic before the student can attempt the test again. The test may be one that is reported to the company or organization offering the training, and signifies that the student has passed the training program or has earned the proficiency certificate.

The key concept is this: always know why you are asking questions of the trainee. Differentiate between questions that are used to collect data for decision-making and questions that are used to provide advance organizers or motivation. When testing produces data, always differentiate between temporary data used primarily to help a trainee master the material, and permanent data, or information used to make decisions about whether or not the student has mastered the material.

Pre-Testing and Post-Testing

Another way to look at testing is to consider the point in the instructional sequence when testing is required of the trainee. We like to think of three situations when testing is used: pre-testing, progress testing, and post-testing.

Pre-Testing

Pre-testing takes place before the trainee is exposed to any of the training material. There are three primary purposes to pre-testing:

1. *Advance organizers.* Provides trainee with general information about what is covered in the section or module. Can substitute for section objectives.

2. *Comparative data.* Collects data about the trainee's knowledge of the material; later compared with the post-test data to assess the learning gains.

3. *Placement.* Allows student to opt out of certain sections and be properly placed in the correct section or module based upon his or her knowledge of the material to be covered.

Progress Testing

This type of testing takes place during an instructional sequence. These tests are generally informal progress checks that advise the trainee to reexamine a particular section or to skip over a section of material. It also provides tailored feedback (see below). The importance of this type of testing is to help the trainee assess how well he or she understands the material.

Post-Testing

Post-testing is a formal evaluation done at the completion of a section or module. This is the "final exam" for a section and determines whether or not the trainee has mastered the material in the section or module. It may also be compared with pre-test scores to assess the trainee's learning gains.

Response Types

There are three primary types of responses that can be elicited from trainees during CBT testing: recall, recognition, and manipulation. The three types can generate many variations. The variations are limited only by your creativity, the power of the computer, and the power of the response algorithms your programmer can generate.

Recall

Recall or construction responses are the most difficult for the trainee to generate and the computer to evaluate. These are questions that require the trainee to supply or construct an answer to a question. The most difficult of all these are essay questions. If you have an unlimited programming budget and access to a supercomputer, you *may* want to consider requiring trainees to answer essay questions. Such questions make very heavy demands on computing power and are highly dependent upon natural language parsing programs. If essay questions are used at all, they are generally not evaluated by the computer. Rather, you ask the trainee to provide a thoughtful written response to a question and then provide her with a model answer to the question. The trainee must judge for herself the adequacy of her response. Construction responses are often used to test the trainee's deep comprehension of a topic or to apply knowledge to a new situation.

Much easier to deal with are single-word responses or fill-in-the-blank questions. The computer can easily compare the student's response with a list of answers prepared in advance. A common use of this type of questioning is to show the trainee a drawing or photo of a piece of equipment. The trainee is asked to type in the names of various parts of the equipment.

Recognition

Recognition type responses are easier for both the trainee and the computer to handle. Typical recognition questions are True/False, multiple choice, and matching questions. These types of questions are best geared for assessing a trainee's knowledge about a topic or process.

Manipulation

The most interesting and most realistic testing situations occur during simulations, when a trainee is asked to manipulate a simulated process or piece of equipment. Using a photo of a piece of equipment, the trainee might be asked to identify the correct name of a part of the equipment and drag its name from the parts lists to the actual part. Or, the trainee might be asked to identify, in sequence, the correct steps to close down an errant piece of machinery. In doing so, he might be expected to drag levers or simulate the turning of valves. These types of simulations and manipulation questions are most often used to test a trainee's ability to synthesize information and apply the knowledge or skills in a realistic situation.

Effective Feedback

The effectiveness of feedback is well-established in human learning. Feedback simply means letting the trainee know how he is doing. The best feedback has the following characteristics.

Timeliness

Feedback should come immediately after the trainee answers a question or manipulates an object. She should be informed immediately of the correctness or adequacy of her response. Our research shows that students start getting annoyed if they are not informed of the correctness of their response within two seconds of completing their response. Immediate feedback facilitates the learning process. (Of course, in certain testing situations, the trainee will not receive immediate feedback for each question.)

Appropriateness

The feedback should be directly related to a particular question. Phrases like, "You are doing a good job," thrown in at random times are useless. Feedback should be directly related to the question. For example, "Yes, you have correctly identified the ventricular aorta."

Proximity

The feedback should be immediately adjacent to the trainee's response. Proximity in location and in time are important characteristics of effective feedback.

Dignity

The trainee's responses should be treated with dignity. It is a well-established principle of learning that praise is much more effective than punishment in the learning process. Avoid sarcasm in dealing with a trainee's answers to questions. Use the incorrect response of a trainee as an opportunity to inform him of where he went wrong, but do it in a dignified way. Don't ridicule or mock a trainee's responses.

Feedback Types

The simplest type of feedback is simply letting the trainee know if she answered the question correctly. This is known as Knowledge of Results (KR). Typically, you see such KR feedback as "Correct" or "No, try again." Again, to be effective, this simple KR approach must be proximate in time and space to the trainee's response. A more effective learning mechanism is KR+ or Knowledge of Results plus Amplification. KR+ reinforces to the trainee why the response was correct or incorrect. For example, "Yes, the aorta is the main artery of the body. As you can see in the diagram, it carries blood from the left ventricle of the heart to most of the major organs of the body."

Adjunct Memory Support

Adjunct memory support refers to on-line help reminders that are immediately available to trainees. It can also refer to off-line take-aways or printed reminders and charts. As Ruth Clark, an educational psychologist and education specialist, advises, "Keep visible on the screen the information the learner will need to refer to during instruction, especially for questions" (Clark, 1997).

REFERENCES

Adhikari, R. 1998. "Keep Control of Streaming Costs, Practices." *Information Week*, June 8, p. 4.

Clark, R. 1997. "Authorware, Multimedia, and Instructional Methods." *http://www.macromedia.com/support/authorware/how/expert*

Cyrs, T.E. 1997. *Teaching at a Distance.* Las Cruces, NM: Center for Educational Development.

Hall, B. 1997. *Web-Based Training Cookbook.* New York: John Wiley & Sons.

Luther, A.C. 1994. *Authoring Interactive Multimedia.* Boston: Academic Press.

8

Training Design and Production Tips

The goal of this chapter is to organize and highlight important training design and production tips from previous chapters and to provide a comprehensive training program production guide.

TRAINING PRODUCTION RESOURCES

Staff Development Team

The most effective video training and interactive multimedia is built by a team of people. Few of us have all the skills necessary to pull off a complex video training or multimedia program. Here are the suggested team members for a sophisticated, professional level interactive multimedia project.

Project Manager
A team leader coordinates the activities of the various people involved in the project.

Subject Matter Expert (SME)
This person is responsible for the content of the program. He or she is an expert in the subject matter you are teaching.

Instructional Designer
Versed in adult education theory and the principles of good instructional design, this member of the team provides the overall training program design and creates the program evaluation method.

Author-Programmer
This staff member is the authoring system specialist, who also may do some computer programming within the authoring system.

Media Specialists
Audio, video, graphics, and animation specialists are essential for quality media production.

TRAINING PROGRAM DESIGN

The training program design process is critical to successful training. Program design consists of clearly identifying the problem you wish to solve through the program, setting measurable program objectives, doing a thorough audience analysis, and selecting the right media or combinations of media to reach the desired objectives. Program design should always take place in the creation of training programs, and it should take place for informational/communications programs as well. With good design, you often find out that a video or interactive multimedia program is not needed at all, and that a group meeting, series of audio tapes, or traditional classroom training might better respond to the problem. Program design creates the road map that the entire learning event will follow, with clear, measurable objectives that also allow for program evaluation.

TRAINING PROGRAM ANALYSIS

Training program analysis determines the need for training. The first and most critical step in the design process is that of needs analysis: what do you want to accomplish, and how do you want to accomplish it? Needs assessment determines whether performance is below required levels and whether training will be an effective means of improving the performance.

Questions to ask during this assessment phase:

❑ What task or job needs improvement?
❑ Are there standards of performance?
❑ What is the required performance?
❑ What is the difference between good and poor performance?
❑ Is performance currently being measured?
❑ What impact does the problem have on the individuals responsible for the work and the organization?

The assessment phase will include the performance requirements and measurement strategy to assure that the training is on target and achieving the desired outcomes.

DEFINING THE PROBLEM

Problem identification should identify a deficiency in performance and indicate a performance standard against which the deficiency may be measured. Ask:

- ❑ Can training correct the problem? Training may not be the solution to all company problems. You must analyze carefully to see if training is indeed the correct action to take.
- ❑ How are you going to evaluate the results? Establish a standard so evaluation can take place.
- ❑ How important is the problem to the overall goal of the company? The development of a training program, whether it be a classroom lecture, workbook, video, or interactive CD-ROM is expensive. You should try, therefore, to calculate what the problem is costing the organization. Ask what is the return on investment? You must decide how big the problem really is and determine just how high a priority it should have.

Consider internal and external factors that may influence training. Internal factors that might influence the training are student motivation, values, and health; external factors are company politics, workplace design, systems and methods, policy and procedures. Training programs will have much greater impact when designers take internal and external factors into consideration.

DEFINING THE TRAINING AUDIENCE

The more accurately you define the audience, the more chance you have to create a success. Ask:

- ❑ How much does the audience already know about the material being presented? A thorough needs analysis targets the audience.
- ❑ Is the audience motivated to watch the program? Audience motivation determines script and program approach.
- ❑ How large is the audience? Audience size and location often dictates the media delivery system.
- ❑ How will the audience access and see the program? This is an important question, for knowing how the audience will access and see the program helps with program design and media delivery selections.

OBJECTIVES

Each decision you make during program development and media selection will be influenced by the training program objectives. Therefore, the objectives of the program should be explicit and written in measurable terms.

Clear objectives help answer some basic questions about the learning experience:

❑ What are you asking the students to achieve?
❑ How will you know if they have achieved it?
❑ What standards are you basing the performance on?

The objectives really set the stage for learning to take place. They give direction to the instruction and provide guidelines against which to measure the learning that has indeed been achieved.

DEVELOPING LEARNING STRATEGIES

The learning strategy or activity provides the vehicle for the training experience. The instructional designer tries to select the strategy most likely to achieve the desired result, whether it be lecture, group discussion, demonstration, role-playing, site visits, games, case studies, or programmed instruction. The instructional strategy is influenced by the type of learning that is taking place. The types of learning, called learning domains (cognitive or intellectual skills, attitude, and motor skills), affect the way in which you teach or the strategy you select.

TRAINING TECHNOLOGY SELECTION

Training technology selection requires the designer to consider the relative values of instructional objectives, strategy, audience, resources, and budget. Ask:

❑ What medium — given the time, budget, and resources we have — will create the results I want in the most efficient and economical way?

Remember that intellectual skills require interaction with the content; motor skills require demonstration and practice; and behavior change requires appropriate modeling and practice. Technology selection is influenced by the type of learning the objective requires.

PRE-PRODUCTION PLANNING: SCRIPTWRITING

Concept Development

In the development of video or interactive programs, the *concept* is the framework or theme you choose for delivering the content to the audience. Once you have researched the content and have an understanding of the audience, you can develop the concept you want to use for delivering the information. The concept sets the parameters for production, style, and interface considerations. In video programs, the concept may take the following forms, among others:

❑ interview
❑ game show
❑ documentary
❑ case study
❑ humorous vignette
❑ demonstration

It is important to create a concept that will be appropriate for the audience.

Interactive Design Document

A critical step in developing interactive training is the interactive design document. Developed as a communications tool by the design team and client, the interactive design document describes what the planned program will be and what it will accomplish once it is developed. The document should include a statement of need, based on the needs analysis, the intended audience, and the approach the program will take. The document details the program goals, objectives, instructional strategy, navigation considerations, and evaluation plan. Also included are equipment considerations, schedules, and guidelines for deliverables.

Content Outline

Once the concept is approved for the training program, you start the scripting process. The basic scripting process follows a series of steps that will vary depending upon your knowledge of the subject, the complexity of the production, and the budget. You will first develop a working *content outline* that sequences the information you have to present and frameworks the amount of information to be covered.

Storyboard

Once you have approval on the content outline, script development or research on the content begins. As the script is being developed, visuals are being selected and the storyboard is developed. A *storyboard* is a visual representation of the "shots" or "pictures" you feel are needed to tell your story. The storyboard can

Interactive Program Design Tips

Good interactive multimedia training is based solidly on human learning theory. Here are a few interactive program design tips we feel are crucial for you to use when you design interactive training:

1. *Active Learning.* The learner must be actively engaged in the learning task. Active, interactive learning, not passive learning, is the key.
2. *Knowledge of Results.* When a student answers a question, he or she should know immediately whether or not the answer is correct.
3. *Overlearning.* "Practice makes perfect" sounds like a cliché, but it is vital in the learning process.
4. *Sequencing.* Specify learning objectives so that the learning accumulates in a logical fashion.
5. *Spaced Practice.* Numerous, short training modules yield better learning and retention than long modules.
6. *Learner Characteristics.* Training modules must be geared to the interests and abilities of the learners.

Always keep in mind WHY you are offering multimedia training. The purpose is to encourage changes in learner behavior, and to assist in the acquisition of new skills or information. You need to focus on effective training, not glitzy use of media. Multimedia training is effective because it is multi-mode — text, audio, animation, graphics, and video. Any one of these media can be effective by itself. Taken in combination, they offer powerful potential for dynamic, extremely effective training. The options they provide afford you the opportunity to say things in different ways in different combinations of media to get your points across.

be simple drawings on 3x5 cards, or more refined drawings on printed storyboard forms. Often, rough sketches of the required shots will be enough to convey your visual thoughts. An important element, the storyboard allows the producer to share visual choices and creative approaches with the client, get a feeling for the pacing and timing of the program, and "edit" the program for visual continuity and clarity of message. It also allows producers to "direct" the program on paper for overall visual and oral effectiveness. For interactive multimedia programs, the storyboard often becomes the "script."

INTERACTIVE PROGRAM PROTOTYPE

During the final phase of production, samples of the training program will be tested with target audiences. For multimedia development, this is often referred to as *prototyping*. Prototyping lets you test your ideas and assures that your authoring program will deliver the features that you want. The prototype helps you focus on the overall length and complexity of the program, as well as the final budget.

Prototyping will help in the final preparation of materials; specifics like graphic color and bit-sizes (refer to graphics production tips later in this chapter);

Interactive Program Production Tips
Tricks for Good Screen Design

These are important aspects of screen design, and you will find them quite helpful as guidelines.

Be Consistent. Consistency in screen design means that the important pieces or types of information are placed in the same place and in the same fashion from screen to screen.

Create Intuitive Design. Simplicity and consistency lead toward screen designs that are intuitive to the trainee

Avoid Page Turning. Page turning means the trainee is required to look at a series of information screens and is asked to do nothing but turn the page or move on to the next information screen. This is the worst kind of training. Don't waste expensive trainee time and expensive equipment asking a trainee to use a computer to do something a book can do much better and more cheaply.

Avoid Sensory Overload. Be simple in your design and avoid cluttered, busy screens. Think through the educational value of each element you place on each screen, and don't use it unless you can justify its instructional relevance.

Follow Natural Eye Movements. Use the natural inclination of left-to-right reading to your advantage and avoid requiring the trainee's eyes to move from bottom to top or right to left to interact with a screen.

Avoid Scrolling Text Boxes. Scrolling text boxes are fine for documenting, archiving, or providing dictionary entries, but don't use them as substitutes for the printed page.

Use Balance. Keep the important elements at the center of the screen. Reserve the top and bottom inch for static informational or navigation icons or choices. Keep the critical information front and center.

Use Colors Conservatively. Unless you can control precisely the machine your trainees will use, it is better to be conservative in the use of colors and levels of graphics. If exact color match between on- and off-screen materials, such as printed support materials, is essential, use the industry standard color charts for proper color matching.

Use Simple Backgrounds. Create light, very simple backgrounds, especially if you are displaying text. Use color sparingly to accent or draw attention to a word or phrase.

Reduce Typeface Variety. Use the least number of typefaces and sizes possible to meet your design objectives. Two typefaces is usually plenty. Also, stick with standard typefaces that you are sure will be present on low-end trainee computers. Use color sparingly to accent or draw attention to a word or phrase.

sound file types; digital video formats; and display requirements. Test the prototype on as many target platforms as possible.

Certain authoring programs allow you to create sample flowcharts, screen designs, and interactive branching designs that provide feedback on the usability of your designs. A prototype CD-ROM (often called a check disc) can be created

on CD-R, or Compact Disc Recorders. These low-cost recording devices allow the designer to burn sample CD-ROMs for test purposes. The prototype becomes a working model of a segment of the program, and allows everyone on the team to "test" the design early in the development process before too much work has been done.

PROJECT DESCRIPTION FORM

The following multimedia project tips were created by *Wheeler Multimedia Consulting* of Chicago (773-866-2438). For multimedia projects, these tips will help provide answers to basic questions for multimedia production.

Interactive Design Tips

❑ *Project Type* defines the type of work needed. The questions cover new programming, modifying an existing program, or the type of code that needs to be written.

❑ *Features* define all of the multimedia features required, such as audio, digital video, and printing capabilities.

❑ *Target operating system*, key question, defines the target platform to be used for program delivery.

❑ *Target processor* defines the type of operating system that will be used for program delivery, such as 486, Pentium, 68040, or 604.

❑ The next question defines how the program will run, on the hard drive, CD-ROM, diskette, or Internet.

❑ *Color depth* defines how graphics will be created.

❑ *Deliverables* answer the question of how the program will be delivered to the client.

❑ *Level of distribution* defines how the program will be used.

MORE MULTIMEDIA PRODUCTION TIPS

Scott Wheeler, president of Wheeler Multimedia, a multimedia development company in Chicago, adds the following observations for multimedia production.

Playback Platform

It is vital that the result of the production effort will playback smoothly and reliably on the intended user's machine. Many horror stories of multimedia

production are based on the simple fact that no effort was made to determine what kind of computer the end-user will have to play back the program. What operating system are they using? Although most computers found in offices use the *Microsoft Windows 95* and *Windows 98* operating systems, there may be some Macintosh computers as well. The Macs will only constitute a small percentage of the installed base, if there are any at all. It is relatively inexpensive to accommodate both Mac and Windows operating systems on a single distributed CD-ROM — if is known that that will be necessary at the beginning of the project. This format is often referred to as a "Hybrid" CD-ROM, a multi-format CD-ROM.

The end-user of your multimedia program will appreciate the time and effort you take to determine the kind of machine they are most likely to have, and this will be helpful in discussing the kind of production that can be supported by the kind of equipment you find in your survey.

Planning Is Imperative

Most multimedia productions will run right from the CD-ROM, without being installed or copied to the computer's internal hard disk. In this case, hard disk size and speed are unimportant. However, some free disk space is necessary, otherwise the operating system (and the whole computer) may run very slowly. Anything less than 10MB disk space is questionable, and less than 2MB free disk space almost guarantees slow performance, especially if the installed RAM is 16MB or less. The speed of the CD-ROM is very important if the production is intended to run directly from the CD-ROM. CD-ROM drives are specified in $^3x^2$. A 2x drive is quite slow and has not been manufactured for several years. Today's machines feature 16x to 32x CD-ROMs and offer excellent performance. Try to determine the speed of your clients CD-ROM drive.

If the CD-ROM drive is slow, you may want to install the program onto the computer's hard disk. In this case, you will need a lot of free disk space for installation, typically 20 to 300MB, but possibly more. If the production is to contain much animation, audio, and video, which will be required to play back quickly and smoothly, it may not permit the production to be played from the CD-ROM. This is accomplished by producing installer software, which automatically copies the production to the user's hard disk, and places icons for running it in the program manager, start menu, or Macintosh finder.

If the production is not to be distributed on CD-ROM, it may be distributed on diskette or by downloading (copying) over the Internet or company network. This is a significant limitation, for then program size must be relatively small, permitting only small quantities of audio, video, and animation. Diskette distribution is also more costly, as diskette duplication is more expensive than CD-ROM replication, particularly because it will involve several, not just one diskette.

Audio

If your multimedia production is to include audio, or video with audio, that you wish the user to be able to hear, the computer must have audio playback capability. Every Macintosh has built-in audio playback capability. PC/Windows computers must have an audio card and speakers for audio playback. Since PC/Windows computers do not have built-in speakers, there are more possibilities for audio playback to fail. There must be an audio driver so that the audio card can do its work. There must be speakers plugged into the correct jack on the back of the computer and turned on, with the volume control turned up, and they must be plugged into a power supply. This offers many opportunities for audio problems. However, some computers are now offering monitors with built-in speakers, which somewhat lessens these difficulties. Almost all computers sold in the past two years automatically come with audio cards built in. As with graphics resolution, there is an issue of audio playback quality. All audio cards support [3]8-bit audio playback, but only more recent and more expensive audio cards support higher quality [3]16-bit audio playback. Although stereo audio is not usually featured in multimedia productions, if a presentation environment is available, and a high-quality amplification system is available, stereo, 16-bit audio will provide excellent audio quality.

Distribution

Distribution over a network or the Internet is fine for small productions. A multimedia production does not have to be huge and can make a quick decisive point with 5MB or less of disk space. Users can be motivated to learn more or to call and order something, for instance. Some companies have high-speed networks or Intranets that allow for rapid transfer of many megabytes (MB) in a small amount of time. For them, electronic distribution may be practical and desirable.

Graphics

An important and often overlooked aspect of computer graphics is the color depth or number of colors the computer can simultaneously display. The usual choice is 256 colors. This setting offers the fastest playback on a given machine and requires the least amount of disk space and RAM. Other settings, such as *thousands* and *millions* of colors, offer better, smoother looking pictures, but require two times and four times more RAM and disk space, respectively.

Diverse Installation Bases

Multimedia is software. If it only has to run on one machine in a training center, it will be easy to choose a machine (or substitute one) that it will run well on. If

it only has to run on the machines in a particular company, it will be under the control of the IS (Information Services) department, and we can assume (though perhaps not rightfully) that the machines will be of similar configuration. There is a chance that someone will have trouble running your program, but the chances are not that great. If the production is to be distributed to large numbers of people in many different companies, then the probability that there will be some difficulty running the program somewhere is just about certain. In this case, greater care will have to be taken to test on a larger number of machines before mass distribution is undertaken.

CD-ROM PRODUCTION

Determine Technical Specifications

Before production of the interactive CD-ROM program begins, determine the technical specifications of the computers for the target audience. Determine the speed of their CD-ROMs, computer, and RAM; the type of operating system, hard disc space, and peripheral hardware (graphic cards, audio capabilities, etc.); and software (*Video for Windows*, *Quicktime*, etc.). If you are producing for multi-platform playback, the authoring system you choose will have to support multi-platform development. Allow extra time for debugging platform idiosyncrasies and allow extra space (dual tracks) for multiplatform delivery.

Pre-Mastering

Once text, graphics, animation, video, and audio segments are created, they are pre-pared for the mastering process. All media elements are digitized and computer software programs like *CD-Creator* from Adaptec (*http://www.cdr.adaptec.com/em*) or *Hot Burn* from Asimware Innovations (*http://www.asimware.com*) help you prepare your multimedia files for the mastering process. Adaptec's *Toast* compact-disc recording software creates CDs that are readable in most CD-R and CD-ROM drives and can create audio CDs that can be played back in virtually any audio CD player. Normally, these pre-mastered files are then sent to outside mastering and duplication facilities where they are transferred to a storage medium such as Exabyte tape (computer tape cassette).

Most glass masters from which duplicate CD-ROMs can be made are created from DDP (disc description prototype)-formatted Exabyte tape. Exabyte/DDP is the pre-mastering choice for the majority of CD manufacturers.

Optimize the design of the program for speed. CD-ROM has slow data seek times and transfer rates because of the way data is stored and retrieved on the disc. Therefore, the location of files on the CD becomes an important factor in the performance of the application. Group pertinent data into related blocks

Scriptwriting Tips

❏ Write with an emphasis on picture. After all, we are creating a visual training experience.

❏ Use words to support and enhance the visual message.

❏ Don't get wordy. Let the visuals carry the message.

❏ Use words that the audience is familiar with. Be prepared, depending on the viewers' familiarity with the content, to define words and provide an additional glossary in printed support materials.

❏ Use an informal, conversational style. Video is a personal, one-on-one medium that involves direct narration to one individual in the audience.

❏ Use "you" and "we" whenever possible to establish an informal one-on-one experience for the viewer. This holds true for writing for multimedia as well. Write sentences as you would speak, because the interaction between the computer and the student is a dialogue.

❏ When writing multimedia programs, think interactively. Successful multimedia training programs are good interactive experiences, offering students many opportunities to interface with the content being presented.

❏ Write meaningful interactions at least every three to five screens.

❏ Each screen should be self-contained, with a balance of content, space, and a complete idea.

❏ Keep in mind that computer screens are much smaller than the printed page in a text and handle type and color differently. Good screen layout and attention to the amount and size of type is critical.

❏ Be consistent with writing style, format, headings, and colors. Help the student by organizing content and providing headings, subheadings, and good directions.

❏ Be consistent with student input; prepare pages and information in a consistent manner. Standardize the locations of answers, prompts, feedback, and screen control.

❏ Try to provide lots of white space on the screen. Screens are much easier to read with generous amounts of white space.

❏ Provide captions with your graphics and photos.

of information. Cut down the time it takes for the laser to travel across the surface of the CD. For example, place often-used menu screens at the center of the program so they can be accessed quickly. And consider moving files off the CD onto the local hard drive for better performance. Check with CD-ROM duplication facilities for tips on storing data.

Provide the mastering facility with high-quality audio and video, preferably broadcast, BetaSP video with standard time code.

Be prepared for the limitations of digital video. Running quarter screen, CD-ROM video at a frame rate of 50K per second at 15 frames per second will show VHS-quality video at best. Expect washed-out color, jerky playback, and blocky edges. Compressing video to make it fit on CD-ROM creates artifacts and

Visualization Tips

Good visualization increases program interest and content retention (the majority of us are visual learners). As learners we like to *see* how a process works rather than being *told* how a process works. Take advantage of the visual process in training for more successful programs.

❑ The center of interest is maintained by establishing and maintaining dominant images.

❑ Consistent, quality images help move the information along and provide logical flow for the viewer.

❑ Standard, universal images communicate clearly to audiences, and color enhances emotional communications.

❑ Be concise. When developing visuals and graphics for your training programs, limit visual information to single concepts and single points.

❑ Don't clutter the screen with information the learner can't use, and keep the backgrounds simple.

❑ Avoid visual distractions, focus the viewer's attention with appropriate visuals, and create consistency with visuals.

❑ Limit your use of colors. Colors should be used to organize and reinforce information, to clarify, highlight, and focus attention. Multiple color combinations can cause confusion.

❑ Quite often simple, line drawings are more effective than photographs.

❑ The compositional structure of the picture influences understanding. The more orderly the composition, the easier it is to "read." Too many details will cause confusion, and viewers will waste valuable time deciphering what is important.

❑ Allow time for the viewer to digest the information presented. Length of shots and scenes are determined by content and how much time is needed to "read" the screen for understanding.

❑ The viewer often brings prior experience and knowledge to the visual, therefore, always consider the amount of information the viewers have regarding your presentation. Never assume a picture alone will convey the intended message — *Know your audience!*

motion problems within the picture. This level of digital video does not handle high contrast well, nor does it handle fast action and zooms. Keep the backgrounds within your scenes simple, keep camera movement to a minimum, and use even, low-contrast lighting.

Include clear, program installation notes and user documentation with the CD-ROM packaging.

CD-ROM Duplication and Replication

After the *pre-mastering* process, CD-ROMs are prepared for duplication. This involves burning the data onto blank CD-R (compact-disc record) using a laser beam. CD-Rs create a "gold master" or copy of the original source material. This

process is usually reserved for small quantities of CD copies, prototypes, and test samples.

The replication process is used for large quantities of CDs, usually 500 or more. In replication, the original gold master is used to create a "glass master," which in turn is used to create the replication master or mold from which copies are manufactured.

Large video and CD-ROM duplication facilities offer complete pre-mastering, duplication, and replication services, and services that also include graphics development for CDs and packaging. Most stock popular CD-ROM packaging items.

MEDIA PRODUCTION TIPS: VIDEO

Digital Video

❏ Full-screen, full-motion video (640x480) runs at 30 frames per second at 30MB a second. Just one frame of 24-bit video takes 1MB of computer data, and 10 seconds of video would fill a 300MB hard disk. Most computers do not have the processing power to handle the speed and bandwidth required for full-motion video, so compression hardware and software are required. Compression boards squeeze video down to a size and speed the computer can handle. A typical single-speed CD-ROM will play 24-bit video, 320x240, at 15 frames per second, at a transfer rate of about 150K per second. There are numerous compression technologies to make digital video possible. JPEG (used mostly for encoding still images), MPEG (used to encode moving images), and MPEG 1 and 2 are common compression technologies. MPEG will deliver compressed video (about 5:1 compression) at a rate that allows CD players to play full-motion movies at close to 20 frames per second.

❏ The television (U.S.) interface resolution is 640x480 with 24-bit color running at 30 frames per second. Compression/decompression hardware should be able to handle these television standards. Compression hardware also allows you to edit video in the computer. Compression hardware, coupled with an editing software program such as *Adobe Premiere*, or a hardware/software editing system such as the *Media 100*, will provide the tools necessary to edit audio and video on the computer. This digitized, edited video can then be output to videotape or prepared for CD-ROM. A few software programs (e.g., *Terran Interactive's Media Cleaner Pro* or *Macromedia's Shockwave*) will prepare the video for publishing on a Website.

❑ Compression does create problems, however; as you decrease the frame rate and the size of video, the quality suffers. There is no getting around the fact that changing the video signal into a format the computer can use will cause degradation of the signal. But there are techniques we can use to help with quality.

❑ Video playback quality on the computer relates directly to the quality of the video compressed and the rate at which it is played back. Therefore, it is important to record the highest quality video signal you can for compression and depend on hardware for high quality, video decompression for delivery. The less the video is compressed (2:1, for example), and the faster it is played back, the better the quality of the video.

❑ Take special care in shooting footage you plan to capture, because the quality of your original footage will make a huge difference in the quality of the compressed video. Plan to shoot broadcast quality, BetaSP format if your budget allows. If you shoot on S-VHS, pay special attention to lighting and capture the video from a VCR—playback from camcorders can be unreliable.

❑ If you use popular compression hardware like the *Truevision Targa* board or the *Media 100* editing system, expect to spend about two minutes for compressing each minute of video.

❑ Capture at the highest frame rate, size, and color depth your hardware system will allow. Save the original footage at the highest possible quality. You can then adjust frame rate to match target playback platforms.

❑ Keep your compressed video files small (only a few seconds in length—5-second shots are a good benchmark); the CD-ROM will handle the smaller files better.

❑ Digital video tends to lose contrast as colors drop out. If the video looks choppy, increase the frame rate; jerkiness becomes noticeable below 15 frames per second.

❑ Make lines for graphics at least 2 pixels wide to avoid flicker on the screen due to video interlacing.

❑ Keep graphics and titles within the safe video area. Computer screens and television screens display information differently; care should be taken to assure that the graphics and titles you create on the computer will display correctly on the television screen.

❑ Because digital video must stream rapidly and without interruption from your disk drive, defragment and optimize your disk on a regular basis with utilities like *Norton's Speed Disk*.

❑ To maximize the quality of your video, minimize the amount of unneeded detail in the pictures you shoot. Keep backgrounds in the

scene simple. Compression sees all information as picture, treating all information equally, so unneeded details in a scene will affect the quality of the compression.

❑ Light the scene evenly, using low-contrast lighting techniques. The more shadows in the scene and the higher the contrast, the harder your compressor has to work and the worse your final digital video will look. Lighting will have the most affect on overall picture quality. Be sensitive to the lighting within the scene and to what you are emphasizing with light. Remember, in terms of attracting and holding a viewer's attention, the human eye is naturally drawn to the brightest element in the scene.

❑ Minimize action within the scene. Again, compression cannot handle busy, action-packed scenes because virtually every pixel must change from one frame to the next, taxing compression. Avoid camera movement, zooms, and pans, and use a tripod to keep the camera steady.

❑ Use filters on your camera lens: neutral density filters are used for exposure control to reduce the amount of light entering the lens without changing the color quality. FL-D or B filter, used under fluorescent lighting, allows natural color eliminating the deep blue-green cast. Haze 2A filter reduces excess blue caused by haze and ultraviolet rays. Contrast filters reduce the harsh, contrast look in video to create a "warm" film look. A Polarizer filter is ideal for all-around outdoor color; it reduces glare and reflections, saturates colors, and darkens the blue sky.

Video Production

❑ Video is a visual medium. We consciously or unconsciously stress the picture. But video really is a combination of production values that all come together to form the program. These elements are light, sound, composition, camera angles, movement, music, pace, special effects, graphics, color, and talent. All of these affect the message. Lighting for video is used primarily to illuminate the subject so that the camera can "see" it. The video director uses light to create images that the camera will record. Light is an aesthetic element as well, because it helps in composition, creating shadow, color, texture, and form. Lighting can also be used to create a mood, a psychological condition that would not naturally be present.

❑ The television screen is a flat, two-dimensional medium made up of only height and width. Lighting (and staging, color, and sound) can create the illusion of depth. Lighting creates this illusion by separating the

subject from the background, and by giving an impression of roundness and texture.

❑ Good lighting focuses the viewer's attention, brings out picture detail and creates a realistic picture.

❑ Sound is another aesthetic element that is used to shape and enhance the message. Sound can become a confusing, distracting, disorienting element in the program. It must be tightly controlled to add realism, depth, and interest to the program, as well as credibility and emphasis.

❑ Good sound-recording techniques should separate the voice of the main speaker from the natural background noise, add mood or emotion to the message, and add to the overall rhythm and pace of the program.

❑ Good sound recording relies heavily on controlling the environment in which you are shooting; therefore, location scouting to check recording conditions, recording equipment, and microphone selection must take place well in advance of the actual production.

❑ Control of the ambiance (natural room sounds), and dialogue is a critical production responsibility, and the selection of the appropriate, believable sound effects can make or break a program.

❑ Screen composition, camera angles and depth of field are all aesthetic elements that require advanced planning. Each element affects the way in which the message is received by the viewer.

❑ Camera angles and composition are usually described as the arrangement of pictorial elements within the scene. We place and move objects and talent within a scene to create the most impact for the message and viewer. You choose what to "show" the viewer with composition and angles. By placing objects and subjects at key locations within a scene or frame, we can emphasize or deemphasize them.

❑ The camera angle determines the viewpoint and the area covered in the shot. You must decide what viewpoint will best depict your message and how much of the area of the scene the viewer must see to understand what is going on. It is not just a matter of selecting a close-up medium shot or a wide shot, you have to select the angle of view. The angle you select will determine how the audience will view the action.

❑ Colors evoke responses and feelings. As you are shooting in video, you should become sensitive to what colors add to your message. Reds, oranges, and yellows appear to be closer to the viewer and have a stimulating effect. Blues and greens appear to be distant and have a calming effect.

❑ Colors can be combined to create depth within the picture, as well as contrast. However, if colors are too bright, they can draw attention to

themselves and distract from your picture. Too many colors in a scene can also distract the viewer and become too busy. This is especially true of backgrounds.

❑ The aesthetic element of motion adds a great deal of complexity to the medium of video. It is one thing to create an aesthetically pleasing still picture, and quite another to create an aesthetically pleasing *moving* picture. Video should be a continuous, logical flow of visual images. It shouldn't be a collection of individual still images. Moving images combined with sound become a coherent message. By combining a series of shots, scenes, and sequences, video becomes a controlled rhythm of moving images that create a whole message.

Video for the Internet

HTML, HyperText Mark-up Language, is a standard document format used to display pages on the Internet. HTML was developed primarily to deliver still graphics and text on the Web. Special streaming video servers are needed to carry multimedia to the desktop, and video-ready browsers are required to see multimedia. The Internet does not handle video nearly as well as CD-ROM or DVD, therefore careful attention should be paid to creating quality video and then using appropriate compression rates for your target audience. The three main standards in video compression are MPEG, Cinepak, and Indeo. Each compression scheme handles video compression differently and requires unique decompression technology at the user end. Cinepak is clearly the most popular to date; offering cross-platform development and playback, it will deliver video on just about any computer. Indeo is still primarily used for PC/Windows delivery, and MPEG is best-suited for hardware-assisted decoding. Some Web HTTP servers can stream video, but low bandwidth, connectivity standards, CPU speeds, and compression schemes all affect the quality of the video delivered.

At this point in time, it would be advised to take a multi-technology approach to Internet training delivery. Use the Internet for text and still graphic delivery, student interaction, and training scheduling and management, and link it to CD-ROM or DVD for media-rich files.

GRAPHICS

Graphics can help visualize the abstract, illustrate the invisible, and demonstrate the complex. Graphics can create a visual style for a program that will differentiate this program from all others. The color scheme, typeface, logo design, and other graphic elements provide additional information through

Graphic Tips

- ❑ Always apply the *KISS* principle — Keep It Simple Stupid! — add clarity not confusion.
- ❑ Each screen should be self-contained, with a balance between content, space, and complete idea. Only use key words.
- ❑ Use progressive disclosure; control what information the viewer sees.
- ❑ Ragged right lines are easier to read than right justified. Avoid hyphenated words
- ❑ Organize along the eye-movement path — top to bottom, left to right. Avoid placing new information on the lower left side.
- ❑ Text display techniques such as labeling, highlighting, and illustrations assist students in (a) the task of focusing on important points, and (b) selectively processing the text.
- ❑ Lists do not work well in linear video. If you must list items, do not go beyond three or four items.
- ❑ Graphics illustrations are useful to maintain viewer interest, but more importantly should be utilized for retention, acting as memory cues or to summarize information.
- ❑ Do not have the narrator read the graphics word for word.
- ❑ Keep illustrations as realistic as possible — they must be recognizable without supportive text. Eliminate unessential details. Critical attributes can be highlighted with arrows and color
- ❑ Assist the viewer with content organization by visually structuring the graphics with consistent headings, subheadings, and colors.
- ❑ Text presented in all CAPS tend to be less legible and give the screen a very solid appearance.
- ❑ Color can be used to distinguish between different kinds of information, highlighting and offering contrast, but keep this use to a minimum.
- ❑ Limit the color palette to two or three colors on a contrasting background.
- ❑ Provide a consistent "look" with graphics for video and printed support material.

their visual approach, whether it be informality, humor, sophistication, boldness, or subtlety. Decide which visual approach will provide the most clarity for the subject matter.

Vector versus Bitmap

In general, graphics for multimedia, CD-ROM, and animation development fall within two categories: bitmap (BMP = bit mapped, GIF = Graphic Interchange Format, and JPEG = Joint Picture Expert Group) file format and vector-based graphics. Each format has qualities that affect their display and storage characteristics within the computer.

Bitmaps display quickly on the screen and offer photorealistic detail. If the file size is small, they will display quickly in Internet applications. They are generally

Check Your Graphics

- ❏ *Focus* — What area demands the viewer's attention? There should be one area of focus.
- ❏ *Simplicity* — Keep graphic designs simple; eliminate nonessential information.
- ❏ *Balance* — Graphic design should have balance, an apparent equality of weight on either side of the center line.
- ❏ *Consistency* — Type styles, colors, and design should have consistency.

- ❏ *Harmony* — There should be a pleasing relationship between all of the elements.
- ❏ *Appropriate Style* — Is the design appropriate for its purpose?
- ❏ *Variety* — Provide creative variety so there is enough difference to prevent monotony.
- ❏ *Contrast* — Design enough difference between elements.

referred to as discrete dots arranged in rows and columns. Each dot corresponds to a pixel on the computer screen. They are harder to edit and change without causing distortion, and bitmaps may appear differently on screens depending on how your video adapter card displays pixels.

Vector-based graphics are described as sets of instructions that precisely describe the size, position, shape, and color of each line in the image. Vector-based graphics work well for simple images; they display correctly regardless of screen resolution. However, for more complex images and graphics that will be displayed on the Internet (there are no Internet-standard file formats for vector-based graphics), bitmap graphics are a better choice.

When creating graphics for Internet delivery, choose a standard format (GIF or JPEG), and keep the files as small as possible. Eight-bit color graphics (256 colors) at 640x480 work well for both CD-ROM development and Internet delivery. Your target audience will need video adapter cards to see higher-quality images.

When creating graphics for video, be sure to use an NTSC (National Television Standards Committee) video monitor to check the graphics. Video developed for broadcast in the United States and Japan is based on a standard (NTSC) and scans 525 horizontal lines (a frame) every 1/30 of a second. The frame is actually drawn in two parts (fields), and the process is called interlacing. Although computer screens have the same aspect ratio (4:3) as television screens, they only scan 480 horizontal lines, sequentially at a faster rate. So graphics developed on the computer screen can look quite different on the television screen. Computers handle color better than television as well, so colors are not always identical on the two screens.

Rules for Design

The visual medium carries with it basic rules for design and composition:

❏ The eye will always be attracted to the brightest spot on the screen, and moving objects carry more weight than stationary objects.

❏ The upper portion of the screen carries more weight (importance) than the lower portion, and darker objects will dominate and appear heavier than their lighter counterparts.

❏ Since we read from left to right, the eye normally travels from left to right, therefore the right side of the frame can attract and hold more attention than the left side.

❏ Objects appearing at the edge of the screen will appear heavier since the center of the screen is compositionally weakest.

❏ Light objects appear to advance toward the viewer, while darker objects appear to recede into the background.

Editing Systems

Before starting graphic design, consider if the graphics will be edited with a non-linear, digital editing system. Each of over 100 nonlinear editing systems have different file requirements for graphic development. Ask:

❏ How will you deliver the graphics?

❏ Is your removable storage device compatible with the facility that will do your editing?

❏ Which pixel size and aspect ratio is required for the editing system?

For example, the *Quicktime* animation codes in Millions of Colors (RGB) at its highest setting is a safe, compatible format for delivering graphic files to the editor, and CD-ROM storage offers a compatible delivery that allows for a permanent archive.

LOGISTICS

If you are shooting video on location, preparing the location shooting scene, props, transportation, and food for crew breaks are all details we call *logistics*. All the details of the logistics need to be pre-planned and brought up in the pre-production meeting. Someone, perhaps a production assistant, has to follow through with the important details — and all details of production are important.

General Tips
Working with Talent

❑ Give the talent plenty of advance notice. Provide information well in advance so the talent can prepare and schedule the time.

❑ If there is a script involved, allow the talent to rewrite the script so it sounds natural to them. Putting the material in their own words will create a better performance.

❑ Communicate! The more the talent knows about the production, what is expected of them, and the schedule, the more success you will have.

❑ Discuss their wardrobe selection ahead of time, so they arrive on the set prepared and looking right.

❑ Arrive early, be prepared, have everything ready for the talent, don't make them wait, know what you want, and be decisive!

❑ Create a comfort zone. Anticipate the talents needs: provide a separate room or area for the talent to prepare make-up and hair, practice lines, drink coffee, or relax between scenes

❑ Explain the production process to the talent. First-time talent usually do not know all that is involved in the shooting of a video. Explaining the process from script development to editing will help relieve their anxieties about the production. Have them visit a production shoot if that is possible.

❑ Introduce the crew to the talent; try to make the talent feel as comfortable as possible and a part of the team.

❑ Communicate blocking instructions first and then rehearse lines. Concentrate on delivery first, action second. Do not give nonprofessional talent too much to do and remember. Plan to shoot in short segments.

❑ Give plenty of praise; build their confidence, which will show up in their performance.

❑ Rehearse difficult technical shots that involve camera movement in advance without the talent. Use a stand-in to rehearse difficult shots.

❑ Use a stand-in to light the set. When the talent arrives, do minor adjustments to the lights.

❑ Give nonprofessional talent good directions. Tell them where to stand or sit, how to sit (legs uncrossed, arms folded on lap or on the arms of the chair), and where to look if they are being interviewed off-camera.

❑ Be sure to ask their permission before you mic them, or have them mic themselves with your direction about mic placement. Usually the mic is hidden under a tie or a collar of a blouse, so use discretion when dealing with mic placement.

❑ Don't let the talent just "wing it." Even if they don't have a prepared script, they should practice — out loud — what they are going to say several times before they arrive for the shoot. They should also understand the purpose of the entire video production, so they understand how their part fits into it.

International Distribution Tips

❑ Are you developing a video training program for international distribution? If so, you have to consider the different international television standards, such as NTSC, National Television System Committee (North America). Other countries often use different television standards such as PAL, Phase Alternation Line and SECAM, Sequential with Memory. A television signal using the NTSC system must undergo signal conversion for use in countries with other standards. Be sure the duplication facility you choose knows in advance that you are planning international distribution so that they can make the appropriate dub master for the right standards. In some cases, some corporations may want a simultaneous PAL and NTSC production. This will effect your production shooting as well as your post-production requirements.

❑ Producing a program for multiple languages presents its own set of challenges. It is best to have someone on the crew — and present during the editing process — who understands the language. Not all foreign language scripts match perfectly with English scripts. Foreign versions may take longer to "read": the sentences may last longer, which affects the length of the shot. Seldom can you make a straight translation of a script without having to re-edit the program.

❑ If you are doing a foreign language version of a script, you may want to record the narration on two tracks. Do the foreign narration on one track and then go back and have the person who did the track put in key words or phrases in sync on the other track. You may not fully understand the narration, but if you ever get lost, at least you can figure out what paragraph you're on. This procedure also allows the editor to follow along pretty easily without having to know the language. There are services that provide language translation. Often you can find translation services in the phone book, but there are companies such as Henninger Video in Washington, DC, that specialize in translating and even producing foreign language video productions.

❑ Captioning (visual text of audio portion of the program) is becoming more of a criteria with any kind of government-based video project. Often exhibits produced for NASA and the National Parks and museums are required to have captioning. However, you should be aware that captioning poses an aesthetic question, as well as a time question (adding time to the post-production process). Aesthetically, it's better to put on a nice-looking video-based caption, rather than have an actual open captioning device that's used for the hearing impaired. An open captioning device usually displays typewriter characters on the screen, less pleasing to the eye than professional, video, character generators that produce attractive fonts and colors. These devices tend to be more of a dot matrix display. However, companies that provide captioning services for open and closed captioning are specialists. You can send them a tape (of your finished program) and they can transcribe it

(continued)

(continued)

almost in real time by just listening to it. A skilled typist using a character-generator, on the other hand, is going to take longer, and that will impact on the editing time. The trade-off is that of aesthetics versus speed. Henninger Video provides captioning services as well.

❏ Also, if you know you're going to have captioning in the lower third of the screen throughout the entire program, you have to plan where you are going to put the name supers and other text that need to appear in that area of the screen.

❏ If closed captioning is required, a whole set of specialized equipment is necessary to properly record the closed caption data into the vertical interval signal. Open captioning tends to be something that most editing facilities can do, even though it's just character-generated. Open captioning adds to your editing time, as well as cost and planning, over and above just doing the program.

❏ Sometimes, if you're doing a translation into a foreign language, it's more cost-effective to do so in the country that you are translating the script for. They do such translation routinely, and are thus able to provide better lip sync — particularly if it's English to French, because there is a lot of that type of translation in Canada, and English to Spanish, where there is a lot of that happening in Mexico City.

Some of these location details include:

❏ equipment and crew transportation to the location
❏ parking considerations
❏ location site maps for talent and crew
❏ security clearance for talent, crew, and equipment
❏ loading and unloading arrangements on location
❏ location shooting clearance and permits
❏ special safety issues at the location — special jackets, outerwear or long sleeves, hard hats, safety glasses, and I.D. badges are often needed for the crew in manufacturing areas
❏ meal arrangements for talent and crew
❏ security issues for equipment and storage of equipment if it is an overnight production
❏ telephone access, communications, bathrooms, and changing facilities for talent
❏ traffic control for exterior shots
❏ special union requirements or restrictions at the location

Often the person responsible for the details of the logistics is the production assistant (PA). The PA assumes the responsibility of managing transportation, parking considerations, food or lunch breaks, props, special talent arrangements, and a million other details that can make or break the shoot.

Logistics usually fall within several categories that include talent, crew, and location:

❑ *Talent arrangements* often include rehearsals, scripts, releases, contracts, union requirements, wardrobe, and makeup.

❑ *Crew arrangements* involve transportation considerations (this will expand if there is out of town travel involved), loading and unloading location of equipment, call-out time (when to have crew arrive at the set in the morning), lunch or food arrangements, contracts for outside services, time sheets, W-2 forms, and insurance.

❑ *Location arrangements* often include approvals to shoot on location, releases for locations, permits, location contacts, security, traffic control, parking and equipment logistics, and equipment staging arrangements for the day of the shoot. Location arrangements must be made for the appropriate props and talent to be available for the day of the shoot, appropriate power and audio arrangements for the day of the shoot, and safety considerations for crew and talent.

LOCATION SHOOTING

Location shooting offers many advantages (and disadvantages) over shooting in the studio. One advantage is credibility. Location shooting allows the viewer to experience the actual "visual feel" of the location, whether it be a meeting room, manufacturing area, hospital operating suite, or external scene. Scenes shot on location add a certain amount of credibility to the script; however, they can add problems as well.

The problems of location noise, lighting, and environmental conditions should always be addressed during the pre-production process. Time spent in solving as many of these problems as you possibly can will always pay off in time saved during production. Think of as many things as you possibly can that could go wrong on the day of the shoot, and address these potential problems during pre-production.

Site Survey

Most producers will agree that one of the most important considerations for location production is the location site survey. The site survey will provide invaluable

Location Scouting Tips

❏ Bring to the survey: a notepad for room diagrams and lighting plots; a light meter (if appropriate); a tape measure to measure windows for gels and room sizes; a compass for sun and shadow direction; and a still camera.

❏ To determine which outlets are on which circuits, take along a circuit tester or night light, and contact the building engineer for building plans to help you identify power placement, room locations, and traffic patterns.

❏ Shoot photos or camcorder footage during the scout.

❏ Be sure everything is put back in its proper place after the shoot.

❏ Visit each location at the time scheduled for the actual shooting, so you can experience lighting, sound, and traffic conditions. Find out what other activities are scheduled at the time of the shoot (such as shift change, a retirement party in the next office, or building cleaning and maintenance).

❏ Check access to locations for equipment movement. Are the doors big enough for easy equipment movement for dollies and carts? Are there easy accesses for crew and talent?

❏ Check the ceiling height at each shooting location for lighting requirements. Can you hang backlights? Do you need ladders, lifts, or scaffolding to hang lights? Are there ceiling sprinklers that may create a problem when you turn on the production lights? Are there ceiling alarms that may create a problem with lights and sets?

❏ Check room noise (ambiance) for air-conditioner noise, fluorescent light hum, background music, outside traffic noise, hallway noise, elevator and soda machine noise, and extra noise at shift changes and in rooms above the location.

❏ Check the wall colors and reflective surfaces within the scene that may affect your lighting.

❏ Check room lighting conditions. Are there windows in the scene? Can they be gelled so they match the color temperature of your lights? What will be your predominant lighting source? Are there other lighting sources or mixed lighting sources that will affect your lighting requirements? Can the fluorescent lights be turned off? Do the lighting conditions change throughout the day?

❏ If shooting exteriors, check the sun's position in the sky at the scheduled time of the shoot for reflections and shadows; exteriors may require extra lighting and reflector equipment.

❏ What are the power limitations? Will there be sufficient power for the lights and equipment? Will you need to make an electrical tap? Check distances for electrical cables from power sources.

❏ Create a room plan and lighting diagram for each scene for furniture placement; lighting, equipment, and camera placement; and power outlets.

❏ Use the location checklist, given earlier in this chapter, and contact sheet, and be sure office managers and supervisors, building engineers, electricians, shop stewards, and security are listed.

logistical information for the crew and director, and for the script as well. Often after the site survey has taken place, script changes occur. Once on location, you can determine if the camera angles called for in the script are possible; if talent movement, backgrounds, and lighting is appropriate for the conditions of the scene; and if the script audio requirements are possible. Notes are taken (and photos, if possible) on power, lighting, and sound considerations, as well as equipment and crew logistics and what special location problems need to be solved before the day of the shoot.

The site survey allows you or the assigned director to actually "see" the scenes, action, and shooting logistics required by the script. The director can enhance the script based on what he or she experiences on the location (e.g., sites and sounds that may not appear in the script, such as interesting background highlights and lighting conditions). The director will walk through the script scene by scene, shot by shot to determine shooting feasibility, camera positions, and special lighting requirements, then make notes in each scene on camera placement, talent and camera movements, special audio conditions, and changes in the script based on site logistics.

The site survey also allows the director to properly block the script, schedule the shooting based on best shooting conditions for each scene, and determine equipment set-up and movement. Equipment placement will be determined along with audio recording considerations (mic placement and ambient noise). The site survey will allow the director to make the proper location contacts and start the location problem-solving process.

TECHNICAL LOGISTICAL CONSIDERATIONS

The following section is made possible thanks to Coleman Cecil Smith and his excellent technical reference, *Mastering Television Technology: A Cure for the Common Video*, published by Newman-Smith Publishing Company.

Power

Each electrical circuit is designed to provide a maximum amount of electrical current. To make sure that a circuit will not overheat and catch fire, a fuse or circuit breaker is installed in the circuit. The fuse or circuit breaker is designed to break the circuit if the designed maximum current draw is exceeded. Once tripped, a "blown" fuse must be replaced or a "tripped" circuit breaker must be manually reset.

To make sure that the current flowing through a circuit is not interrupted during production, some calculations during location scouting are appropriate. The following procedures should be followed:

1. Decide which wall outlets will be most convenient to power equipment and lighting.

2. Determine to which circuit each desired wall outlet is connected.

3. Determine which circuit breaker or fuse is in each desired circuit and the designed maximum current load for that circuit. The electrical current (in Amps) that the circuit is designed to safely carry is printed on the fuse or circuit breaker in that circuit; 15 Amp, 20 Amp and 30 Amp circuit breakers are the most commonly found sizes.

4. Determine which other wall outlets (and connected equipment and lights) are on the same desired circuits. Determine the total load (in Amps or Watts) of all other equipment and lights on the desired circuits that will be operating during the production. This should be printed on the equipment, frequently on the back or bottom. If there is no printed information, look for a fuse or circuit breaker size. In North America, you may convert Watts to Amps with the following formula:

$$Current(Amps) = Lamp\ Power\ (Watts)/110\ (Volts)$$

5. The total amount of current available to power television equipment and lighting on each circuit is the designed maximum current load minus the load of other equipment connected to the circuit that will be operating during production.

6. The total amount of current consumed by equipment and lighting is the production current load. Look at the load printed on each piece of equipment and the load of the lamp in each fixture and add them together to determine the production current load.

Lighting Equipment Power

The lighting of the scene is the most important factor in improving the quality of the picture. The amount of current required to operate lighting instruments may be determined with the same Watts-to-Amps conversion formula above. For quick reference, common lamp Wattages converted to current demands (at 110 Volts) are as follows:

100 Watts demands	0.9 Amps
250 Watts demands	2.3 Amps
500 Watts demands	4.5 Amps
600 Watts demands	5.5 Amps
750 Watts demands	6.8 Amps
1000 Watts demands	9.1 Amps
2000 Watts demands	18.2 Amps

The total load on a given circuit must not exceed the maximum designed load for that circuit. If it does, the circuit will eventually be interrupted. The interruption may not come immediately, depending on the amount of overcurrent demand, but it will eventually occur.

Power Extension Cords

Extension cords are frequently used in portable production to provide temporary power. In general, the larger the load, the larger the conductors within any extension cord should be. In addition, the longer the extension cord, the larger the conductors within the extension cord should be. Extension cords that have conductors that are too small for the application pose a serious fire hazard.

Two-wire consumer extension cords should be avoided entirely. Three-wire (with a long grounding pin on the plug) rated for "heavy-duty" use should be used.

Extension cords are designed to be used only for portable applications. Permanent installation of outlets to fulfill frequent power demands should be completed by a competent electrician.

ENVIRONMENTAL LOGISTICS

Physical factors that will affect the quality of the picture and sound must be carefully considered for a potential production location. The two primary areas in which problems may be encountered are picture and sound.

Picture

The primary factor affecting picture quality is lighting. The amount of lighting, the placement of lighting sources, and the quality of lighting all affect the picture.

Quantity of Light
A potential production location must be scouted for too much or too little lighting to achieve the desired depth-of-focus in a given scene. In most situations, the lighting must also be balanced in such a way that the desired objects in the scene are brighter than undesired scene objects. Both of these considerations involve the amount of light, an increase in which requires an increase in current through the circuits providing power.

When estimating the amount of light required, remember that varying times of day, varying weather conditions, and varying distances from large reflective objects (like white or mirrored buildings) will have a significant impact on the quantity of natural light available during production.

Quality of Light

The quality of light is a very important factor when evaluating a potential production location. Television cameras see things differently than the human eye — different colors are seen with different intensities. To achieve a natural-looking television scene, the camera must be "color balanced" to match the characteristics of the human eye under similar lighting conditions.

Color balance is coarsely adjusted with colored filters between the lens and the camera's imaging devices (tubes or "chips"). Fine adjustment of color balance is performed with electronic "white balance" and "black balance" circuits in the camera. To make sure that a camera is properly adjusted for a particular scene, it should be balanced immediately before the production is to be taped.

Mixing several types of light creates mixed results in the picture. In general, only one type of light source (tungsten, sunlight, quartz-halogen, etc.) should be used in any given scene. Fluorescent light sources should be avoided. If there is a mixture of light sources, it is usually best to try to overpower the scene with light from one source. In office production environments, it is common practice to place large gels on windows and to overpower fluorescent lighting with quartz-halogen lamps.

When considering the quality of light in a given scene, remember that varying times of day, varying weather conditions, and varying distances from large reflecting objects will have a significant impact on the quality of light available during production. Nearby colored objects will reflect colored light onto objects in the scene.

Sound

Quantity of Sound

In most productions, the perceived amount of sound coming from the desired source must be higher than the amount of sound coming from any undesired source. This may be controlled by selecting a different microphone (a "shotgun" instead of a lavaliere); or it may be controlled by increasing the amount of desired sound (louder talent); or it may be controlled by decreasing the amount of undesired sound (with baffles, etc.). The final result is to increase the volume of the desired sound while reducing the volume of the undesired sound.

In investigating potential production locations, look for loud noise generators like pedestrian, automobile, train, and aircraft traffic, and also fans. Remember that there are daily variations in the amount of sound from these and other sources — it may be most desirable to shoot on a weekend or at other non-business times.

Quality of Sound

The quality of the desired sound is an important consideration in evaluating a production location. Microphone placement and technique must be carefully

evaluated for the particular scene. In general, the closer the microphone is to the desired sound source, the better; conversely, the farther away the microphone is from the desired source, the louder other sounds will seem.

Beware of locations that impart an echo to the sound. There is no practical way in which a "barrel sound" or other reflective sound distortion can be corrected.

Some sound distortions may be corrected with equalization and "sweetening" during post-production, but getting the best possible quality during production is critical for consistently good results.

Sound Intrusions

There will always be short-term intrusions into the desired sound that are created by outside sources. Emergency sirens, noisy aircraft, noisy automobiles, and noisy crowds are common sources of undesired noise.

To reduce the quantity of some of these undesired noise sources, dial out on telephones, employ crowd control, shoot on weekends or in the dead of night, shoot when the wind is from a particular direction (near airports), or employ other sound-avoiding measures.

Ditty Bag

A film term applied to the video world, the *ditty bag* (a little a dis and a little a dat) is another important equipment item to take along. The ditty bag contains all of the items you wished you had brought along:

- ❑ extra lamps
- ❑ gaffer tape
- ❑ extra video tape
- ❑ small make-up kit
- ❑ clothes pins and special fasteners for lights that are often found at your local hardware store
- ❑ string, rope, rubber bands, masking tape, and a knife
- ❑ small kit of tools
- ❑ flashlight and batteries (also batteries for mics)
- ❑ clipboard for logs and script
- ❑ extra production forms and talent release forms
- ❑ pens, pencils, and markers
- ❑ small first-aid kit
- ❑ camera filters and lens cleaning kit
- ❑ and every conceivable technical adapter you can think of

Resources

We would like to acknowledge the information and support the following authors, manufacturers, and suppliers have provided in the development of this book by offering this production resource list.

STOCK FOOTAGE AND MUSIC LIBRARIES

Film/Video Stock Libraries

Action Sports Adventure, 330 W. 42nd St., New York, NY 10036 (212) 594-6838

Airboss Stock Library (military), 4421 Bishop Ln., Louisville, KY 40218 (502) 454-1593

American Production Services, 2247 15th Ave. West, Seattle, WA 98119 (206) 282-1776

Archive Films, 530 W. 25th St., New York, NY (800) 876-5115

Cameo Film Library, 10620 Burbank Blvd., N. Hollywood, CA 91601 (818) 980-8700

Cascom Inc., 806 4th Ave., South Nashville, TN 37210 (615) 242-8900

CBS News Archives, 524 W. 57th St., New York, NY 10019 (212) 975-2875

Cinema Arts Inc., P.O. Box 70, South Sterling, PA 18460 (717) 676-4145

Cinenet Cinema Network, 2235 First St., Simi Valley, CA 93065 (805) 527-0093

Clip Joint, For Film, 833 B. N. Hollywood Way, Burbank, CA 91505 (818) 842-2525

Comstock Stock Photography, 30 Irving Place, New York, NY 10003 (212) 353-8686

Dreamlight Images East, 163 E. 36th St., Suite 1B, New York, NY 10016 (212) 850-1996

Energy Productions Timescape Image Library, 12700 Ventura Blvd., 4th Floor, Studio City, CA 91604 (818) 508-1293 or (800) IMAGERY

Film Bank, 425 S. Victory Blvd., Burbank, CA 91502

Firstlight Productions, Inc., 15353 N.E. 90th St., Redmond, WA 98052 (206) 869-6600

Footage.net (stock footage on-line) *INFO@FOOTAGE.NET.* (508) 369-9696

Great American Stock, 2290 Cantina Way, Palm Springs, CA 92264 (619) 325-5151

Hot Shots & Cool Cuts, Inc., 330 W. 42nd St., New York, NY 10036 (212) 967-4807

The Image Bank/Film Search, 111 Fifth Ave., 4th Floor, New York, NY 10003 (212) 529-6700

Imageways, 412 W. 48th St., New York, NY 10036 (800) 862-1118

Los Angeles News Service, 1341 Ocean Ave. #262, Santa Monica, CA 90401 (310) 399-6460

Merkel Films (sports), Box 722, Carpinteria, CA 93014 (805) 648-6448

National Aeronautics & Space Administration, Lyndon B. Johnson Space Center, 2101 NASA Road 1, Houston, TX 77058-3696 (713) 483-8602 (Still Footage) (713) 486-9606 (Research Video)

National Geographic Film Library, 1600 M St. N.W., Washington, DC 20036 (206) 898-8080

NBC News Archives, 30 Rockefeller Plaza, Rm. 922, New York, NY 10112 (212) 664-3797

Paramount Pictures Corp., Stock Footage Library, 5555 Melrose Ave., Hollywood, CA 90038 (213) 956-5510

Producers Library Service, 1051 N. Cole Ave., Hollywood, CA 90038 (213) 465-0572

Second Line Search, 330 W. 42nd St., Suite 2901, New York, NY 10036 (212) 594-5544

The Stock House, 6922 Hollywood Blvd., Suite 621, Hollywood, CA 90028 (213) 461-0061

Stock Video, 1029 Chestnut St., Newton, MA 02164 (617) 332-9975

Streamline Film Archives, Inc., 432 Park Ave. South, Room 1314, New York, NY 10016 (212) 696-2616

Timescape Image Library, 12700 Ventura Blvd., 4th Fl., Studio City, CA 91604 (800) IMAGERY

Universal City Studios, l00 Universal City Plaza, Universal City, CA 91608 (818) 777-1695

Video Tape Library, 1509 Crescent Heights Blvd., Suite 2, Los Angeles, CA 90046 (213) 656-4330

WPA Film Library, 12233 S. Pulaski, Alsip, IL 60658 (708) 385-8528 or (800) 777-2223

Music Libraries

Associated Production Music, 6255 Sunset Blvd., #820, Hollywood, CA 90028

Chameleon Music, P.O. Box 339, Agawam, MA 01001-0339 (800) 789-8779

City Tunes Production Music, 311 Austin Rd., Mahapac, NY 10541 (914) 628-7231

DeWolfe Music Library, 25 W. 45th St., New York, NY 10036 (212) 382-0220

Dimension Music & Soundeffects, Inc., P.O. Box 992, Newman, CA 30264-0992 (800) 634-0091

Energetic Music, Inc., P.O. Box 84583, Seattle, WA 98124 (800) 323-2972

FirstCom Music, 12747 Montfort Dr., Suite 220, Dallas, TX 75240 (800) 858-8880

Fresh Music Library, 80 S. Main St.., Hanover, NH 03755 (800) 545-0688

Gene Michael Productions, 1105 N. Front St., Suite 29, Niles, MI 49120 (800) 955-0619 or (616) 684-0633

Impact Music, P.O. Box 67, Dale, WI 54931 (800) 779-6434

Killer Tracks, 6534 Sunset Blvd., Hollywood, CA 90028 (800) 877-0078

Manhattan Production Music, P.O. Box 1268, Radio City Station, New York, NY 10101 (212) 333-5766 or (800) 227-1954

The Music Bakery, 7522 Campbell Rd., Suite 113-2, Dallas, TX 75248 (800) 229-0313

Musi-Q Productions, Inc., 3048 Coral Springs Dr., Coral Springs, FL 33065 (800) 749-2887

Network Music, 15150 Avenue of Science, San Diego, CA 92128 (800) 854-2075

Sonic Science, Spadina Ave., Suite 767, Toronto, Ontario, Canada M5V 2Ll (800) 26-SONIC, (416) 351-9100

PRODUCTION SOFTWARE

Multimedia Graphics and Animation

Animator Pro, 3-D Studio, Autodesk, Inc., 2320 Marinship Way, Sausalito, CA 94965 (800) 879-4233

Arts and Letters, Computer Support Corporation, 15926 Midway Rd., Dallas, TX 75244 (214) 661-8960

CorelDraw, Corel Systems Corp., 1600 Carling Ave., Ottawa, Ontario, Canada KlZ 8R7 (800) 836-DRAW

Crystal Graphics, Inc., 3110 Patrick Henry Dr., Santa Clara, CA 95054 (800) 979-3535

ElectricImage Animation System, ElectricImage Corp., 117 E. Colorado Blvd., Suite 200, Pasadena, CA 91105 (818) 577-1627

Fractal Design Corporation, 335 Spreckels Dr., Aptos, CA 95003 (408) 688-5300

Freehand, Aldus Corp., 411 First Ave. South, Seattle, WA 98104-2871 (206) 628-4526

Illustrator, Photoshop, Adobe Systems, Inc., 1098 Alta Ave., Mountain View, CA 94039 (415) 961-4400

Infini-D (3-D animation program), Metacreations, *http://www.metacreations.com*

RIO, AT&T Software Systems, 2701 Maitland Center Pkwy., Maitland, FL 32751 (800) 448-6727

Tempra, Mathematica, Inc., 402 S. Kentucky Ave., Lakeland, FL 33801 (800) 852-MATH

TIPS, Truevision, Inc., 7340 Shadeland St, Indianapolis, IN 46256 (317) 841-0332

Xaos Animation Tools, 600 Townsend St., Suite 270E, San Francisco, CA 94103 (800) 833-9267

Authoring Software

CBT Express, Asymetrix Learning Systems, 110th St., Bellevue, WA 98004 (800) 448-6543

Course Builder, Discovery Systems International, P.O. Box 1188, 137 S. Gay St., Knoxville, TN 37901 (888) 284-5389

Director, Authorware Professional, Macromedia Inc., 600 Townsend St., San Francisco, CA (800) 326-2128

Hypercard, Claris Corp., 5201 Patrick Henry Dr., Santa Clara, CA 95052 (408) 987-7000

Icon Author, AimTech Corp., 20 Trafalgar Sq., Nashua, NH 03063 (800) 289-2884

Quest, Allen Communications, Wayside Plaza II, 5225 Wiley Post Way, Salt Lake City, UT 84116 (801) 537-7800

Toolbook, Asymetrix Learning Systems, 110th St., Bellevue, WA 98004 (800) 448-6543

Production

Avery Labels, 150 N. Orange Grove Blvd., Pasadena, CA 91103

Collaborator II (character development, story creation, structure, and analysis), The Writer's Computer Store, 11317 Santa Monica Blvd., Los Angeles, CA 90025-3118 (310) 479-7774 (very comprehensive collection of production software)

Corkboard, The Idea Processor, The Whole Shebang, 205 Seventh St., Hoboken, NJ 07030 (201) 963-5176

Dramatica, Screenplay Systems, Inc., 150 East Olive Ave., Suite 305, Burbank, CA 91502 (818) 843-6657

Easy Log, Limelight Communications, 2532 W. Meredith Dr., Vienna, VA 22181 (703) 242-4596

Edit Lister, Log Master, Comprehensive Video Supply, 148 Veterans Dr., Northvale, NJ 07647 (800) 526-0242

Edit List Master, Future Video Products, Laguna Hills, CA 92653

The Executive Producer, The Executive Librarian, Imagine Products, Inc., 581 S. Rangeline Rd., Suite B-3, Carmel, IN 46032 (317) 843-0706

EZ Write Marketing Plan Writer, Force Marketing, One Commerce Place, Suite 350, Nums Island, Quebec, Canada H3E lA4 (800) 363-9939

Idea Fisher, Idea Fisher Systems, Inc., 2222 Martin St., Suite 110, Irving, CA 92715 (714) 474-8111

Inspiration, Inspiration Software, Inc., 2920 S.W. Dolph Ct., Suite 3, Portland, OR 97219 (503) 245-9011

Log Producer, Easy Caption, Image Logic, 6807 Brennon Ln., Chevy Chase, MD 20815 (202) 452-6077

Production Prompting Systems, Comprompter, Inc., 141 S. 6th St., La Crosse, WI 54601 (608) 785-7766

SAW (audio workstation software system), Innovative Quality Software, 2955 E. Russell Rd., Las Vegas, NV 89120-2428 (702) 435-9077

Scene Stealer, Dubner International, Inc., 13 Westervelt Place, Westwood, NJ 07675 (201) 644-6434

Scriptor, Movie Magic Budgeting, Movie Magic Script Breakdown & Scheduling, Dramatica, Screenplay Systems, 150 East Olive Ave., Suite 203, Burbank, CA 91502 (818) 843-6557

Scriptwriting Tools, Morley & Associates, 1923 Lyans Dr., La Cauite 203, Burbank, CA 91502 (818) 952-8102

Showscape Storyboard Software, Script Master, Lake Compuframes, P.O. Box 890, Briarcliff, NY 10510 (914) 941-1998

Storyboard Quick, Storyboarder, The Writers' Computer Store, 11317 Santa Monica Blvd., Los Angeles, CA 90025-3118 (310) 479-7774

Storyline Computer Software, Truby's, 1739 Midvale Ave., Los Angeles, CA 90024-5512 (800) 33-TRUBY

Turbo Budget, The Writers' Computer Store, 11317 Santa Monica Blvd., Los Angeles, CA 90025-3118 (310) 479-7774

Warren Script Applications, Stephanie Warren & Associates, 3204 Dos Palos Dr., Los Angeles, CA 90068 (213) 874-7963

Write Pro, Fiction Master, Write Pro, Inc., 43 South Highland, Ossining, NY 10562 (914) 762-1255

Facility Management

CreativePartner (software for image and sound networking), E-motion, 2650 E. Bayshore Rd., Palo Alto, CA 94303 (800) 385-6776

Media Management Information System, Droege Computing Services, 20 West Colony Pl., Suite 120, Durham, NC 27705 (919) 403-9459

NSI'S Tape Library System, Nesbit Systems, Inc., Five Vaughn Dr., Princeton, NJ 08540 (609) 799-5071

Schedule All, Schedule All, 20377 N.E., 15th Court, Miami, FL 33179 (800) 334-5083

Studio Management Software, Library Management Software, NDG Phoenix, 115 Hillwood Ave., Suite 201, Falls Church, VA 22046 (703) 533-5024

Video Management System, HintonWells Media Products, One Paces West, Suite 1260, 2727 Paces Ferry Rd., NW, Atlanta, GA 30339

Vidicaption (open captioning system), Image Logic, 6807 Brennen Ln., Chevy Chase, MD 20815-3255 (301) 907-8891

PRODUCTION RESOURCES

Audio Plus Video/International Post (standards conversion), 240 Pegasus Ave., North Vale, NJ 07647 (201) 767-3800

Cohen Insurance (production insurance), 225 W. 34th St., New York, NY 10122 (212) 244-8075, 9601 Wilshire Blvd., Beverly Hills, CA 90210 (310) 288-0620 ("What you should know about production insurance" booklet)

Central Bookings (crew location and contacts) (800) 822-CREW

Crews Control (crew location and contacts) (800) 545-CREW

Devlin Videoservice (standards conversion), 1501 Broadway, Suite 408, New York, NY 10036 (212) 391-1313

Motion Picture, TV, and Theatre Directory, Motion Picture Enterprises Publications, Inc., Tarrytown, NY 10591 (212) 245-0969

Prolog5 (CD-ROM-based equipment directory), Testa Communications, Port Washington, NY

The Source, National Electronic Directory of Directors, Music/Sound Designers, The Source Maythenyi, Inc., 1499 W. Palmetto Park, Boca Raton, FL 33486 (800) 525-0230, (800) 392-9701

Video On-Line (on-line equipment resource), Video Copy Services, 1699 Tullie Circle, Suite 117, Atlanta, GA 30329 (800) 553-3616, (404) 321-6933

Virtual Vision Associates (a unique group with members located throughout the country, providing full multimedia development and production services, video production, and training development), contact Steve R. Cartwright, (520) 577-0347

International Production Resources

Eurocrew Ltd., London 01144-71-284-4465 (resource for NTSC crews in Europe)

Independent Television News (ITN/WTN), ITN House, 48 Wells St., London W1P 4DE (071) 637-2424 (crews and services worldwide)

International Teleproduction Society, Inc., 990 Avenue of the Americas, Suite 21E, New York, NY 10018 (TV facilities trade association)

Leo Baca, Carnet Representative, U.S. Council for International Business, 1212 Avenue of the Americas, 21st Floor, New York, NY 10036-1689 (212) 354-4480

Medical Advice for the Traveler (booklet), by Kevin M. Cahill, M.D., Director, The Tropical Diseases Center, Lenox Hill Hospital, New York, NY

National Association of Broadcasters (NAB), 1771 N Street, N.W., Washington, DC 20036 (research, technical, legal information)

Publications Department, U.S. Dept. of Commerce, 14th Street & Pennsylvania Ave., N.W., Washington, DC 20230 (202) 377-5494 (foreign economic trends and overseas business reports)

Royal Television Society, RTS North America, Inc., KAET-TV, Arizona State University, Tempe, AZ 85287-1405

State Department Publications, Room B648, U.S. Dept. of State, 320 21st Street, N.W., Washington, DC 20520 (202) 647-2518 (background papers on countries — general economic, social, and cultural information)

Visnews, Visnews House, Cumberland Ave., London NW10 7EH (081) 965-7733 (crews and services worldwide)

Unions, Guilds, and Organizations

Alliance of Motion Picture and Television Producers (AMPTP), 14144 Ventura Blvd., Sherman Oaks, CA 91423 (818) 995-3600

American Federation of Musicians, 1501 Broadway, Suite 600, New York, NY 10036 (212) 869-1330

American Film Institute, J.F.K. Center, Washington, DC 20566

Association of Independent Commercial Producers (AICP), 100 E. 42nd St., New York, NY 10017 (212) 867-5720

Directors Guild of America, 7950 Sunset Blvd., Hollywood, CA 90046 (213) 656-1220

International Television Association, 6311 N. O'Connor Rd., Irving, TX 75039

National Association of Broadcasters, 1771 N. Street NW, Washington, DC 20036

Producers Guild of America, Inc., 8201 Beverly Blvd., Suite 500, Los Angeles, CA 90048 (213) 651-0084

Screen Actors Guild, 5757 Wilshire Blvd., Los Angeles, CA 90036

Society of Motion Picture and Television Engineers, 595 W. Hartsdale Ave., White Plains, NY 10607-1824

The Songwriters Guild, 6430 Sunset Blvd., Suite 317, Hollywood, CA 90028 (213) 462-1108

Writers Guild of America, WGA–East, 555 W. 57th Street, New York, NY 10019 (212) 245-6180

U.S. Military Contacts

Air Force: Chief TV/Movie Liaison (213) 209-7525

Army: Chief of Public Affairs (213) 209-7621

Coast Guard: Public Affairs Liaison Office (213) 209-7817

Marine Corps: Director, Public Affairs Office (213) 209-7272

Navy: Director, Navy Office of Information West (213) 209-7481

Film Commissions

Alabama Film Commission, Office of, 340 N. Hull Street, Montgomery, AL 36130

Alaska Motion Picture and TV Production Service, 3601 C Street, #722, Anchorage, AK 99503

Arizona Motion Picture Development Office, 1700 W. Washington Ave., 4th Floor, Phoenix, AZ 85007

Phoenix Motion Picture/Commercial Coordinating Office, 251 W. Washington Ave., Phoenix, AZ 85003

Arkansas Motion Picture Development Office, 1 State Capitol Mall, Little Rock, AR 72201

Northwest Arkansas Motion Picture Association, P.O. Box 476, Siloam Springs, AR 72761

California Film Office, 6922 Hollywood Blvd., #600, Hollywood, CA 90028

San Diego Motion Picture and TV Bureau, 110 West C. Street, #1600, San Diego, CA 92101

San Francisco Bay Area Film/Tape Council, P.O. Box 77024, San Francisco, CA 94107

Colorado Motion Picture Commission, 1313 Sherman St., #523, Denver, CO 80203

Connecticut Film Commission, 210 Washington St., Hartford, CT 06106

Delaware Development Office, 99 Kings Highway, P.O. Box 1401, Dover, DE 19903

Washington, DC, Mayor's Office of Motion Picture and TV, 717 14th St. NW, Washington, DC 20005

Mayor's Office of Motion Picture and TV Development, District Building, Rm. 208, Washington, DC 20004

Florida Motion Picture Bureau, Collins Building, 107 W. Gaines St., Tallahassee, FL 32399

Florida Motion Picture Bureau, Metro-Dade Office of Film and TV Coordination, 73 W. Flagler St., Rm. 1900, Miami, FL 33130

Georgia Film and Videotape Office, 285 Peachtree Center Ave., Marquis Two Tower, Atlanta, GA 30303

Mayor's Film Office, County of Hawaii, Department of Research and Development, 34 Rainbow Dr., Hilo, HI 96720

Idaho Film Bureau, Capitol Building, Room 108, Boise, ID 83720

Illinois Film Office, 100 W. Randolph St., Rm. 3-400, Chicago, IL 60601

Indiana Film Commission, Indiana Department of Commerce, One North Capitol, Suite 700, Indianapolis, IN 46204

Iowa Film Office, Iowa Development Commission, 600 E. Court Ave., Des Moines, IA 50309

Kansas Film Commission, 503 Kansas Ave., 6th Floor, Topeka, KS 66603

Kentucky Film Office, Berry Hill, Louisville Rd., Frankfort, KY 40601

Louisiana Film Commission, P.O. Box 94185, Baton Rouge, LA 70804

Maine Film Commission, 167 Maine Ave., Portland, ME 04103

Maryland Film Commission, 45 Calvert Street, Annapolis, MD 21401

Office of the Mayor, 100 N. Holliday St., Baltimore, MD 21202

Massachusetts Film Bureau, 100 Cambridge St., Boston, MA 02202

Detroit Producers Association, 3117 Woodslee, Royal Oak, MI 48073

Minnesota Motion Picture and Television Board, 100 N. 6th Street, Suite 880C, Minneapolis, MN 55403

Mississippi Film Commission, P.O. Box 849, Jackson, MS 39205

Missouri Film Commission, P.O. Box 118, Jefferson City, MO 65102

Department of Commerce, Montana Travel Promotions, 1424 9th Ave., Helena, MT 59620

Nebraska Telecommunications Center, P.O. Box 95143, Lincoln, NE 68509

Nevada Motion Picture Division, McCarran International Airport, 2nd Level, Las Vegas, NV 89158

New Hampshire Film and Television Bureau, P.O. Box 856, Concord, NH 03301

New Jersey Motion Picture and Television Commission, One Gateway Center, Suite 510, Newark, NJ 07102-5311

New Mexico Film Commission, 1050 Old Pecos Trail, Santa Fe, NM 87501

North Carolina Film Office, 430 N. Salisbury St., Raleigh, NC 27611

North Dakota Economic Development Commission, Liberty Memorial Building, Capital Grounds, Bismarck, ND 58505

Ohio Film Bureau, P.O. Box 1001, Columbus, OH 43266-0101

South Carolina Film Office, P.O. Box 927, Columbia, SC 29202

Texas Film Commission, P.O. Box 12728, 210 E. 5th Street, B-6, Austin, TX 78711

Tennessee Film, Entertainment & Music Commission, 320 6th Ave. N, 7th Floor, Nashville, TN 37219

Utah Film Development, 6290 State Office Building, Salt Lake City, UT 84114

Vermont Film Bureau, 134 State St., Montpelier, VT 05602

Virginia Film Office, Department of Economic Development, 1000 Washington Building, Richmond, VA 23219

West Virginia Film Industry, Development Office, 2101 Washington St., East Charleston, WV 25305

Calgary Economic Development Authority, P.O. Box 2100, Station M, Calgary, Alberta, Canada T2P 2M5

Edmonton Motion Picture and Television Bureau, 2410 Oxford Tower, 10235-101 St., Edmonton, Alberta, Canada T5J 3Gl

City of Montreal Film Commission, 155 Notre-Dame Street E., Montreal, Quebec, Canada H2Y lB5

Ontario Film Development Corporation, 81 Wellesley St., Toronto, Ontario, Canada M4Y 1H6

Ottawa-Hull Film and Television Association, 19 Fairmont Ave., Ottawa, Ontario, Canada K1Y 1X4

Quebec Cinematographique,2836 Rue Allard, Montreal, Quebec, Canada H4E 2M2

Toronto Film Liaison, 18th Fl, East Tower, New City Hall, Toronto, Ontario, Canada M5H 2N2

The Caribbean/Bahamas Film Promotion Bureau, P.O. Box N-3701, Nassau, Bahamas

Jamaica Film Office, 35 Trafalgar Rd., Kingston 10, Jamaica W.I.

Puerto Rico Film Institute, 355 Franklin Delano Roosevelt Ave., Hato Rey, Puerto Rico 00918

Virgin Islands Film Promotion Office, P.O. Box 6400, St. Thomas, U.S. V.I. 00804

BOOKS

Alessi, Stephen M., & Trollip, Stanley. 1991. *Computer-Based Instruction: Methods and Development*. New York: Prentice-Hall.

Anderson, Carol J., and Veljkov, Mark D. 1990. *Creating Interactive Multimedia*. Glenview, IL: Scott Foresman.

Anderson, Gary. 1993. *Video Editing and Post-Production*. Boston, MA: Focal Press.

Bergman, Robert, and Moore, Thomas. 1990. *Managing Interactive Video/Multimedia Projects*. Englewood Cliffs, NJ: Educational Technology Publications.

Blackman, Barry. 1997. *Creating Digital Illusions*. New York: John Wiley & Sons.

Boyle, T. 1996. *Design for Multimedia Learning*. New York: Prentice-Hall.

Browne, Steven. 1994. *Videotape Editing*, 2d ed. Boston, MA: Focal Press.

Cartwright, Steve R. 1986. *Training with Video*. Boston, MA: Focal Press.

———. 1990. *Secrets of Successful Video Training*. Boston, MA: Focal Press,

———. 1996. *Pre-Production Planning for Video, Film, and Multimedia*. Boston, MA: Focal Press.

Chamness, Danford. 1986. *The Hollywood Guide to Film Budgeting and Script Breakdown*. Los Angeles, CA: S.J. Brooks.

DiZazzo, Ray. 1993. *Directing Corporate Video*. Boston, MA: Focal Press.

Floyd, Steve. 1991. *The IBM Multimedia Handbook*. New York: Brady Publishing.

Gates, Richard. 1992. *Production Management for Film and Video*. Boston, MA: Focal Press.

Gibbons, Andrew S., and Fairweather, Peter G. 1998. *Computer-Based Instruction: Design and Development*. Englewood Cliffs, NJ: Educational Technology Publications.

Hooper, Richard Simon. 1997. *Authorware: An Introduction to Multimedia*. New York: Prentice-Hall.

Katz, Steven, D. 1991. *Film Directing, Shot by Shot*. Studio City, CA: Michael Wiese Productions.

Kehoe, Vincent, J-R. 1985. *The Techniques of the Professional Make-Up Artist*. Boston, MA: Focal Press.

Kemp, J.E., Morrison, G.R., and Ross, S.M. 1998. *Designing Effective Instruction*. Upper Saddle River, NJ: Merrill.

Kennedy, Thomas. 1989. *Directing Video*. Boston, MA: Focal Press.

Kommers, Piet. 1996. *Hypermedia Learning Environments: Instructional Design and Integration*. Mahwah, NJ: Lawrence Erlbaum.

Lee, W.W., and Mamone, R.A. 1995. *The Computer Based Training Handbook: Assessment, Design, Development, and Evaluation.* Englewood Cliffs, NJ: Educational Technology Publications.

LeTourneau, Tom. 1987. *Lighting Techniques for Video Production: The Art of Casting Shadows.* Boston, MA: Focal Press.

Lowell, Ross. 1992. *Matters of Light and Depth.* Philadelphia, PA: Broad Street Books.

Mager, Robert F. 1962. *Preparing Instructional Objectives.* Belmont, CA: Fearon Publishers.

Maier, Robert. 1994. *Location Scouting and Management Handbook.* Boston, MA: Focal Press.

Mathias, Harry, and Pattersson, Richard. 1985. *Electronic Cinematography: Achieving Photographic Control over the Video Image.* Belmont, CA: Wadsworth Publishing.

McCormack, Colin, and Jones, David. 1997. *Building a Web-Based Education System.* New York: John Wiley & Sons.

Merrill, Paul, et al. 1996. *Computers in Education.* Boston: Allyn & Bacon.

Miller, Pat P. 1990. *Script Supervising and Film Continuity.* Boston, MA: Focal Press.

Morley, John. 1992. *Scriptwriting for High-Impact Videos.* Belmont, CA: Wadsworth Publishing.

Newby, Timothy J., et al. 1996. *Instructional Technology for Teaching and Learning: Designing Instruction, Integrating Computers, and Using Media.* New York: Prentice-Hall.

Reiser, R, and Gagne, R.M. 1983. *Selecting Media for Instruction.* Englewood Cliffs, NJ: Educational Technology Publications.

Shambaugh, R.N., and Magliaro, S.G. 1997. *Mastering the Possibilities: A Process Approach to Instructional Design.* Boston: Allyn and Bacon.

Shuman, J.E. 1998. *Multimedia in Action.* Belmont, CA: Integrated Media Group.

Smith, Coleman. 1988. *Mastering Television Technology: A Cure for the Common Video.* Richardson, TX: Newman-Smith Publishing.

Smith, P.L., and Ragan, T.J. 1999. *Instructional Design.* Upper Saddle River: NJ: Merrill.

Sneed, Laurel C. 1991. *Evaluating Video Programs: Is It Worth It?* Boston, MA: Focal Press.

Tucker, Brian. 1997. *Handbook of Technology-Based Training.* New York: Gower Publishing.

Van Nostran, William. 1989. *The Scriptwriters Handbook.* Boston. MA: Focal Press,

Vaughan, Tay. 1993. *Multimedia: Making It Work.* Berkeley, CA: Osborne McGraw-Hill.

Wiese, Michael. 1990. *Film and Video Budgets.* Studio City, CA: Michael Wiese Productions.

Wodaski, Ron. 1994. *Multimedia Madness!* Indianapolis, IN: Sams Publishing.

Zettl, Herbert. 1973. *Sight Sound Motion: Applied Media Aesthetics.* Belmont, CA: Wadsworth Publishing.

Book Catalogs and Sources

American Society of Training and Development. Training Bookshelf. 1640 King St., P.O. Box 1443, Alexandria, VA 22313-2043.

Focal Press. Catalog of video and multimedia production books. (800) 366-2665.

Media Arts Catalog, Books on film/video production, AV/corporate video, theater/performing arts. Boston, MA: Focal Press.

Multimedia Resource Catalog. Information Resources for Multimedia Professionals. Future Systems, Inc., P.O. Box 26, Falls Church, VA 22040-0026.

MAGAZINES

AV-Video, Knowledge Industry Publications, 701 Westchester Ave., White Plains, NY 10604 (800) 800-5474

CBT Solutions, 44 Brewster Rd., Hingham, MA 02043 (617) 749-4929

Creative Training Techniques (CTT), Lakewood Publications, Inc., 50 S. Ninth St., Minneapolis, MN 55402 (800) 328-4329 or (612) 333-0471 Service Center

Digital Video, Miller Freeman Publishing, 411 Borel Ave., Suite 100, San Mateo, CA 94402 (650) 358-9500

Emedia Professional, 213 Danbury Rd., Wilton, CT 06897-4007 (203) 761-1466

Inside Technology Training, Ziff-Davis Publishing, 10 Presidents Landing, Medford, MA 02155 (888) 950-4302

IT, Training Information Network Ltd., Jubilee House, The Oaks, Pulslip Middlesex HA4 7LF United Kingdom Telephone: 0895-622112 Fax: 0895-621582

MicroComputer Trainer, 696 9th St., P.O. Box 2487, Secaucus, NJ 07096-2487 (201) 330-8923, Fax: (201)330-0163, *loretta@panix.com*

Performance and Instruction, International Society for Performance and Instruction (ISPI), 1300 L Street NW, Suite 1250, Washington, DC 20005 (202) 408-7969, *75143.410@compuserv.com*

Training and Development, Technical & Skills Training, American Society for Training and Development (ASTD), 1640 King St., Box 1443, Alexandria, VA 22313. Membership and Information: (800) 628-2783; Customer Service: (703) 683-8100; Information Center: (703) 683-8183; *astdic@capcon.net*

Training Directors Forum, Lakewood Publications, Inc., 50 S. Ninth St., Minneapolis, MN 55402 (800) 328-4329 or (612) 333-0471 Service Center

Training Magazine, Lakewood Publications, 50 S. Ninth St., Minneapolis, MN 55402 (800) 328-4329 or (612) 333-0471 Service Center; *trainmag@aol.com*

Videography, Miller Freeman Publishing, 460 Park Avenue South, New York, NY 10016 (212) 378-0400

MANUFACTURERS

Adobe Systems, Inc., 1098 Alta Ave., Mountain View, CA 94039 (415) 961-4400

Avid Technology, Metro Tech Park, 1 Park West, Tewksbury, MA 01876 (508) 640-6789

Canon USA, Inc., 610 Palisade Ave., Englewood Cliffs, NJ 07632 (201) 816-2900

Carpel Video (video accessories), 429 E. Patrick St., Frederick, MD 21701 (800) 238-4300

Cisco Systems, Inc., 1072 Arastradero Rd., Palo Alto, CA 94304 (650) 845-5200

Data Translation Incorporated (Media 100), 100 Locke Dr., Marlboro, MA 01752 (508) 481-3700

D-Vision, Touchvision Systems, Inc., 8755 W. Higgins Rd., Suite 200, Chicago, IL 60631 (800) 8-DVISION

The Grass Valley Group, Inc., P.O. Box 1114, Grass Valley, CA 95945 (916) 478-4120

ImMix (Video Cube), P.O. Box 2980 Grass Valley, CA 95945 (916) 272-9800

JVC Professional Products, 41 Slater Dr., Elmwood Park, NJ 07407 (201)794-3900

Lowell-Light Incorporated (lighting), 140 58th St., Brooklyn, New York 11220 (718) 921-0600

Matrox Video Products Group, 1055 St. Regis Blvd., Dorval, Quebec, Canada H9P 2T4 (514) 685-2630

Mole-Richardson Company (lighting), 937 N. Sycamore Ave., Hollywood, CA 90038 (213) 851 0111

O'Connor Engineering Labs (tripods), 100 Kalmus Dr., Costa Mesa, CA 92626 (714) 979-3993

Panasonic Communications & Systems, 2 Panasonic Way, Secaucus, NJ 07094 (201) 348-7000

Sennheiser Electronics Corporation (microphones), 6 Vista Dr., P.O. Box 987, Old Lyme, CT 06371 (203) 434-1759

Shure (microphones/mixers), 222 Hartrey Ave., Evanston, IL 60202-3696 (708) 866-2200

Sony, 3 Paragon Dr., Montvale, NJ 07645 (201) 358-4107

3-M Optical Recording, 3M Center, Bldg. 223-5N-01, St. Paul, MN 55144-1000
(612) 733-2142

Tiffen MFG Corporation (camera filters), 90 Oser Ave., Hauppauge, NY 11788
(516) 273-2500

Vinton Broadcast, Inc. (tripods), 44 Indian Lane E., Towaco, NJ 07082
(201) 263-4000

WORLD WIDE WEB

EPSS, Performance Centered Design and Knowledge Management,

http://www.epss.com

Fair Use Guidelines for Educational Multimedia,

http://www.indiana.edu/~ccumc/mmfairuse.html

HTML, The HTML Writer's Guild,

http://www.hwg.org/resources/html/index.html

Multimedia Authoring Resource Site,

http://www.mcli.dist.maricopa.edu/authoring/

Multimedia Development Tools,

http://www.mime1.marc.gatech.edu/mm_tools/

Selecting and Implementing Computer Based Training,

http://www.clat.psu.edu/homes/bxb11/CBTGuide/CBTGuide.htm

Training Resources,

http://www.trainingsupersite.com

The U.S. Distant Learning Association,

http://www.usdla.org/

The Virtual Vision Associates, multimedia development,

http://www.cartwright@theriver.com

Web-based Instruction Resource Site,

http://www.personal.psu.edu/faculty/w/d/wdm2/design.htm

Web-based training information center,

http://www.clark.net/pub/nractive/wbt.html

Index

About the CD-ROM...

This Companion CD-ROM features many of the sample training software and interactive videos used as examples throughout the book. Refer to **README.rtf** for the various installation instructions and specific program system requirements.

You will need to have a media player installed on your computer to access most of the software components, and the MP3 video files specifically. To install the Windows Media Player included on this CD-ROM, run **D:\Software\WinMedia\mpie4ful.exe** (where **"D"** is the designation of your CD drive). For more detailed instructions about Windows Media Player, go to the Microsoft website at **www.microsoft.com/windows/mediaplayer**.

Don't forget to check out the Focal Press Catalog. You'll need Adobe Acrobat or Acrobat Reader to access this pdf file; Acrobat Reader has been included on this CD; however, you may also download it directly from Adobe at **www.adobe.com**.

To install Acrobat Reader 4.0 directly on your computer from the CD, run **D:\Software\ACROREAD\Installers\ACRD4ENU.exe** (where **"D"** is the designation of your CD drive). To launch Acrobat Reader 4.0 directly on the CD, run **D:\Software\ACROREAD\CD\READER\ACRORD32.exe**, then open **D:\Catalog\FPCat99.pdf**.

Beyond providing replacements for defective disks, Butterworth-Heinemann does not provide technical support for the software programs included on this CD-ROM. The programs have been prepared for demonstration sampling purposes only. For assistance with installation or accessing the content of this CD, please see **README.RTF**. You may also address your questions via email to **techsupport@bhusa.com**. Be sure to reference item number **CD-03256-PC**.